CRAFTLAND

ALSO BY JAMES FOX

The World According to Colour: A Cultural History

British Art and the First World War, 1914–1924

CRAFTLAND

A Journey Through Britain's
Lost Arts & Vanishing Trades

JAMES FOX

THE BODLEY HEAD
LONDON

1 3 5 7 9 10 8 6 4 2

The Bodley Head, an imprint of Vintage, is part of the
Penguin Random House group of companies

Vintage, Penguin Random House UK, One Embassy
Gardens, 8 Viaduct Gardens, London SW11 7BW

penguin.co.uk/vintage
global.penguinrandomhouse.com

First published by The Bodley Head in 2025

Copyright © James Fox 2025

The moral right of the author has been asserted

Marbling and endpapers © Jemma Lewis Marbling & Design
Hand motif © Nathaniel Russell
Integrated illustrations © Helen Cann
Chapter opening images © Neil Bousfield (chapters 1, 2, 7 and 11); Kit Boyd
(chapters 3, 4, 6 and 10); and Lucie Spartacus (chapters 5, 8, 9 and 12)

No part of this book may be used or reproduced in any manner for the purpose
of training artificial intelligence technologies or systems. In accordance
with Article 4(3) of the DSM Directive 2019/790, Penguin Random House
expressly reserves this work from the text and data mining exception.

Typeset in 11.5/18pt Joly Text by Six Red Marbles UK, Thetford, Norfolk
Printed and bound in Great Britain by Clays Ltd, Elcograf S.p.A.

The authorised representative in the EEA is Penguin Random House
Ireland, Morrison Chambers, 32 Nassau Street, Dublin D02 YH68

A CIP catalogue record for this book is available from the British Library

ISBN 9781847927866

Penguin Random House is committed to a sustainable future
for our business, our readers and our planet. This book is made
from Forest Stewardship Council® certified paper.

In memory of Hugo Burge

Contents

Introduction 1

LANDSCAPE

ONE	The Ground Beneath Our Feet	21
TWO	A Roof over One's Head	45
THREE	Into the Woods	71
FOUR	Down the River	95

COMMUNITY

FIVE	Along the High Street	121
SIX	The Making of a Mariner	147
SEVEN	The Ringing Isle	169
EIGHT	The Alphabetician	193

INDUSTRY

NINE	The Watchmaker's Apprentice	219
TEN	Cask Strength	241
ELEVEN	Steel City	265
TWELVE	The Crucible	289

Conclusion 311

A Selection of (Mostly) Extinct Occupations 320

The Thirty-Four Trades of Watchmaking 327

Acknowledgements 331

List of Illustrations 336

Notes 341

INTRODUCTION

The stone-carver was the first to tell me about it. She agreed to speak to the bookbinder, who spoke to the gamekeeper, who spoke to the landlord, who gave the key to his sister, who drove all the way to the Scottish Borders to hand it – somewhat apprehensively – to me.

It was a late April morning – the first spring-like day of the year. The Cheviot hills were white with frost, but the roadsides shone with daffodils and the trees glistened green. I walked through the small Berwickshire village under a shower of birdsong, stepping on shadows of fallen leaves and dodging puddles that hadn't cleared since autumn. Half-way down the

CRAFTLAND

high street, between an old schoolhouse that had long ceased taking pupils and a cast-iron hand-pump that no longer drew water, there stood a ramshackle stone building with steep gables and diamond-pane windows. I'd been waiting more than a year to get inside it.

The door was low and wide, its painted surfaces peeling green over red over blue. I slid the heavy, handmade key into the keyhole, turned the lock, then pushed across the threshold into a darkness that stank of engine oil. As my eyes adjusted to the gloom, the contours of a workshop sharpened into view. There were tools everywhere: lined up on workbenches, crammed into cupboards, spilling out of drawers – all of them browned with rust and blackened by soot. I saw vices, lathes, pillar drills, sharpening stones, cutting wedges, lead-pouring ladles and countless other instruments whose names I didn't know and whose purposes I couldn't fathom.

I advanced deeper into the workshop, ducking cobwebs as I went, passing an anvil dabbed with dusty fingerprints and a cone mandrel that rose from the floor like a ziggurat. At the back of the room lay a stone forge hung with chisels and tongs, and next to it a crude wooden lever on which someone had written: 'Do not tamper with this rockstaff, this is most important'. I looked around then grasped the lever, sliding my palm into a smooth depression formed by many hands before mine. As I pumped the rockstaff up and down an old bellows came to life, wheezing like a large animal woken from a deep sleep.

INTRODUCTION

As the bellows contracted, so, in a sense, did time. The whole workshop, despite its sorry state, seemed trapped in suspended animation – as if its owner had just left the building and would be returning any moment. A leather apron hung by the door and a half-smoked cigarette waited on the workbench. But as I examined my surroundings more closely, I began to realise quite how long this place had been abandoned. I found a Victorian poster advertising ox-driven ploughs, a pile of pre-war shillings on the window-ledge, and a scrap of yellow newspaper reporting a local man's arrest for drunkenly crashing his horse and cart. I circled back to the workbench: the cigarette was a range of Wild Woodbine that I later learned hadn't been manufactured since the 1960s.

From the moment it opened at the beginning of the nineteenth century this little building was the crucible of its community – home to a trade that made every other trade possible. It was the village smiddy: the place people came to get their tools forged, waggons fixed and horses shoed. For 150 years one busy blacksmith succeeded another here, as surely as night followed day. But as cars displaced horses, shops replaced workshops and the local population shrivelled and changed, the demand for their services fell away. The last blacksmith of the village had tried to move with the times, moonlighting briefly as a mechanic and handyman, but he must have known his time had passed. One day, about sixty

years ago, he put out the forge, hung up his apron, locked up the workshop, and – as far as we know – never came back.

Britain was once a craft land – a nation of workshops and studios, masters and apprentices; a society grounded in the act of making things by hand. For much of our history, craft wasn't a quaint pastime but an engine of social and economic life. Without it, the country would have quite literally ground to a halt. Most villages had their own blacksmiths and wheelwrights, their own thatchers and boot-makers. If you wandered down to the river, you'd have seen millers tinkering with waterwheels and tanners drying hides by the reedbeds. In the woods, coppice-workers managed groves of hazel, sawyers cut trees into timber and bodgers turned wood under makeshift shelters. In cottages up and down the land, women and children spun wool, plaited straw and threaded lace by the fireside before selling their wares at the local market.

Few of those people chose their careers, as we generally do today. In most cases they were chosen *for* them – sometimes by ancestors who lived centuries before they were even born. They learned their trade during exacting apprenticeships, perfecting their techniques through skin-blistering repetition. Only after years of training – sometimes more than it takes to qualify as a doctor today – could they call themselves a 'master' of their craft, at which point they usually recruited

an apprentice of their own. A craftsperson's trade wasn't simply an occupation; it was their past, their future – their identity. Though their workshops are largely gone and their skills mostly lost, those identities endure in our surnames. Some – Smith, Wright, Mason, Taylor – are well understood, but others have become so estranged from their origins that we don't even realise they were once crafts: that Turners turned wood, Spurriers made spurs, Dexters dyed cloth, Challoners made blankets and Kelloggs (from 'kill hog') were pork butchers. These names are the long extending shadows of lost crafts, the attenuated echoes of earlier ways of life.

Craft didn't only shape the lives of individuals but defined entire communities. Though many trades thrived all over the country, others clustered in specific regions. The Somerset Levels became famous for willow, Stoke-on-Trent for pottery, Burton-on-Trent for brewing, Sheffield for cutlery, Sunderland for glass, Kidderminster for carpets, Worcester for gloves, Luton for hats, High Wycombe for chairs. In these and many other places, a single trade came to dominate the local economy to such an extent that there wasn't much room for anything else: by the turn of the nineteenth century, every other house in Sheffield was a smithy, a third of all Northampton men were cobblers, and three quarters of Bedfordshire's women were lacemakers.

In today's rationalised world, where every high street looks alike and every shop seems to sell the same mass-produced goods, it can be difficult to grasp just how localised crafts used

to be. Take, for instance, the basket – a humble object once considered so essential to national life that its makers were exempted from military service as late as the Second World War. The British Isles were home to hundreds of different varieties, many unique to a single county, island, stretch of coastline, or even just a cluster of cottages. Sussex trugs – gardening baskets made from cleft willow and sweet chestnut – were indigenous to the villages around Herstmonceux in East Sussex. Gower cockle baskets, which women used to collect shellfish on the mudflats of the Loughor Estuary in Wales, were only made in the village of Penclawdd using hazel coppiced from nearby woods. Kishies, which crofters wore on their backs to carry peat across windswept moors, only existed in Shetland (though Orkneymen had similar baskets called Caisies). Oyster tendles were native to Mersea, watercress baskets to Canterbury, herring swills to Great Yarmouth, whiskets to the Welsh Borders, and Covent Garden sieves to a mere handful of streets in central London. This vast range of receptacles may seem preposterous to us today, with our plastic bags and branded totes, but it is proof of the inexhaustible richness of Britain's traditional crafts.

Just as every area had its own dialects and delicacies so it also had its own handicrafts, which likewise evolved from its residents' particular way of doing things. But as Britain modernised, these local quirks were increasingly seen as barriers to progress. They were first assailed in the eighteenth and nineteenth centuries when canals and railways carved their way

through the countryside, opening up secluded parishes and yoking distant settlements to each other. As goods hurtled back and forth across the country, from their native homes to wherever a market could be found for them, vernacular traditions died away. As metropolitan manufacturers undercut their rural competitors, countless village craftspeople – many of whom were running family firms that went back centuries – went out of business.

The Industrial Revolution, of which the canals and railways were both a symptom and a cause, made matters worse. Year by year, process by process, more human jobs were mechanised: arms replaced by pistons, dextrous fingers by metronomic needles. Spinning mules, power looms, sewing machines, circular saws and mechanical lathes all outperformed the craftspeople they aped, turning Britain into the greatest manufacturing nation the world had ever seen. By the mid 1880s its smoke-cloaked factories produced 43 per cent of the world's manufactured exports (China today makes less than 30 per cent). The output of Birmingham alone was staggering. Every week this 'city of a thousand trades' is said to have turned out:

Fourteen millions of pens, six thousand bedsteads, seven thousand guns, three hundred millions of cut nails, one hundred millions of buttons, one thousand saddles, five millions of copper or bronze coins, twenty thousand pairs of spectacles, six tons of papier-maché ware, £30,000 worth of

jewellery, four thousand miles of iron and steel wire, ten tons of pins, five tons of hairpins, hooks and eyes, and eyelets, one hundred and thirty thousand gross of wood screws, five hundred tons of nuts, screw-bolts, spikes, and rivets, fifty tons of wrought iron hinges, three hundred and fifty miles length of wax for vestas, forty tons of refined metal, forty tons of German silver, one thousand dozens of fenders, three thousand five hundred bellows, a thousand roasting jacks, one hundred and fifty sewing machines, eight hundred tons of brass and copper wares, besides an almost endless multitude of miscellaneous articles, of which no statistics can be given, but which, like those enumerated, find employment for hundreds and thousands of busy hands, and are destined to supply the manifold wants of humanity from China to Peru.1

Activity on this scale couldn't fail to leave a mark. The textiles industry, which once employed a fifth of the country's total workforce, permanently transformed the north of England, creating a red-brick world of mills, canals and terraces that continue to organise people's lives today. Its legacy is even woven into the fabric of our language. Every time we 'cotton on' to something, 'reel off' some facts, feel 'hemmed in', hang 'on tenterhooks', 'line our pockets', laugh ourselves into 'stitches', describe one person as being 'dyed in the wool', two people as 'cut from the same cloth', tell a windbag to 'put a sock in it', call a coward a 'wet blanket', or label an unmarried woman a 'spinster', we are referring to the production of textiles.

Britain's pre-eminence was short-lived. Over the last half century or so the United Kingdom has undergone another, opposite, revolution. As other nations followed its lead and global competition increased, the country's manufacturing industries ran out of steam. By the end of the 1980s the world's first industrial society was well on its way to becoming the world's first *post*-industrial society. Today, manufacturing accounts for just 10 per cent of our economy. As the country transitioned to the service sector, from a producer society to a consumer society, the 'workshop of the world' lost the vast majority of its workshops.

The industrial and de-industrial revolutions extinguished thousands of manufacturing occupations, some of which had been practised on these shores for centuries. Spare a thought for the ballers, benders, blubbermen, bogeymen, boners, bottom stainers, cock-makers, devils, eye punchers, faggotters, fiddlers, flashers, flirters, pom-pom men, quarrel-pickers, snobs, whiff-makers and willy men whose once respectable livelihoods now sound like vulgar nicknames.2 Most of those jobs died out long before you and I were born. But the process that brought about their disappearance hasn't yet reached its conclusion. As we continue to modernise and globalise, as ever more analogue processes are digitised, as artificial intelligence does to our workforce what machines did to the Victorians, many traditional practices face a similar fate.

According to Heritage Crafts, an organisation that monitors threatened trades much like the World Wildlife Fund tracks

imperilled species, 285 traditional crafts are still practised in Britain. More than half are endangered – seventy-two of them critically so. Some are sustained by just one surviving practitioner. In each of these cases a whole strand of our heritage hangs by a fraying thread, contingent on the fate of a single person: their family circumstances, financial situation and physical health. Many of these survivors are battling to keep going, either because they feel they owe it to their predecessors, or because they simply can't imagine doing anything else. But the odds against them grow every day. Their businesses have been getting less viable for decades due to cheaper, mass-manufactured imports, changing lifestyles and the challenge of recruiting apprentices. In the last decade alone, four old crafts (cricket ball-making, gold-beating, lacrosse stick-making and mould- and deckle-making) have disappeared from Britain – and with them centuries of accumulated knowledge and skill. Some believe we are now on the cusp of what biologists call a 'mass extinction event'.

* * *

I've always loved handmade things. Whenever you encounter a hand-crafted object – whether it's an Old Master sketch, an antique watch or a simple stoneware mug – you are meeting something that is by definition unique, with its own fingerprint of quirks and imperfections. That's because every such item, no matter how accomplished or clumsy it may be, bears

the indexical residue of a particular moment in time, when a human being put something into the world that didn't exist before and couldn't exist anywhere else. To hold it in your hands is to converse with its maker, who – moments, months, maybe centuries earlier – wove, moulded or carved those same surfaces. This, I think, is what makes artisanal objects so enchanting, and why – when so many of our possessions are cheap and disposable – people keep and cherish them, then pass them on as heirlooms.

I, like many, descend from a family of artisans. My father's grandparents were Polish Jews who, fleeing the pogroms, migrated to the East End of London where they worked gold, cut diamonds and made cheap garments (which they called *schmutter*). My mother's father originated in Cyprus, acquiring his surname – Violaris – from the violins his father made and played in the ancestral village. Over time, however, both sides of my family disavowed their artisanal origins. My Jewish grandfather stopped making fabric and started selling it; my Greek grandfather gave up violins and went into the property business. To them, like so many of their generation, manual labour seemed incompatible with self-improvement and social aspiration. When in 2001 I became the first person in my family to go to university, my Greek grandfather held a glass of cheap champagne aloft and proudly proclaimed that we had at last produced a 'professional'.

'Craft' is a slippery concept. It can be a noun (the 'craft' of carpentry), a verb (to 'craft' something well), an adjective ('craft'

beer) and even an adverb (like the one I've 'craftily' snuck in here). Some theorists argue that it's a modern invention – a reactionary response to industrialisation – while others think it's an ancient and universal human impulse. Some assume it applies only to traditional practices, while others believe it's equally at home in modern industries.3 The truth is none of us knows *exactly* what craft is – or at least we can't agree. This book therefore relies on the simplest of definitions: craft, in the words of one popular dictionary, is 'an activity that involves making something in a skilful way by hand'.4

Wedged uncomfortably between art and manual labour, craft has long been misunderstood and belittled – often, I'm afraid, by art historians like me. For much of the modern period my predecessors portrayed craft (once dubbed the 'minor' or 'mechanical arts') as a feckless foil to the so-called 'fine arts'. If painting and sculpture were products of genius then craft was the domain of tradesmen, peasants and – worst of all – women. We've known for some time how wrong those distinctions are. Craft is just as culturally significant as its more celebrated counterparts. Indeed, because it evolves organically from the human needs of a particular region, it offers revealing insights into the customs of ordinary men, women and children: how they lived, worked and played. The history of craft isn't just the history of making: it's the history of everything.

This book aims to tell its story. We will travel all over the British Isles in search of endangered crafts and the remarkable people who sustain them. Our journey will take us from

the Scilly Isles to the Scottish Highlands, the Holme Valley to the Home Counties. We'll wander through fields and forests, exploring the many trades that emerged from the country's landscapes. We'll follow narrow lanes into sleeping villages, pass through commuter towns and post-industrial cities, then make our way to the nation's capital. I warn you: not everywhere will be picturesque. Just as blackberries flourish by the side of the road, so crafts thrive in quotidian places, where normal people live and work. We'll spend time in business parks and industrial estates, corner shops and cul-de-sacs – areas that have long been ignored and disparaged but which are in fact great crucibles of creativity. If, as the critic Raymond Williams once wrote, 'culture is ordinary', then so are the places where it happens.

Every region has its genius. Every area possesses its own combination of physical, social and cultural ingredients that make it unlike anywhere else in the world. Each chapter paints a portrait of one of those places, whether it be a county or a coastline, a hamlet or a metropolis. We'll investigate its landscape, history, indigenous customs and local industries, asking why they emerged where they did and why they subsequently declined. Why did bell-founding thrive in Loughborough and chair-making in High Wycombe? Why did bodgers emerge in the Chilterns and scissor-makers in Sheffield? Why did tailors gather in Savile Row and watchmakers in Clerkenwell? In each case we'll see how these crafts went on to shape the places that produced them, turning villages into towns and towns

into cities, generating wealth, transforming the countryside, becoming a vital source of local identity and civic pride.

Above all, this is a book about people. It follows a group of wallers and thatchers, weavers and wheelwrights, coopers and coppice-workers, potters and tanners, scribes and letter-cutters. We'll step inside their workshops and watch them as they go about their business, studying their techniques, learning their languages, sniffing out their trade secrets. Some are continuing what their ancestors started centuries ago while others have stumbled upon their craft through personal crises or pure chance. Every one of them is paddling against prevailing currents, trying desperately to keep fragile traditions afloat. In sustaining those traditions, in preserving the remains of Britain's manufacturing legacy, they are living repositories of a heritage that is slipping slowly away.

It hasn't, alas, been possible to write about *all* of Britain's traditional crafts, much as I would have loved to. My selection has been limited by time, space, access and many other editorial considerations. Several people proved either too difficult to reach or simply refused to let me visit them. But I have tried nevertheless to cover the widest possible range of makers and places, materials and methods, with a view to capturing the remarkable diversity of this thing we call craft. And with apologies to the country's many wonderful dyers, jewellers, tailors, weavers and wood-carvers: I have mostly focused on endangered crafts, because those are the ones whose stories need urgent telling.

On more than one occasion I was too late. In the two years I've spent writing this book, a handful of centuries-old businesses ceased trading and dozens of historic workshops were demolished or redeveloped (in one case their treasured tools were hurled into skips and buried as landfill). Two Sheffield scissor-putters, one Welsh weaver and a Cambridge signwriter, with more than two hundred years of experience between them, retired only weeks before I was due to visit them. An octogenarian wheelwright's dementia advanced so rapidly that by the time I reached him a lifetime's worth of knowledge had dissolved into angry confusion. A master grinder in Sheffield – considered by many to be the city's last genuine 'little mester' – died only days before I was due to meet him.

This isn't a history book, nor is it one with some powerful thesis to advance. It is the account of a journey whose main purpose is to reveal that which is overlooked and chronicle what might otherwise be forgotten. My goal is to celebrate a group of underappreciated people, and wherever possible I let them speak for themselves. This is their story, not mine. And yet I think what emerges from their disparate lives is a compelling case for craft itself. The crafts may have lost their former social pre-eminence, but they continue to speak to our deepest needs. They ground us in our landscapes and communities, connect us to our physical bodies and material surroundings, and help stimulate the creative instincts that many of us seem to have forgotten. At its best, craft embodies a particular approach to

life and work – a way of *being* in the world – that has arguably never been more valuable.

Sometimes the old ways are the new ways. Sometimes traditions can lead us forward. I believe the trades described in this book tackle some of the most pressing questions we currently face as a society: can materiality survive in an increasingly virtual world? Can local traditions co-exist with globalisation? What does meaningful work look like in an age dominated by so-called 'bullshit jobs'? And how, as we sink ever deeper into the climate crisis, do we build a more sustainable model of production and consumption? Every craftsperson in this book offers an answer to those questions each time they pick up a tool. As screen-blind workers seek more rewarding occupations, as nations reject dying dogmas of 'efficiency' and 'productivity', and as ever more of us seek out greener lifestyles, the crafts of the past may in fact offer us a blueprint for the future.

LANDSCAPE

CHAPTER ONE

The Ground Beneath Our Feet

Dry Stone Walling
Shepley, West Yorkshire

All is quiet on the farm. The tractors are idle and the sheep are dozing. As a sunless dawn breaks across the Yorkshire sky, a small troupe of starlings dances a murmuration in the half-light.

A silver pick-up truck emerges through the mist, rumbles up the slope and parks at the top of the hill. Two dark-clothed figures, their heads hooded, climb out of the vehicle and slam the doors behind them. They remove hammers and crowbars from the boot, then carry them through a gate into the next field, where part of a wall has collapsed in the winter storms.

CRAFTLAND

No one knows exactly how old the wall is – only that it's been standing here for centuries, dividing one plot of land from another, containing countless generations of sheep. It draws an imperfect rectangle across the countryside, running north-east along a ridge, plunging into a valley, turning left at a dell, following a footpath, skipping over a stile, then climbing back to where it started.

The wallers – a brother and sister who live just across the valley – circle the structure and assess its condition. As they debate the best way to repair it, their words curdle into steam and dissolve in the cold air. Then the work begins.

They start by removing the remaining stones, sorting them by size and function, and tossing them into separate piles. As they dismantle the wall, all kinds of creatures escape from the shadows: spiders scuttle into the debris, worms writhe into the mud, and two tired toads waddle off across the grass. At one point they uncover a colony of sleeping peacock butterflies, which they collect in cupped hands and re-settle a few yards down the slope. None of them wakes.

The weather deteriorates as the morning goes on. By 9 am the breeze has become a gale, shaking the trees and hurtling dark clouds across the sky. At 9.20 the rain rolls in off the Pennines in near-horizontal waves, smudging the fields and veiling the hills in grey.

The wallers toil through the morning as the wind rattles their waterproofs and the rain stings their skin. They move like two clockwork machines, bending down, standing up, leaning

over, again and again, hour after hour. Yet there is nothing mindless about their work: every decision matters, every stone counts. They rummage through the rubble, looking for the next piece in the puzzle, turning it over in their hands, inspecting it from every angle, then laying it carefully beside its neighbours. They work wordlessly, methodically, ascending in increments: footers, first lift, through-stones, second lift, toppings.

By the end of the day, as darkness again descends on Yorkshire, the siblings have moved ten tonnes of stone by hand and built a wall that, with luck, will still be standing in two hundred years.

* * *

About 6,000 years ago a band of European migrants crossed the Channel to Britain. They came in small boats that pitched and rolled in the waves. Some probably didn't survive the journey, but those who did went on to colonise their new home with remarkable thoroughness, from the swampy lowlands of southern England to the wind-pummelled islands of the Outer Hebrides.

There is much we don't know about these 'Neolithic' people, but they undoubtedly had a genius for craftsmanship. They wove intricate baskets from reed and willow, produced the first ever pottery on the British Isles, and made stone tools whose polished surfaces continue to shine like new. Long before the idea of a pyramid glinted in an Egyptian eye, they were building stone monuments so large and sophisticated that we still can't comprehend how they did $it.^1$

CRAFTLAND

The most significant Neolithic innovation was agriculture. Before their arrival the British Isles were inhabited by hunter-gatherers who roved the tree-thick landscapes in search of wild food. Their Neolithic successors, by contrast, were farmers: they came here with seed wheat and barley, as well as sheep, goats, pigs and cows, which they somehow transported across the Channel. They slashed and burned their way through the wildwoods, converting ancient forests into the first fields. Then they did something that had probably never been done before, and which to their nomadic predecessors would have seemed utterly bizarre. As they prepared the land for cultivation they gathered loose rocks, carried them to the edges of their fields, and started building walls.

Most Neolithic walls vanished long ago, but in a handful of unspoilt places – places so remote and barren that few have since dared inhabit them – the traces of slightly later Bronze Age walls just about remain. In Dartmoor (which is only a moor because prehistoric farmers clear-felled its oak forests), the remains of ancient stone boundaries scribble miles of etch-a-sketch patterns through grass and gorse. These structures, known locally as 'reaves', were originally capped by walls of native granite, before time, weather and gravity (not to mention pilfering masons of later centuries) reduced them to low rubbly ridges that in places are now virtually invisible.

They are evidence that thousands of years before the Romans built Hadrian's Wall, our predecessors were working with natural stone to re-shape and organise their landscapes.2

The story of dry stone walling is the story of farming. These two ancient practices are so interdependent that they are all but unimaginable without each other. Dry stone walls (called 'dry' because of their lack of mortar) were initially built by farmers themselves and served several agricultural functions, the most important being the enclosure of livestock: shielding them from potentially fatal weather and keeping their insatiable mouths off valuable crops. We often assume that Britain's existing field boundaries evolved organically over the centuries as crofters, smallholders, shepherds and graziers agreed the patchwork plots that make up our countryside. The truth is rather less charming. The vast majority of surviving dry stone walls are not ancient but modern, and were built in a brief, intense burst of activity as part of an aristocratic land-grab.

If you had squelched your way along the highways and byways of medieval England, dodging dung-carts and bandits as you went, the countryside would have looked far less enclosed than it does today. That's because our predecessors' notion of property was very different from our own. Though land was nominally owned by aristocrats, usually in the name of the Crown, it was in practice a widely accessible resource. There were of course some boundaries: you'd have seen hedges and ditches, wattle fences and hurdle gates. If you'd made it up to Yorkshire's hill farms you might have spotted imposing walls designed to prevent wolves (before they were hunted to extinction) from reaching the sheep within.3 Most of Britain's landscapes, however, were open. Peasants worked side-by-side

in large communal fields, hay meadows stretched as far as the eye could see, while livestock nonchalantly rambled through common pastures, woodlands and country lanes.

Towards the end of the Middle Ages, in part because of the booming wool industry, attitudes changed. As manorial lords came to appreciate the enormous value of agricultural land, they began to expand, consolidate and enclose their holdings. They bribed, bullied, blackmailed and negotiated, paying off neighbours, lobbying local courts and ultimately petitioning Parliament to evict their peasant farmers and convert open fields and common pastures into private farmland. As soon as the agreements were complete, they raised fences, laid hedges and built walls around their land, not simply to divide arable fields from pasture or livestock from predators, but to mark out parts of their now exclusive estates. Between 1604 and 1914, more than 5,000 Acts of Parliament converted 6.8 million acres – about a fifth of England's total area – from 'public' land into private property.4

It is difficult to overstate the historical importance of the Enclosures. Some argue that they liberated landowners to improve and modernise their farming methods, leading to increased agricultural productivity and wider economic growth. Others maintain that they displaced and dispossessed entire rural communities, hollowing out the countryside, entrenching disparities of wealth, and producing a nation in which, even today, half of all land is owned by just 1 per cent of the population. But there is one thing about which no one disagrees. The Enclosures, more

perhaps than any other historical process, created the British countryside as we know it, in all its patchwork beauty.

During the peak of the Enclosures, between about 1750 and 1850, walling squads worked across the country, thronging the fields like the sheep they were tasked with containing. To call their work arduous would be to flatter it. Itinerant wallers – among them rural labourers, Irish migrants, even prisoners of war – spent months away from their homes and families at a time. Some were housed in farm outbuildings with farting livestock; others slept under their coats on the hills. They often had to hike several miles simply to reach their construction site, where they worked, in clothes that never fully dried and with blisters that never fully healed, until nightfall.5 For those who lived locally, and whose ancestors had farmed the land for generations, the irony of the whole business can't have escaped them: they were, after all, building the very instruments of their own dispossession.6

Britain's wallers are now forgotten, missing even from Victorian censuses. But they were among the most influential craftspeople to ever work in this country, responsible for one of the greatest infrastructure projects in the nation's history – up there, in sheer Herculean scale, with the construction of the railways. For in not much more than a century, and with just a few basic hand tools at their disposal, these anonymous men extracted hundreds of millions of tonnes of rock and built a network of stone boundaries ten times longer than the Great Wall of China. Placed end to end, they could encircle the Earth's equator five times.7

CRAFTLAND

Dry stone walls are generally confined to the uplands of north and west Britain, with hedgerows (many also dating back to the Enclosures) dominating the more fertile, arable farmland of the south-east. We can in fact map their domain by drawing a single sweeping line across England, from the Dorset coast to the Humber Estuary. The land above this line is wall country (it is also, by coincidence or not, sheep-farming country). This simple distinction, which of course has its

exceptions, is largely dictated by geology. The line closely corresponds with the Jurassic limestone belt, deposited 150–200 million years ago. Only the land north of this belt is blessed with the large quantities of strong, accessible stone needed to construct walls.

Every region has its own walling style, just as it has its own cheese. A knowledgeable waller need only glance at a boundary to know exactly where in the country it belongs. Walls are neurotically neat in the Cotswolds, tightly tessellated in north

DUMFRIES & GALLOWAY, SCOTLAND

ERYRI, WALES

THE COTSWOLDS, ENGLAND

Wales and wildly eccentric in Dumfries and Galloway. In some places coping stones are laid vertically, in others they're slanted, and in others they bounce blithely up and down. In Devon and Cornwall dry stone walls can also contain earth, turf and brushwood, and are confusingly known as 'hedges'.8 In most parts of Britain walls are used to keep livestock in, but in Orkney they do the opposite: the North Ronaldsay sheep dyke (dry stone walls are called 'drystane dykes' in Scotland) encircles the whole island, keeping its seaweed-chewing sheep on the beach.9

The extraordinary diversity of Britain's dry stone walls ultimately originates in the ground on which they stand. The United Kingdom may look modest on a map but it is a marvel of geological complexity. It contains most of the world's major rock types spanning more than half of the planet's history, all crammed into a tiny geographical area. And because dry stone walls are nearly always constructed with local stone, they too vary greatly. In doing so, they visualise the invisible forces that lurch beneath our feet. Whenever you look at a dry stone wall, wherever it is in the country, you are looking at the work of not one but two masons: the human being who built the wall, and the natural forces that built its stone.

* * *

Nowhere in England has more dry stone walls than Yorkshire. It is home to almost 20,000 miles of them – twice as many as any other region. They zigzag through dales and moors, bound up

hills and bounce down valleys, lapping the fields like compulsive cross-country runners. They stitch the countryside together, imposing a spidery geometry on a place otherwise made from curves. They once served as the essential infrastructure for an economy built on sheep farming, but they've also become an important part of the region's identity, featuring in everything from tourist board brochures to adverts selling tea. For many Yorkshire expats the mere sight of a dry stone wall is enough to elicit an ache of nostalgia. 'Who built these walls, why they were ever thought worth building, these are mysteries to me,' wrote the Bradford-born J. B. Priestley. 'But when I see them, I know I am home again; and no landscape looks quite right to me without them.'10

About an hour south of Bradford lies a quiet and rarely visited part of West Yorkshire. This small triangle of countryside is wedged between Huddersfield to the north, Sheffield to the south, Barnsley to the east and the Pennines to the west. It's made up of deep valleys, scrappy hilltop farms and austere Victorian settlements built on the profits of the region's booming textiles industry. For centuries this land was dominated by sheep farming, its fields busy with shepherds and shearers, its pubs rowdy with beaglers and folk singers. But in the 1970s an influx of 'comer-inners' slowly replaced the ageing farmers, and the region mutated into commuter country. Most of the area's rural trades and customs have since vanished, surviving only in the minds of those old enough to remember them. But in the small world of dry stone walling, this place is still a

mecca. Just outside the quiet village of Shepley (its name originating in the Old English, *sceap leah,* for 'sheep clearing') is a smallholding of nine steeply sloping fields. It is home to the pre-eminent walling family in Britain, if not the world.

The Nobles have farmed this land for four centuries and worked as stonemasons for at least two. In the nineteenth century they owned several nearby quarries (known locally as 'delfs') and were involved in major construction projects for the rapidly growing collieries. The business has since passed through five big-handed, cricket-playing generations, whose portraits are kept in a box in the attic. The oldest is a faded Victorian photograph of William Noble, replete with long beard and patterned cravat. Then there's one of his son Henry, whose wing collar looks as rigid as the sandstone he dug from his delf. William's grandson Oliver is pictured on the family's farm in a tweed jacket and torn flat cap; Oliver's brother Arthur attacks a large lump of rock in Pop Larkin suspenders; Arthur's son Bill (now in his eighties) grasps a chisel in one hand and a mallet in the other; and Bill's children Cuthbert and Lydia pose in T-shirts and baseball caps. Fashions may have changed but the work itself hasn't. Cuthbert, whose forearms are tattooed with images of quarrying hammers, even uses the same tools as his ancestors, passed from father to son since the 1840s.

In our restless age, when every generation needs to find its own uncertain path, what must it feel like to be doing the same job, in the same area, as your great-great-grandfather? And what must it feel like to live somewhere that was quite literally built

by your forefathers? Whenever Bert and Lydia go into Shepley for a loaf of bread or a pint in the pub, they are surrounded by their ancestors' work. Noble hands have constructed dozens of houses, erected hundreds of yards of walls and laid thousands of flagstones in the village's lanes and ginnels. They even built the local school, which Bert and Lydia attended, like their father and grandfather before them. The splendid stone building, with its intricately carved façades and urn-capped gables, is a source of great family pride. After drunken teenagers dismantled one of the school's perimeter walls overnight, Lydia spent a whole week in the corner of the playground rebuilding it. She was five years old at the time.

Bert and Lydia learned to wall before they could read and write. While other children played with Lego, they were out gapping field boundaries on the family farm. As the years rolled on, and successive Christmas stockings bestowed them with ever more tools, Bert and Lydia became increasingly accomplished wallers. They briefly considered other careers but were ultimately drawn back, like homing pigeons, to the craft of their predecessors. In 2017, when they were twenty-four and twenty-one, they became the youngest Master Craftsmen in the history of the trade. Lydia is one of only two women ever to have held such a qualification.

The Nobles have walled all over the world but spend most of their time in this quiet corner of Yorkshire, rarely travelling beyond the long shadow of the Emley Moor mast.II They know this landscape like the backs of their callused hands. As they

drive along the lanes from one job to the next, they can spot in grassy hollows the almost imperceptible remains of abandoned delfs; they can tell from the mere colour of a stone exactly which fell or slade it came from; and they can distinguish in the region's many walls the varying standards of workmanship: the accomplished from the amateur, the thorough from the sloppy, the inspired from the fraudulent. They can even identify, like detectives tracking the movements of a serial criminal, the hand of a single waller across various locations. The Nobles are constantly comparing themselves to the masons who came before them, and not always to their advantage. They've been known to shed tears of admiration in front of a well-built wall. 'I often wish I could go back to the nineteenth century', says Bill, 'so I could ask these men how the bloody hell they did it. We like to talk about progress but we're nothing compared to the Victorians. We can't build anything nowadays.'

In a society that craves clicks, likes and quick returns, it can be difficult to appreciate the subtle rewards of walling. The work is underpaid, undervalued and often goes unnoticed. A waller might devote weeks of limb-burning effort to a structure that will only ever be enjoyed by livestock. This doesn't seem to bother them. I once spent an evening with a dry stone waller in a remote north-country pub. We ate pie, drank beer and discussed the many hardships of the trade. But when I asked him about the long-term legacy of his work, he became so eloquent that I borrowed a pen from the bar and frantically scratched his words into my napkin. 'In years to come', he said (if my

food-stained transcription is correct), 'I'll be forgotten and anonymous just like the people who came before me. The only thing I care about is making something that will still stand in the landscape after I'm gone. That's all the credit I need.'

Many wallers are motivated by a desire to contribute to something larger than themselves, to become a small but essential link in a long chain of creation. It has probably always been this way. The Nobles have found all kinds of objects buried within old walls – bottles, clay pipes, hobnail boots – which they believe were left there deliberately by their predecessors: a message from the past to the present, from the person who built the wall to the person repairing it. It's a tradition they gamely continue: Lydia has secreted a number of old mobile phones – arguably the defining objects of our own age – within her walls so that her successors will know a millennial craftsperson was there before them. 'Artists have signatures, don't they?' she grins. 'Well, this is mine.'

* * *

Since the peak of the Enclosures – and perhaps, in part, *because* of them – every sector of Britain's economy has been transformed. Many old professions have died, new ones have been born, and most others have changed unrecognisably. Deposit a twenty-first-century banker in pre-internet London and he'd be helpless; install a Victorian doctor in a modern hospital and patients would be running for their lives. Dry stone walling,

however, is a trade in which any such swap would be straightforward. Today's practitioners might have pick-up trucks and mobile phones but they use the same tools, employ the same techniques, and work at the same pace as even their most distant predecessors. A modern waller's output is exactly the same as it was in the eighteenth century: six or seven linear yards a day, if conditions permit.

The walls themselves are similarly constant, their anatomy unchanged for centuries. Most are at least 4'6" high, the minimum required to prevent even the most determined of sheep from scrambling over them. They taper from bottom to top, in a form known as a batter. The batter isn't dictated by numerical measurements but – as is so often the case in craft – by rule of thumb: the width of the base is roughly half of the height, and the width of the top is half of the base. Most walls have two faces, which are linked by one, two or three courses of through-stones and tightly packed with rubble (called 'fill' or 'hearting'). Every wall is founded on large footings and crowned with coping stones, whose arrangement depends both on the available material and the waller's personal taste.

Unlike standard walls, whose courses are glued forgivingly with mortar, dry stone walls are bound only by gravity and friction – by the precision with which one piece interlocks with another. Herein lies the crux of the craft: selecting the right stone for the right spot. Every time a waller picks up a stone – and this can be thousands of times a day – they have to make a series of quickfire calculations: is it deep enough

to reach the structural core of the wall? Is it wide enough to cross the joint beneath it? Is it high enough to keep the courses running parallel? Is it smooth enough to preserve the wall's profile? There are no shortcuts. Every stone they'll ever handle is a novel problem requiring a bespoke solution. This complex process is further complicated by its wider context. Diligent wallers work not just in three dimensions, but four; not only in space, but across time. They need to keep a constant eye on the future, reserving stones for parts of the wall that haven't yet been constructed, and managing their resources so they don't run out of material before they've finished.12

'I often hear people say that dry stone walling is like a jigsaw puzzle,' says Bert. 'But it's actually like having a thousand jigsaws,

jumbling all the pieces up, throwing away the pictures, then trying to put them back together.' He pauses. 'No, I'm wrong,' he adds, thinking aloud. 'It's more like packing your suitcase. Because if you assemble a jigsaw 10,000 times, it will always make the same picture, but packing your suitcase has infinite possibilities; you can aim for perfection but you'll never achieve it.'

Wallers, like the rest of us, have good and bad days at the office. Sometimes the stone slots into place effortlessly, as if it's been waiting millions of years for that moment. Other times it resists, like a child refusing to be bundled into a buggy. Every waller has endured projects when nothing quite fits, when every stone needs to be laboriously reshaped, when a day's work ends up taking a week.13

I know a little of their pain. I've made several attempts at dry stone walling over the years. Each has ended in exhaustion and humiliation. I recently spent time with a young Northumbrian waller who was repairing a deer park boundary in the Coquet Valley. He invited me to lay a couple of courses along about a yard of wall. It looked like a simple assignment, but I soon ran into trouble. No matter how hard I looked, I simply couldn't find anything that fitted. I tried hundreds of stones in all, rotating them like Rubik's cubes, discarding them, then returning, out of ideas, to the ones I'd previously rejected. Whenever I tried to hammer them into shape they crumbled to dust down invisible faults. After two frustrating hours I gave up, telling my mentor the task was impossible. He stepped over the rubble, picked up a stone that had been lying by my feet all along, and slotted it

perfectly into place. 'Don't worry,' he said, in his soft Geordie accent. 'It's knacky. You'll get there in the end.'

* * *

By the middle of the nineteenth century the enclosure of Britain's landscape was largely complete. The walling squads were disbanded, their members dispersing like dandelion clocks in the wind. We will never know where they went and what became of them. Some surely ended up in the industrial cities of the north, toiling in cotton mills and steel foundries, alongside the countless rural workers their creations had helped evict from the countryside. The walls themselves continued to play their role in upland farming and were maintained by the labourers who remained. But as the twentieth century unfolded Britain's farming practices changed again, and walling – whose fate had been bound to agriculture since the Neolithic revolution – changed with them.

As the agricultural workforce shrank (from about 1.2 million in 1901 to just 200,000 today), as motorised tractors replaced horse-drawn waggons, and as small farms were absorbed by ever larger commercial operations, the country's stone boundaries – once viewed as instruments of agricultural efficiency – came to be seen as irritating, tyre-puncturing impediments to it. Some farmers let them crumble while others actively removed them. Farm by farm, field by field, the ancient practice of walling receded from Britain's landscapes. By the middle of the century

its last full-time practitioners faced the same terminal fate as drovers, fellmongers, haymakers and milkmaids. But unlike those and many other rural trades, walling was rescued from oblivion.

Its advocates had been hard at work since the 1930s, doing what British campaigners have always done best: forming committees, writing reports, awarding prizes to each other in damp marquees. In October 1939, as the country lurched into war, forty tweed-wearing activists held the world's first ever dry stone walling competition in a field in south-west Scotland. Regular competitions were staged thereafter to raise the profile of the trade. But it wasn't until the second half of the century, in large part due to the advocacy of the Dry Stone Walling Association (formed in 1968), that the practice truly rose from the rubble. There are now almost a thousand professional dry stone wallers in Britain: a fraction of the number who roved the uplands during the Enclosures, but probably more than at any time since. Over the last thirty years or so, the United Kingdom has become a global force in walling. Every year, practitioners from all over the world make pilgrimages to the British Isles to learn from people they consider to be the masters of their field.

But though the craft of walling is once again thriving, the walls themselves are not. Unlike their predecessors, and contrary to popular perception, today's dry stone wallers don't spend much time in picturesque fields. Struggling farmers generally can't afford to commission such work, and wallers only reluctantly agree to it. Even with government subsidies, they typically receive less than £85 per linear metre of field wall, in conditions

that sometimes only permit a few yards of progress a day. Most of their custom now comes from private clients who want gardens landscaped or tourist attractions veneered with quaint traditions. We shouldn't dismiss these projects, nor begrudge wallers for taking them on. Crafts have always responded to the evolving needs of society – they need to if they are to stand any chance of surviving. But this shift has nevertheless contributed to the long-term decline of an important part of our rural heritage.

A well-built dry stone wall should last two hundred years. Most of Britain's Enclosure-era walls are therefore approaching, or have already reached, the limits of their lifespan. Thousands of miles of them have vanished in the last century, with most survivors crumbling towards the same fate.14 Look around Britain's uplands and you'll see them sagging, dismembered, collapsing in on themselves, buried beneath undergrowth, gapped by chain-link fences. They are the remains of a mighty national endeavour, each one a monument to human toil and skill. If they were castles or stately homes, or products of fine art rather than rustic craft, they would have been refurbished long ago, replete with information boards and visitor centres. But because they're only walls, we let them crumble. And once they're gone, they are never coming back.

Maybe it doesn't matter. Maybe it's deluded to try to preserve a craft that society no longer needs. But in many places the need persists. Britain still teems with sheep – 32 million, at the last count – and dry stone walls remain one of the best ways of enclosing them. They are more robust than

hedgerows, provide better shelter for livestock than fences, and are far more sustainable than walls made with imported materials and cement-based mortars. And though these boundaries are initially expensive to construct, they generally pay for themselves in the long run. Hedgerows require regular pruning, re-planting and re-laying, while post-and-wire fences will only last twenty or thirty years (a tenth as long as a decent dry stone wall) before they need to be replaced in their entirety.

Though they receive far less credit than hedgerows, which have suffered an even more catastrophic decline in the last century, dry stone walls are also valuable British ecosystems. Every wall possesses its own distinct microclimate, with warm sides and cool sides, exposed exteriors and sheltered interiors, sun-brushed tops and damp-dark depths, each nourishing a different community of species. Its rocky surfaces are fuzzed by moss, lichen and liverwort, the gaps between them nourishing algae and wildflowers. Generally located in exposed environments that lack large-scale vegetation, these boundaries are also a precious habitat for animals, where stoats hunt, songbirds nest, hedgehogs rustle, rodents hibernate and insects creep. For more adventurous creatures a field wall is nothing less than a superhighway, a means of travelling cross-country without being spotted by predators. Every time a wall disappears, a diverse population is made homeless.

If dry stone walls could talk, what would they say? They would tell us about the geological forces that sculpted our country, the farmers who worked its lands, and the livestock that grazed its

surfaces. They would speak of the dramatic social changes they witnessed and helped produce. Above all, they would remind us of the forgotten people who built them, and the remarkable trade they practised. Dry stone walling is perhaps the most fundamental of all crafts. It is motivated by an old and profound human urge to impose ourselves on the landscape, to bend it to our will, to leave a mark that lasts. It has barely changed in 6,000 years and probably never will. Because in the end, no machine, no artificial intelligence, can improve on a practice so elemental: a person in a landscape, placing one stone on top of another.

CHAPTER TWO

A Roof over One's Head

Highland Thatching
Applecross, Wester Ross

In a faraway corner of Scotland, on the country's wild and wind-torn west coast, a small village rose from the moors. Eight stone cottages stood together, huddled against the weather like a flock of sheep. Each one contained a family of crofters who farmed the thin soils, fished the cold seas and foraged for seasonal work. The houses themselves were simple and rustic, their low walls fashioned from unhewn rocks, their thatched roofs shagged with sprouting plants. In one of them lived a quiet couple who sat by the fire every evening, praying their wish would come true. They were well into their forties when their

pleas were finally answered. On a wet day in 1904, after a succession of miscarriages and stillbirths, a healthy boy was born.

Duncan – 'Dunachan' in his native Gaelic – slept in a box next to his parents and took lessons in the schoolhouse behind the byre. He enjoyed a happy childhood, playing hide-and-seek in the heather with his cousins, skimming stones across the sea towards Raasay. As he grew into a man, Dunachan took on more of his parents' duties. He tended the kale patch, sheared the ewe, and trudged every morning to the moors, creel strapped to his back, to cut the peat that fuelled the fire that warmed the family home. It was a hard, monotonous life but it suited him well enough. His world was reassuringly small and predictable, its rhythms governed by the seasons, its routines as immutable as the boulders on the beach.

Until everything changed. In the 1940s Dunachan's parents died in quick succession, leaving him suddenly alone in the house. He moved from the floor to their wooden bed, swaddled in scents and memories. The ongoing war had wider effects, disrupting the area's already fragile supply chains, restricting crofters' access to the seas and limiting opportunities for casual employment. One by one his neighbours, ground down by poverty and hardship, packed up their few possessions, bade their farewells, and disappeared to better lives in Canada and New Zealand. The village grew empty and derelict, its once voluble high street falling silent. By the turn of the 1950s Dunachan was the only person left in Lonbain – the last survivor of a vanished community.

A ROOF OVER ONE'S HEAD

If he was unsettled by his new-found isolation, he didn't seem to show it. Dunachan carried on just as before, stubbornly persisting with the old crofting ways. He continued farming his tiny plot of land, catching shellfish on the shore, digging peat on the moors. He left the village only once a week, walking to the local shop six miles away to restock his supplies of Spam. One day, after hiking through ferocious hailstorms, he arrived at the store drenched and shivering, his long nose blue with cold. The shopkeeper, feeling sorry for her exhausted customer, slipped an extra tin into his coat pocket. Dunachan didn't discover the item until he got home, at which point he trekked straight back to the shop to return it.

The years rolled on. As his hair turned grey and his back bent double, the shy man became a recluse. Days passed without him seeing a soul, let alone speaking a word. He sat alone every evening in the peat smoke, his only connection to the outside world a battery-powered wireless. When the road finally reached Lonbain in the 1970s, tourists started to appear – their curiosity piqued by the primeval cottage near the sea. Dunachan responded by hanging a 'No Pictures' sign on the wall outside his home. In 1982 a television crew spent several months there, using the ruined village as a stand-in for the lost community of St Kilda. Dunachan did his best to ignore the noisy incomers, though by all accounts he grew partial to their catering truck.

The crofter – now in his late seventies – was already struggling to look after himself and his property. His only jumper

was threadbare, his old leather boots flapping around his feet. As the thatched roof disintegrated above him, rainwater regularly flooded the house. With no one left in the area to repair it – and by now far too frail to do so himself – he hung a tarpaulin over his bed, sleeping under a tent inside his home. Unable to fetch peat as he once did, he started burning coal in the fire. The smoke soon gave him pleurisy, from which he never recovered. One day in 1988, after almost forty years living alone in Lonbain, he was removed from his village to a distant care home, where by all accounts he was amazed and delighted by the light switches. He died in his sleep on 25 February 1990, aged eighty-six.

Some say Lonbain died with him.1

* * *

About 450 million years ago two enormous continents collided in modern-day Scotland – the northern one thrusting skywards, the southern one sinking beneath it. The fault line, which runs almost dead straight from the Isle of Arran in the south-west to the town of Stonehaven in the north-east, is now widely considered the threshold at which the Scottish Lowlands become the Scottish Highlands. This part of the country is in many ways a kingdom of its own: a land of 25,000 lochs, 900 islands, 282 mountains, the largest peat bogs in Europe, and apparently more deserted beaches than the Mediterranean.2 The region is also – perhaps ironically

given its magnetic beauty – the emptiest place in Britain. With just twenty people per square mile, it is thirty times less populous than the rest of the country, and as sparsely inhabited as Bolivia and Chad.

For centuries this rugged realm was inhabited by farming and fishing communities, all self-sufficient and fiercely independent. Cut off from trade routes, isolated from shops, deprived of the materials available to almost everyone else in the country, they became by necessity some of Britain's most ingenious craftspeople. In the barren heaths of the mainland, Gaelic-speaking farmers shaped horn and antler into tools, carving fallen branches into sticks and stilts they used to traverse the hills. On the Hebridean islands of Lewis and Harris crofters sat by their looms, weaving tweed fabrics now protected by an Act of Parliament. On the remote shores of the Northern Isles – places that still feel more Nordic than Scottish – Orkneymen made chairs from straw and driftwood and Shetlanders knitted lace so fine that they could draw a whole shawl through a wedding ring.

We tend to think of craft as a luxury: a retirement pastime, a weekend course, a pretty object in a gift shop. But most of the world's crafts originated as necessities. They fulfilled the most basic and essential human needs: providing people with clothes and footwear, furnishings and utensils, and the tools they needed for their livelihoods. None of those needs was more fundamental than shelter: the act of putting a wall around one's family and a roof over their heads.

A ROOF OVER ONE'S HEAD

The building crafts are even older than those of walling. We've been using them for hundreds of thousands of years to protect ourselves from the elements. Even today, when so many manual trades have vanished, it is the people responsible for constructing and maintaining our homes – the bricklayers, roofers, plumbers and electricians – that we can't do without.

Highlanders and Islanders were expert builders. From the sunken dwellings at Skara Brae – still standing after 5,000 years – to crofting cottages like Dunachan's, they used foraged materials and simple techniques to make homes that could withstand Britain's harshest conditions. They dug pits, rammed soil, stacked stones, piled turf, interlocked branches and thatched with all kinds of native plants. These buildings weren't just places of shelter. They were monuments to their creators' skill and tenacity – to the human genius for making do. They were also finely tuned responses to their immediate surroundings, a bridge between the natural and built environments, the landscape and the people who inhabited it.

* * *

'This road rises to a height of 2,053 ft with gradients of 1 in 5 and hairpin bends. Not advised for learner drivers, very large vehicles or caravans.'

It's late September and I'm travelling to the west coast of Scotland to find Dunachan's fabled house. But first I need to traverse the Bealach na Bà – said to be the most dramatic road

pass in Britain. The autumn equinox has brought its customary storms, making the difficult drive even harder. Rain bombards my car from every angle, detonating miniature explosions across its surfaces. I follow the road into a glacial valley flanked by enormous, near-vertical peaks. I wind upwards past rockfalls and waterfalls, negotiating one tight bend after another, squinting through windscreen wipers, pumping the steering wheel like a helmsman on a stormy sea. The ascent is so spectacular, so thrilling, that I can't help shouting and cheering as I go.

When at last I reach the summit, I park up in a lay-by. The wind whistles around me, rocking the car from side to side. As I fight my way out of the vehicle, a gust swings the door wide open and knocks me off my feet, snatching my notepad from the passenger seat and sending half a dozen loose pages flying far off into the valley.

I get back up and stagger windward to the viewpoint. The clouds are below me now, hurtling left to right, obscuring and revealing what lies beyond. When they finally clear, a vista unfurls across the western horizon: the islands of Raasay, Rona and Skye – dark puddles in a silver sea. Between us lies a terrain so desolate and forbidding that it looks like something from another planet: a treeless, roadless, houseless expanse of moorland cratered by lochans that twinkle in the intermittent sunlight. It is my destination.

Applecross has been a place apart since the seventh century, when an Irish monk called Máel Ruba founded a monastery

A ROOF OVER ONE'S HEAD

there. He marked out a six-mile boundary around his institution with stone crosses, then proudly declared it holy land: anyone who entered was to be protected, by God's law, from anything. Applecross changed hands many times thereafter (the Vikings raided in the ninth century and didn't hesitate to destroy the monastery), but Máel Ruba's legacy endured: the place is still known, in Gaelic, as A'Chomraich: the sanctuary. Its isolation persisted well into the twentieth century. The rain-lashed villages that dot its coastline weren't connected to a road until 1975.3 Even today, just two hundred people live year-round on the peninsula, which is served by a single pub, an unmanned petrol station and a post office in someone's garage. Applecross might technically belong to the Scottish mainland, but in every other way it is an island.

It wasn't always so quiet. Just over two hundred years ago this area was home to three thousand Gaelic-speaking farmers, who lived in a cluster of townships surrounded by fertile pastures. But in the second decade of the nineteenth century their new laird decided to replicate the agricultural 'improvements' he'd seen south of the border. He cleared four townships to build his fashionable new sheep farm (replete, of course, with dry stone walls) and relocated their inhabitants to rocky lands along the coast. The crofters farmed their meagre plots with care and persistence, fished the frigid seas and processed kelp (at one point used in enormous, lucrative quantities to manufacture soap and glass), while sustaining a range of ancillary trades. By 1841 there were seventeen weavers, sixteen tailors, nine carpenters,

six blacksmiths, six cobblers, five coopers, a cartwright and a mason in Applecross – not to mention the hundreds of spinners, knitters and basket weavers who kept themselves busy at home.

The situation proved unsustainable. As the kelp industry collapsed, the already infertile soils became less productive and potato crops were decimated by blight, one crofting family after another made the same decision as countless others across the Highlands: they left their ancestral homes in search of better lives elsewhere. Others, such as this unfortunate tailor, were forced out:

> They found him quietly sitting down to his breakfast, when they seized him and pitched him outside the door, sending his humble breakfast after him. They next turned on his wife, who was lying sick in bed. They dragged her from bed screaming, and sent her outside, bruising and discolouring her arm. Her infant child, who was sucking at her breast, was then taken out and laid upon the ground. The whole effects were thrown out after him and the door locked.4

Between 1850 and 1950 the population of Applecross collapsed. Three thousand became two thousand, which became one thousand, which became five hundred. The coastal road, which many hoped would revive the area's fortunes, came decades too late. By then, almost everyone was gone.

I descend the other side of the Bealach na Bà to the Applecross Inn, then turn on to the road that circles the peninsula.

A ROOF OVER ONE'S HEAD

I snake through a landscape of climbing cliffs and tumbling burns, the horizon dissolving into roving sheets of rain. The only persistent traces of civilisation are the 'Passing Place' signs: a common feature of the Highlands that here read like haikus on the transience of human civilisation. Everything in Applecross seems to be a metaphor for depopulation and decline: mid-century tractors rust in the bracken, fishing boats rot on the shore, shepherdless sheep wander along the lanes. The peninsula is filled with peeling signs to villages that, apart from the odd holiday cottage, no longer exist.

It is mid afternoon when I see a sign for Lonbain. I turn off the road and bump down a muddy track until I can drive no farther, then walk towards a rowan tree, scattering a dozen goldfinches to the wind. I hack through bracken to what was once the centre of the village. The kerbstones of the old high street are just about visible beneath grass and nettle. A row of houses runs north–south across the ridge, their thatched roofs gone, their drystane dykes blotched by moss and lichen. I enter each of them, clambering through the rubble, searching for evidence of human habitation – a rotten piece of furniture, a crofter's spade, a pair of shoes – but find nothing. The wind and rain have taken it all. It's hard to believe these buildings were inhabited within living memory: they look like prehistoric ruins.

Only one house bears the remains of a roof, the mouldy thatch drooping over its uneven walls like icing on a poorly made cake. It looks familiar. I bring up a black-and-white

photograph on my phone, comparing the two until I feel certain. This is it: Dunachan's cottage.

I hurry across the vegetable garden, stepping over a bedstead, and push at the front door. It's unlocked. Heart pumping, I duck through the threshold into the property. The interior is dark and pungent, the surfaces black with peat soot. The thatched roof has decayed to rotting pulp, its slimy discharge churning the earthen floors into mud. The walls have been patched up over the centuries, their draughty gaps plugged with soil, woollen socks, 1950s lingerie catalogues and lumps of horse manure that still bear the traces of fingerprints.

I explore the property by torchlight, establishing a sense of its layout. It consists of two rooms separated by a closet, with a fireplace at either end. There are no other facilities to speak of – no bathroom, no kitchen, no plug sockets, no running water. I advance to the end of the south room, its walls panelled with driftwood, and crouch by a hearth that hasn't been lit for decades. I try to imagine Dunachan sitting here in the peat smoke, alone in the darkness, drinking water collected from the burn. It seems almost inconceivable that anyone in Britain could have lived like this as recently as the 1980s.

* * *

A few hundred years ago, the Highlands and Islands were full of buildings like Dunachan's. To outsiders they looked so rustic and rudimentary that some visitors thought them fashioned

by nature. The English were predictably unimpressed, calling them 'murky dens' and 'fuming dunghills'. One seventeenth-century tourist declared them the 'most miserable huts as never eye beheld'.5 Those curious enough to venture inside these so-called 'blackhouses' were haunted by the thatched roofs. 'If there happened to be any continuance of dry weather, which is pretty rare,' wrote Edward Burt (who was in Scotland collecting revenues for the government) in the 1720s, 'the worms drop out for want of moisture, insomuch that I have shuddered at the apprehension of their falling into the dish when I have been eating.'6

Scotland used to be one of the most densely and diversely thatched countries in Europe. Unlike in England, where most thatched buildings were – and still are – roofed with either wheat straw or water reed, Highlanders and Islanders used any and every material they could lay their hands on. Hebrideans

favoured long stems of marram grass that tufted out of the region's sand dunes. Orcadians pulled seaweed from the swell, twisting it into fibrous coils then wrapping it around their gables. The men of the mainland worked with heather, broom, dock and juniper, depending on the species in season. The finest thatching material of all was said to be bracken. Its robust root structures retained their integrity for up to a century, but the plant could only be harvested for two weeks of the year: after the first frost of October but before the winter killed it.7

In most of England thatching was professionalised early on, its practitioners running lucrative businesses in their local areas. But in the Scottish Highlands it remained a largely communal endeavour – a skill almost everyone possessed and regularly practised. Families and friends would gather at forests, beaches and moors to harvest material, then work together – often in large numbers – to thatch a cottage before the weather inevitably turned for the worse. They did this not for money, nor any other quantifiable compensation, but on the understanding that when their home needed to be re-roofed, their neighbours would return the favour. In these isolated, close-knit societies, thatching wasn't considered a trade or even a craft but an essential civic duty – a public demonstration of clan and community solidarity. Indeed, if a Gaelic speaker ever wished to compliment a person's character, he invariably reached for the same proverb: 'He would bare his own house to thatch his neighbour's.'8

Thatching began to decline on both sides of the border towards the end of the eighteenth century. As Britain

modernised and urbanised, homeowners came to see such roofs not as quaint and romantic but primitive and impractical, replacing them with tiles as soon as they could. Their disappearance in Scotland was accelerated by the Highland Clearances. As traditional crofting communities dispersed, their frail homes were abandoned and left to decay. The traditional thatched blackhouse, once a widespread feature of the Highlands and Islands, all but disappeared from their landscapes. There are now only three hundred thatched buildings left in the whole of Scotland, and just three Highland thatchers capable of maintaining them.

They aren't easy men to find.9

* * *

About a month before my visit to Lonbain, I made another journey to a different part of the Highlands, just north of the Cairngorms. I'd been told that an elusive thatcher was gathering material in a wild and primeval woodland. I entered the forest just after dawn. The ground – though I couldn't see any of it – was submerged beneath flowering heather, which suffused everything in a violet haze. A herd of giant Scots pines, some of them many hundreds of years old, surrounded me on every side, each one disfigured by its battles with the elements. Most of them had lost branches to the winter winds; others, long dead, stood like zombies, their outstretched limbs hung with wisps of lichen. As I advanced through the woods,

these ancient trees slid over and past each other in surreptitious parallaxes. The rising sun winked between them, roving through the gaps like a searchlight.10

I had been walking for about an hour when I saw them: a line of figures, their faces hidden by netted hats, marching through the woods whipping the trunks with branches. They looked like belligerent beekeepers, or a troupe of performance artists channelling the spirit of Basil Fawlty. But they were doing something that used to be a common feature of Highland life, on which much local thatching depended: they were pulling heather.11 The pullers were looking for long straight stems with plenty of foliage. Once they'd tugged suitable branches from the earth, they beat them clean of soil and moss, then tied them into hug-sized bundles called *cuals*. Their work was repetitive and uncomfortable. Midges dive-bombed them continuously, nibbling skin covered even by nets and gloves.

The pullers were employed by Brian Wilson: a grey-haired man in a lumberjack shirt whose torn breast pockets spooled with twine. Wilson – who once spent four months circumnavigating the 1,800-mile coastline of Scotland in a kayak – had worked all over his beloved country, restoring blackhouses, brochs and crannogs across the Highlands and Islands.12 He had just been hired to repair and re-thatch Dunachan's cottage. When he had gathered sufficient heather – about four hundred *cuals*, by his estimation – he planned to load them on to his flatbed truck and make the hundred-mile journey west, crossing the Bealach na Bà, to Applecross.

Wilson's quest to become a Highland thatcher began forty years ago, when, as a young ranger in a remote corner of Argyll, he became fascinated by the derelict cottages that peppered its rocky peninsulas. He wanted to learn how to repair their drystane dykes and thatched roofs, but there were no books or instruction manuals to learn from, and hardly any surviving buildings to study. Out of ideas, Wilson visited a fabled figure from the mountains of Kintail who was widely seen as the last genuine Highlander. Duncan Matheson, known simply as 'The Stalker', was a crofter, poacher, fish-smoker, whisky-distiller, stick carver and dyker – and perhaps the only person in the country who still thatched the Scottish way. The skills had been in his family for generations, but having just fallen out with his sons, Matheson agreed to take Wilson on as an apprentice. 'He was the last link to proper vernacular traditions in Scotland, the last of the line,' said Brian, sitting on a fallen tree. 'I was very lucky to overlap with him for a few years.'13

One of Wilson's first thatching projects was, of all places, Dunachan's house. Shortly after the crofter's death Matheson had been asked by the National Trust for Scotland to patch up the rapidly decaying property. The two men spent several weeks there in the early 1990s – Wilson traipsing across the moors gathering materials; Matheson, deerstalker on head, pipe in mouth, affixing them to the roof. Brian remembers the first time he entered the cottage, which still contained a small bed, a wooden settle, and a three-legged cutty stool that had

probably been fashioned by one of Dunachan's forefathers. 'I was shocked when I first saw it,' Brian recalls. 'The whole place was a time capsule: a portal into a way of life that by then had vanished everywhere else.'

* * *

It's October, and the National Trust is undertaking a full restoration of Dunachan's house with traditional Highland techniques. The walls have just been repaired by Becky Little, one of Britain's last remaining mud masons. She replaced the mortar with clay soil dug at the base of the Bealach na Bà, rebuilt a gable with wattle woven from Applecross hazel, and reinstated the chimney breast by mixing soil and rush from what was once Dunachan's vegetable garden. Brian Wilson, meanwhile, has already repaired the timber frame with equally local materials. 'We've grown accustomed nowadays to going to a builder's merchant and driving home with a processed, usually imported, product in the back of our car,' he says. 'But the men who built this property didn't have that luxury. They had to make do with whatever their immediate landscape provided.' When he learned that one of the building's cruck frames – a curved piece of timber that rises from the ground to support the roof – had rotted, he spent a month searching the peninsula for a natural replacement. Brian was on the verge of giving up when, right next to

his camper van, he spotted a dead limb of an ash tree of exactly the right shape and size. It had been there all along.

With the cruck frame installed and the purlins (beams running lengthways along a roof) and cabers (rafters running perpendicular to the purlins) replaced, Brian sets to work on the roof covering. He begins by removing the old thatch, much of which was laid by his late master decades ago, then tiles the roof with hundreds of strips of locally cut turf (known in Gaelic as *sgrathan*). The material has been used in vernacular building traditions all over northern Europe and beyond for millennia. In Iceland, where trees were virtually non-existent and volcanic rock too hard to cut, entire houses were built from it. Highland thatchers typically lay *sgrathan* in overlapping fish-scale patterns, turf-side down, across the roof. The grass itself dies in the darkness but its root structure survives for centuries, providing a breathable layer of insulation from cold, wind and noise, as well as a robust substrate on which the thatch itself can be affixed.

After five hard days, Brian and his young assistant Troy have turfed the whole roof. But their first proper thatching day is a washout. Torrential rain confines them to Brian's fetid van all morning, where they consume a pack of ginger nut biscuits while watching submarine training exercises in the waters of the Inner Sound. But just as they're about to concede defeat and return home, the clouds lift, a feather of blue appears in

the sky, and a trace of sunshine lands on Lonbain. The men leap straight to work, hurrying through the gate, climbing up the ladder and disappearing into a fragrant haze of steam that rises off the heather.

Like many traditional crafts, Highland thatching looks perfectly straightforward until you try to do it. The heather is cleaned, sorted and bunched into fist-sized bundles – a process English thatchers call 'yealming'. Brian then lays the yealms, root-side up, foliage-side down, along the roof in one row after another. 'As with lots of monotonous manual jobs, it seems to take forever,' he laughs, 'but then suddenly it's done and you realise it didn't take that long at all.' The positioning of the yealms is critically important. Every bundle of heather needs to be blended with those below and beside it to form a continuous surface. This ensures that rainwater will run down the pitch from one external branch to the other before dripping harmlessly off the eaves instead of sinking into the building.

Brian regularly fastens the heather to the roof to prevent it being blown off in storms or snatched by nesting eagles. He does this with hazel spars cut on the banks of Loch Ness. He clamps them like hairclips over the thatch, ties them with tarred twine, threads the twine through the eye of a two-foot-long thatching needle, then plunges the needle all the way through the roof. Troy meanwhile waits inside, doing his best not to be impaled. As the needle emerges through the ceiling, old fragments of turf, peat and sludge fall onto his face and

into his mouth. He removes the twine from the needle, ties it around a caber and taps the needle with a metal hook, at which point Brian withdraws the tool and knots the string around the spar. They will need to do this many more times over the next two weeks. When the thatching is complete, Brian will bind the roof with a lattice of rope braided from slender stems of heather, offering added protection against the elements.

* * *

It is Wednesday evening at the Applecross Inn, and the customers are outnumbered by Labradors. Brian and Troy are sitting by the window, watching the waves beating the quay and the rain on the glass. They are busy discussing the future. When the blackhouse at Lonbain next needs to be thatched, in twenty or thirty years' time, Brian won't be around to do it. He is counting on Troy, the country's only emerging Highland thatcher, to pick up where he leaves off. But they face the same problems as so many other British craftspeople: Brian can't afford to offer Troy a full-time apprenticeship, and Troy can't afford to forgo a salary for the duration of his training. Brian also recognises the limitations of his line of work. 'Highland and Island thatching is never going to be big business,' he says, sipping his beer. 'People are happy to buy Orkney chairs and Fair Isle sweaters, but very few want to live like Dunachan, under the damp darkness of a thatched roof.'

Why, then, bother to preserve it? Brian believes that Highland thatching is, despite its traditional associations, a 'technology fit for the future'. Its roofs are efficient insulators, have negligible carbon footprints, and at the end of their lives can be used to fertilise the earth whence they came. They also embody an important principle shared by many crafts:

> Highland thatching, and Highland traditions in general, remind us of something that for all our progress we seem to have forgotten: that it makes sense to work with local materials. It makes economic sense, it makes ecological sense, and it makes emotional sense. To go through life surrounded by these wonderful, freely-available materials and not know how to use them is to miss out on a great deal of what it means to be alive in the world.

The challenge for Highland thatching, as for most other crafts, is relevance; how to find its purpose in the twenty-first century. If, Brian suggests, local councils and public institutions committed simply to thatching bus shelters, information booths and interpretation centres with vernacular materials, the famous roofs of the Highlands would rise again, supporting a small but stable population of thatchers, and returning an almost extinct Scottish art to everyday life.

This matters. Traditional practices like thatching have shaped Scottish identity since the eighteenth century, when it entered a union with England and ceased to be an independent

nation. Its many indigenous crafts are now so densely entangled with the notion of Scottishness that it's almost impossible to imagine the country without them.14 But even these famous practices are endangered. There are only a dozen bagpipe-makers, half a dozen kilt-makers and just a handful of full-time sporran-makers left in Scotland, whose numbers are continually shrinking. Even the Royal Regiment of Scotland now has its sporrans made abroad.15 Other, more localised crafts disappeared long ago. 'Every region and island used to have its own way of making chairs, weaving cloth, knitting lace, just as it had its own particular whisky,' says Brian, now on to the Ardbeg. 'The only reason Orkney chairs, Shetland lace and Fair Isle sweaters stand out is because we've lost all the others.'

Decline isn't inevitable. Twenty years ago, Harris tweed, a handwoven woollen cloth made on the islands of the Outer Hebrides, likewise faced extinction, despite an Act of Parliament designed to protect it.16 Production had fallen by 90 per cent since the 1960s, after decades of dwindling demand. In 2007 a group of local men embarked on a mission to save their beloved product. Shaking off the fabric's dowdy association with old men's jackets, they successfully reinvented it for modern markets. Harris tweed is now exported to more than fifty countries. The industry employs hundreds of people on the Isle of Lewis and Harris alone, some of them young trainees. It has become the largest single private-sector employer in the Western Isles, generating millions for the local economy.17

Few Scottish crafts have the global reputation of Harris tweed, and none are protected by law. But the fabric's remarkable revival is proof that traditional crafts can play a part in the future of the Scottish Highlands. They are, in fact, one of the only outlets for remote rural areas marked by long-term economic and demographic stagnation to diversify their economies and regenerate their communities.18 Isolated regions will always struggle to attract large-scale industries, but they have much to offer self-employed practitioners looking for bigger workshops and smaller overheads. There are now signs, faint but unmistakable, that this is beginning to happen. All over Scotland – from Leith to Lerwick, Galloway to Stornoway – workshops are appearing, galleries opening, craft collectives forming. In time, with luck, we may just see the ruined cottages rebuilt, the abandoned villages repopulated, and the Highlands and Islands once again become craft lands.

CHAPTER THREE

Into the Woods

Woodland Crafts
The Chilterns

If you had visited a typical English woodland a few hundred years ago, or at pretty much any point before then, you would have been ambushed by activity. The sounds of thudding axes, rasping saws and ale-loosened conversation reverberated through the trees. Waggons trundled back and forth through the understorey, past tents, tool sheds and piles of freshly cut timber. If you had made it through to the glades at the centre of the forest, you would have bumped into gangs of mud-smeared labourers – felling trees, sawing trunks, peeling bark, burning charcoal, turning utensils. These men vanished from the

underwood decades ago, but their legacy is very much still with us. If your surname is Barker, Cleaver, Collier, Forester, Hurst, Parker, Turner, Sawyer, Shaw, Underwood or Woodward, there's a good chance your ancestors once worked in or near the woods.1

Most woodlands today are quiet, peaceful landscapes – places we go to *escape* work – but they are still marked by yesteryear's trades. Lower your glance and adjust your focus and you may notice, for example, networks of shallow furrows wrinkling across the ground. They are called 'hollow ways' – imprints left by carts and wheelbarrows to-ing and fro-ing through the centuries. Many woodlands are pocked by deeper depressions that once served as saw pits, where two sawyers (a 'top dog' and an 'underdog') spent exhausting days cutting trees into timber by hand. You might also find the remains of abandoned charcoal hearths, lye pits and quarries, all camouflaged by time and concealed by brambles. Many plants are themselves scarred by the history of human labour. If a tree kinks at right-angles just above the ground, it was probably once a hedgerow; if its trunk repeatedly swells into arthritic knuckles, it's likely been subjected to pollarding.

For the best part of a thousand years – from at least the Norman Conquest to the Industrial Revolution – Britain's woodlands were institutions: the factories of the pre-modern world. They built people's homes, fuelled their workshops and provided the raw materials for most manufactured items, including the vast naval fleets on which the country's Empire came to depend. They were managed by an army of highly skilled woodsmen

operating all over the British Isles who cultivated and preserved these landscapes, creating balanced and sustainable ecosystems that benefited not one species but many. They did this not because they were environmentalists – the concept would have meant nothing to them – but because it was in their interests to do so: their livelihoods, and those of their neighbours, depended on keeping these renewable resources intact.2

* * *

The Chiltern Hills rise like a great green wave north-west of London, rolling through the counties of Bedfordshire, Hertfordshire, Buckinghamshire and Oxfordshire until they're stopped in their tracks by the River Thames. They cradle a classically English landscape of undulating fields, hedgerows and copse-crowned valleys, peppered with picturesque villages and neat market towns. The Chilterns also happens to be one of the most forested places in England. Almost a quarter of the area is covered in woodland, 60 per cent of which is 'ancient' (defined as having been in continuous existence since 1600). Two hundred years ago, thousands of local men earned their living beneath the canopy, cutting timber and preparing firewood for London's 1.4 million consumers. Now, however, only a few traditional woodsmen remain in these otherwise forsaken places.3

One of them, based in the aptly named village of Woodcote in Oxfordshire, is so committed to the region's trees, and so

professionally dependent on them, that every year he participates in an ancient ritual in their honour. In the dark, desolate days of January he makes a series of journeys through the region's fruit orchards, pours cider over frost-fringed roots, hangs toast on dormant branches, and proceeds to wake the trees from their slumber. Face painted in ghoulish patterns, head crowned by pheasant feathers, he stomps through the orchards, banging pots, lighting fires and chanting songs used for centuries to scare off winter spirits and solicit a bountiful harvest. 'Drink to the bud and the blossom, drink to the root of the tree, drink to the fruit of the summer, Wassail! Let cider run free!'⁴

Andrew Jarvis has spent all six decades of his life in the Chilterns, and knows its secrets as well as anyone. His elderly mother is one of the area's last traditional lacemakers, continuing a local custom that dates back to the sixteenth century. Andrew's woodland work takes him and his Jack Russell all over the region. Spend a decent length of time there and you'll likely see his Land Rover rattling over the vales with a trailer full of timber behind it. He provides landowners, farmers and rural craftspeople with services that were once commonplace but are now rare to the point of extinction. Andrew is, like Brian Wilson, one of Britain's last makers of spars – the hazel pegs used by thatchers to affix materials to roofs. It is a monotonous and poorly remunerated business (he receives just 14p for each carefully crafted spar), but he has no intention of giving it up: 'If people like me stop making them, the skills will

be lost for ever. I can't allow that.' Andrew spends the winter season – officially from the end of September to the beginning of March, when the plants are dormant and the birds aren't nesting – laying hedges in the fields and managing coppices in local woodlands. He is, as far as he knows, the last full-time, professional coppice-worker in the Chilterns.

Coppicing (the term is related to the French *couper*, 'to cut') is probably the oldest form of woodland management, believed to be in continuous operation throughout Europe since the Neolithic period. The practice involves the repeated felling of a tree back to a stump (called a stool) in order to stimulate a regrowth of shoots or poles that can then serve a variety of purposes. Trees are cut at different intervals, depending on the species and the size of pole required. Willow is cut every year, beech and birch every three or four, hazel every six or seven, chestnut every fifteen to twenty, and oak and hornbeam every fifty. In the past, most serious coppice-workers divided the underwood into sections (known variously as panels, cants, fells, coupes, sales, burrows and haggs), each containing a range of species on different cycles, so guaranteeing a crop every year.

Every gardener knows that judicious pruning will revive and energise a plant, which can otherwise end up strangled by its own congested foliage. Much like pollarding (a similar practice but where cuts are made closer to a tree's crown), coppicing significantly extends a plant's lifespan. Britain's oldest trees, some of them several thousand years old, have all reached such maturity as a direct result of regular trimming. Coppicing

doesn't simply benefit the plant in question. Much like dry stone walling, it produces a wide, rich ecosystem. The clearing process draws sunlight into the forest's penumbral depths, triggering an explosion of plant life in the spring and summer, which in turn provides valuable habitats (often more diverse than those found in 'natural' woodlands) for small mammals, birds and pollinating insects. One of them, the heath fritillary butterfly, is so wedded to these outdoor workshops that it's nicknamed the 'woodsman's follower'.5

Most English woodlands used to contain some form of coppice, often alongside larger trees (called 'standards') grown for timber. Coppiced material served a range of purposes, being fashioned into baskets, brooms, fences, firewood, tool handles, walking sticks, tanning bark and the wattle beneath every bit of daub.6 But as the demand for wooden wares fell away, the country's copses – many of which had been managed

continuously for more than a thousand years – were ripped out or quietly abandoned. Since the beginning of the twentieth century 90 per cent of Britain's actively coppiced woodlands have vanished, many replaced by vast monocultural grids of conifers. This has damaged not just the profession that cultivated them but the species that depended on them. The last few decades have seen dramatic declines in the numbers of nightingales, dormice and butterflies, all of which thrive in the underwood. The 'woodsman's follower' would already be extinct in this country had conservationists not intervened to save it.7

It is late January – a week after the last wassail – and Andrew is working in a secluded valley at the southern edge of the Chilterns. He parks in a muddy layby and carries his tools into a sloping beech forest. The mature trees rise around him like columns then vault together into a tessellated canopy, creating a space so resonant that even a tiny wren seems to be wielding a trumpet. Andrew wades through drifts of dead leaves that for a few enchanted weeks in spring will vanish beneath bluebells. Beyond the wood, on a terraced bank, lies a large copse of hazel. Hundreds of stools explode out of the wet ground in silvery stems.

Despite appearances, this patch of underwood is a ruin. It was orphaned a lifetime ago, untouched since the Second World War. Most of the stools are 'overstood' or 'derelict' (terms used to describe a coppice that has fallen out of rotation and grown into so-called 'high forest'). Andrew spent four years persuading the owners and their sceptical gamekeeper to let him bring

this once productive plot of land back into rotation. But he recognises that woodland management can be an unappealingly long-term commitment: 'These stools will next need to be cut in six or seven years, by which time I'll be in my sixties,' Andrew says. 'Realistically I'll only see one or two more crops in my lifetime, and there's no one to follow me. All this effort will probably come to nothing.'

Andrew moves through the milky winter light, stepping over beer bottles left by the last men to work this land. He coppices each tree close to the ground with clean, angled cuts, ducking and swerving as branches tumble around him. He assesses the crop as he goes. 'Rubbish!' he shouts, throwing a dog-legged pole aside. Then 'Oooh, that's dreamy that is!' brandishing a dead-straight branch like a trophy. He removes the spidery tops of the trees and lays them back over the stools to protect the coming shoots from browsing deer, then sorts and processes the rest of the hazel. He cuts thicker, straighter poles to a length of about 5'5" (the distance between his outstretched hands) and longer, slimmer ones to around 10', trims them with an old billhook, places them on separate piles, and ties them into bundles of ten and twelve respectively. Both are destined for a local hedge-layer. The shorter poles will become stakes, driven into the ground along the full length of the hedgerow; the longer ones will become binders, woven horizontally between the stakes. Together they'll form the scaffolding around which various plant species will grow into a stock-proof barrier. Andrew receives just £1.30 for each item, so he needs at

least two hundred to make the day worthwhile. He works from dawn till dusk, pausing only for a flask of tea and a rectangle of leftover Christmas cake.

Woodsmen like Andrew used to be an important cog in the machine of British society, as essential to our predecessors as plumbers and delivery drivers are to us. Before industrialisation, globalisation and of course plastic, most manufacturing materials came not from foreign factories but local forests. Woodland management wasn't just a valuable craft in its own right but the wellspring of all the others. It supplied blacksmiths with their firewood, coopers with their stakes, tanners with their bark, wheelwrights with their timber and basketmakers with their willow. Without the workers of the woods, few of those crafts would have been viable.8 And yet even now, in a society that values forests and is committed to expanding them, the trade is overlooked.

'There's all this talk nowadays of rewilding,' Andrew sighs. 'It's a lovely idea, don't get me wrong. But it's often based on a misunderstanding. This woodland, like so many ancient woods around the country, hasn't survived because we left it alone. It's survived because we managed it, coppiced it, thinned it – because we *used* it. If everything becomes rewilded, species will become completely overwhelmed by other species and die out. By managing our woodlands, you're allowing different plants and animals to live in harmony with each other, and not be swallowed up by bramble and gorse.' He takes a final bite of his Christmas cake and gestures around him. 'This

landscape has been cultivated for thousands of years specifically for us to be able to live and work on it. If we want to continue doing that, which surely we do, we need to re-learn the art of woodland management.'

* * *

Before it became a metroland, filled with professionals commuting back and forth from London, the Chilterns was a craft land. Its villages teemed with artisans, who toiled in weatherboarded workshops and flint-faced cottages. The region's women were particularly successful, many earning more from lacemaking and straw-plaiting than their husbands did from their jobs. In the nineteenth century several larger industries crystallised in the area, all of which relied on the forests around them. The market town of Chesham became a national centre for boot-making, which tanned its leather with native tree bark, and brush-making, which made ingenious use of local woodworkers' offcuts. Both trades have now almost disappeared, with only one sixth-generation brush-making firm surviving opposite a second-hand car dealership in the town centre. But the Chilterns' most successful manufacturing industry – and the only one that built a genuinely global reputation – originated in another town, a few miles along the chalk ridge.9

In its setting, High Wycombe has a distinctly un-English grandeur. It scrambles up the sides of a wooded valley so steeply that its buildings seem piled on top of each other. From certain

viewpoints, and through squinted eyes, you might even think it lies in the foothills of a major mountain range. But as you descend the slopes to its centre, a standard British town sharpens into focus. Its High Street has the same shops and cafés as the rest of the country, its surviving Victorian factories converted into flats. If, however, you know where to look, you can still find evidence of the trade that built this town and made it famous. In a crumbling old building on Dashwood Avenue, the last sawdust-splashed workers continue to practise it. On a drab industrial estate just off Grafton Street, an old man runs a museum devoted to it. And at the football stadium on the western edge of town, Wycombe Wanderers fans can still be heard chanting about it.

As far as we know, High Wycombe's chair-making industry came into being at the end of the eighteenth century. Its earliest practitioners were small-time rural craftsmen, working in garden sheds and tumbledown barns when the fields didn't need to be harvested and the trees didn't need to be felled. But in the subsequent century their industry grew at pace. By 1875 there were more than 150 furniture-making workshops in and around High Wycombe, making 4,700 chairs a day. The town, which had tripled in size since 1800, was by then the uncontested furniture-making capital of the world, sending chairs all over the country and shipping some of the very first 'flat-packs' across the Empire. Those chairs became a valued source of collective identity – as important to its residents as ships were to the people of Belfast and steel to those of Sheffield. When, in 1877, they heard Queen Victoria was planning to visit they built a grand archway of

chairs over the High Street and crowned it with flags and banners (they did the same for the Prince and Princess of Wales seven years later, and to mark the millennium in 2000).10

Why did chair-making flourish in High Wycombe? Did Wycombites sit down much more than their compatriots? No: the craft almost certainly took off here, just as others did elsewhere, because of access to natural resources. In an age of poor transport connections, most industries evolved near their raw materials. High Wycombe's furniture-makers were no exception. They became particularly reliant on beech, which grew so profusely on the surrounding hills that it was nicknamed 'Buckinghamshire weed'. This affordable, long-lasting wood could easily be turned and steam-bent into pretty much every part of a chair.

Some chair parts weren't only made from the local woodlands but *in* them, by a group of local craftsmen who went on to become nationally famous. Indeed, I can think of few British occupations that are more marinated in myth and legend.

No one really knows how the bodgers got their name. Some think it started as a term of abuse, to describe their supposedly crude workmanship (we still talk of a poorly executed job as having been 'bodged' or 'botched'). Others think it was a corruption of 'badger', from a time when many rural tradespeople had to wear a permit or badge to operate legally. One thing, at least, is certain: the bodgers themselves rarely used the term and didn't much like it. As far as they were concerned, they were wood-turners: exponents of a trade that had been practised on these shores since before the time of Christ, producing

many of society's most essential objects and utensils – their bowls, goblets, tools and wheels.

Unlike most turners, bodgers didn't bring their materials to their workshops; they took their workshops to their materials. They purchased plots (or stands) of woodland every year, usually at raucous auctions held in village pubs. In the autumn they hauled their tools into the trees and constructed basic huts in suitable glades. They stayed there through the winter, working long days in often freezing conditions, sustained by simple meals cooked over the fire and black tea brewed in pondwater. In the bleak months of December and January, when they toiled through hours of darkness, they laid trails of pale wooden shavings across the forest floor so they could find their way in and out. Bodgers worked in the woods until the spring, when the bluebells told them it was time to leave. Then they dismantled their huts, packed up their tools and spent the summer months picking fruit, reaping fields and propping up the bar in local pubs until it was time to move to the next stand of woodland and bodge all over again.11

A bodger's first job was to fell the suitable trees in his stand. He usually did this with a family member, using axes and two-man saws. They sliced the trunks into logs then hacked and shaped the logs into roughly cylindrical forms called billets. When this was done, the bodger crept into the hut and sat down at his pole-lathe, which he had built to his own specifications. He placed a billet on the lathe, tying it to a springy pole above and a treadle below. When the billet was secure and he was

comfortable, he started turning. He pressed the treadle again and again until the billet was rotating back and forth at speed. He then cut its spinning surfaces with a chisel, moving its blade across the object in compact, controlled movements. In a matter of seconds, amid a cascade of ribboning shavings, the billet shapeshifted into an elegantly turned component.

An accomplished bodger could turn more than a hundred chair legs, stretchers or spindles in a day. At the end of the week he carted his wares through the lanes and sold them to the furniture manufacturers in and around High Wycombe. He received a few farthings (forty or fifty pence in today's money) for each handcrafted item. The rest of the chair was manufactured by other specialist craftsmen in the workshops and factories. Benchmen cut arms, splats and side-rails, bow-benders steam-bent curved backs, and bottomers shaped seats by wedging the blanks between their feet and adzing buttock-shaped indentations. The most challenging job fell to the framer, who had to assemble the various components into a working chair. He refined the surfaces with specialist planers called spokeshaves, bored holes into the seats and backs (each one at a subtly different angle, judged by eye alone), then carefully glued the pieces together. The chair was then passed on to a finisher (usually the youngest member of the team) who waxed or varnished its surfaces.

High Wycombe's businesses turned out a great variety of furniture. Its most famous brands, Ercol, G Plan and Parker Knoll, would go on to influence the evolution of mid-century

modern design. But their reputation, which long pre-dated these firms, rested above all on 'Windsor chairs'. No one knows for certain how these items acquired their name. There is little evidence that they were ever manufactured at scale in Windsor, though many Chilterns-made chairs were transported to the town before being shipped down the Thames to London. The term actually refers not to a place but a construction method: a Windsor is a chair whose legs and back are discontinuous, with the seat being the axis of construction. It is, put simply, a stool with a back.

In the nineteenth and twentieth centuries these modest objects became a fixture of cottages, pubs and civic buildings

up and down the land. They also became one of our greatest contributions to world culture: half of all wooden chairs on the planet are said to be Windsors or their direct descendants. The item is now so ubiquitous that it's virtually impossible to go more than a few days without using one. Next time you find yourself sitting in a Windsor chair, be sure to examine its legs: if the chair is old enough, there's a good chance they were fashioned by a bodger in a Buckinghamshire glade.

At their zenith in the late nineteenth century hundreds of bodgers were at work in the Chilterns, the beech forests resounding with growling lathes and country songs. But the forces of industrialisation, which had already transformed so many other British industries, had by now reached their tree-sheltered world. High Wycombe's furniture manufacturers had been modernising since the 1860s, using steam-powered saws, tenon-cutters, dowel-shapers, seat-borers, cane-strippers and adzing machines to mechanise and accelerate previously manual processes. The bodgers were initially untouched by these developments, much to the industry's astonishment. 'It seems almost incredible', wrote the *Furniture Gazette* in 1877, 'that in this, the last quarter of the nineteenth century, any intelligent man can be found who will go on day after day with arrangements that were old when their grandfathers were born.'12

Their stay of execution was short-lived. From the early 1900s, more and more factories decided to manufacture their own turned parts on-site with mechanical lathes. As their orders dried up, the bodgers ebbed from the woods like the red

squirrels that once scuttered around them. By the 1930s they were almost impossible to find, as the author and artist Clare Leighton learned to her frustration:

> They are not found for the looking. Like all the good things of this life, discovery must come unexpected. How does one find a four-leaved clover? Hunt for it over the years, and it will elude you; but one day, when you have forgotten about it, there it is, at your feet. And so, with chair bodgers, you may search these woods, feeling certain that you know where they were a month ago; but they will have disappeared, leaving behind them no intimation of their new whereabouts.13

By the 1950s only three genuine bodgers remained in the Chilterns: Samuel Rockall in Summer Heath, Silas Sanders in Stoke Row, and Owen Dean in Great Hampden. All three retired in 1959 – almost as if they knew they couldn't survive the social revolution of the 1960s.14

More than sixty years have passed since professional bodging became extinct in the Chilterns. The makeshift huts have been devoured by the forest, the pole-lathes burnt as firewood. All that survives of the bodgers, apart from the fading memories of those who knew them, are images. In the profession's final years, British filmmakers journeyed deep into the region's woodlands like ethnographers searching for endangered tribes, aiming to chronicle the craftsmen before they vanished. They returned bearing footage of lithe men with bird-like faces, in

flat caps and V-necks, speaking in accents so broad and rustic that it's hard to believe they lived just a few miles from London. These black-and-white films, with their wobbling intertitles and solemn voice-overs, were an elegiac portrait of a dying trade: the past clinging on to the present as the present tries to leave it behind.15

* * *

It is early May. The lanes above Wendover are so narrow, and so encircled by foliage, that they resemble a network of tunnels. Shards of sunlight puncture their ceilings and tiger-stripe the tarmac below. I head up into the hills, looking for the landmarks I'd scribbled down in my notepad: a roadside stall selling eggs, a five-bar gate policed by hostile dogs, a post-box being swallowed by a hedgerow. At the crest of the ridge an unsurfaced bridleway recedes into tree-dense darkness. About a hundred yards down the track a small timber cabin appears in the underwood like something from a German fairy-tale. A wrought-iron lantern squeaks in the breeze above a sign into which the words 'Woodsman's Cottage' have been carved. I check my notes a final time, cross the bridleway, duck under the sagging branches of an old sycamore, and reach a gate marked 'Private'.

I'd heard lots about Hengrove Wood. A number of local people had mentioned it to me, whispering its name like a secret. 'A special place, that is,' a retired chair-maker remarked,

in his lusty Bucks accent. He wrote a number on the back of my notepad, which I rang that evening.

Steve wasn't expecting the call. He didn't know how I'd managed to find him and couldn't understand why I was interested in him. He explained that he'd spent the last fifty years living and working beneath the canopy, shunning the outside world. He told me how, inspired by E. F. Schumacher's book *Small is Beautiful*, published in 1973, he'd always tried to operate like the woodsmen of yesteryear. He had avoided financial transactions wherever possible, preferring traditional barter: a winter's worth of firewood in exchange for a lantern made by the local blacksmith; a barn's worth of timber for a farmer's help felling trees. 'I've been happily swimming against the tide doing things which perhaps don't seem to make much economic sense', he chuckled, 'but which, to me anyway, make so much *common* sense.'

I unhook the gate and step into Steve's wood. New leaves, lime-green and skin-smooth, hang on the trees like fairy lights. A mist of bluebells floats in the understorey. I soon spot the tell-tale signs of woodland management: piles of brash, puddles of sawdust, tractor tracks (left by Steve's 1956 Fordson Major, still running). As I plunge deeper into the woods the white noise of birdsong is punctured by thumps, scratches and cracks. Then, in a glade at the centre of the forest, under the tapered roof of a wooden shelter, I see a dozen people at work. They toil in the fire-smoke, stooping over chopping blocks and shave horses, hands fidgeting away in their laps. A

bowl-turner carves a hollow into a lump of elm, a spoon-carver trims an oblong of ash with a hand-axe, a basket-weaver braids dandelion stems into rope. At the heart of the group is Steve himself, white hair hanging around his shoulders, clothes potholed from a morning of charcoal-burning. He is busy at his pole-lathe, shaping a billet of beech he's felled nearby. I ask him what he's making. He removes his foot from the treadle and looks up. 'A Windsor chair,' he replies, smiling.

Craftspeople have been coming to Hengrove Wood for decades. They meet here every month to work with materials culled from Steve's land, to share tools and skills, and to chat and sing by the fire as the darkness thickens around them. The group is dominated by people who've taken up green woodworking as an antidote to their keyboard-tapping careers. Few of them earn a living from such work, as their predecessors did. If a downtrodden Victorian woodsman somehow fetched up here, he would probably find the whole thing rather mystifying. But on days like this, when a quiet woodland is transformed into a busy workshop and the music of making fills the air, it's not hard to picture how things used to be. Indeed, as I watch Steve pedalling his pole-lathe within his own stand of trees, it feels like the bodgers – at least in spirit – are still alive.

What's unfolding here isn't unusual. People are gathering in glades and copses all over the country to learn the skills that once flourished in our forests. The once extinct trade of pole-lathe turning is now practised by hundreds, with more joining

their number all the time. For many, craft is part of a much wider ambition. Whenever they turn a bowl or carve a spoon or work a coppice, they're really trying to fashion a different model of life and work: more local, natural and sustainable than one based on efficiency and productivity. Some might see this as a naïve retreat into an idealised, pre-industrial past. But as Steve's hero E. F. Schumacher once wrote: 'Any intelligent fool can make things bigger, more complex, and more violent. It takes a touch of genius – and a lot of courage – to move in the opposite direction.'16

For the first time in well over a century the winds of change are behind the woodland crafts. We all now acknowledge the role that trees and forests will need to play in our future if we are to restore biodiversity, reduce our carbon emissions and mitigate the effects of climate change. The government itself has pledged to plant 30,000 hectares of trees – an area the size of the New Forest – every year, with the aim of increasing tree cover in the United Kingdom from 13 per cent today to 16.5 per cent by 2050 – higher than it has been in more than a thousand years (though less than half the European average). It is also determined to make our woodlands more economically viable, stimulating domestic production of timber (of which we currently import 80 per cent) and encouraging consumers to choose renewable wood products wherever possible.

If we are to achieve these goals we will need a large, skilled workforce to plant, maintain and harness the country's new forests. The dying trades of the woods will have to be reborn, not as quaint pastimes, but as professions of genuine national

importance. As we transition to a green economy, woodsmen and women may prove as essential as wind turbine engineers, solar panel fitters, heat pump technicians and electric vehicle machinists: an old trade joining the new to help craft the future.

CHAPTER FOUR

Down the River

Rush Weaving
Bedfordshire

I grew up on the edge of the Chilterns, in Bedfordshire. My parents moved to the town of Dunstable when I was eight because it was the only place near London they could afford. We had no other reason to be there – no family, friends or ancestral ties – and never felt like we truly belonged. And yet in some respects Bedfordshire was just as stranded as us: too far south to be the Midlands, too far north to be the south-east and neither close enough to the capital to be a home county nor distant enough to have a distinct regional identity. I remember one day looking out of my bedroom window across the housing

estates around us. As I surveyed the semi-detached homes and parked Ford Escorts, I unjustly concluded that Bedfordshire was the most boring place in the country – if not the world.1

I didn't realise that my home county was undergoing a remarkable transformation. Over the last few decades Bedfordshire has embraced the growth industries of our age, remaking itself into a hub for Britain's booming service sector. It's now packed with business parks, retail outlets and entertainment complexes, many of them constructed on former manufacturing sites. Enormous warehouses and distribution centres sprawl across the landscape, capitalising on the county's middling location between north and south. Haulage trucks jam the ever-widening motorways, carrying imported goods from online retailers to waiting consumers. Bedfordshire today is a monument to a modern economy grounded in the relentless circulation of goods, people and capital.

It's hard to believe that less than a hundred years ago the county was famous for its crafts. The north was renowned for lace, which at one point was being made in almost every household. The south was the nation's capital of straw-plaiting, a quaint cottage industry that had somehow become a global phenomenon.2 At the peak of their powers in the 1930s, the people of Luton and Dunstable – most of them women – were producing 70 million straw hats a year and exporting them all over the world. For a brief period Luton was as famous for its boaters and bonnets as Delft was for pottery and Cuba for cigars. Long after its great industry died, the town's football club still bears the nickname 'the Hatters'.3

Every part of the county had its own specialism. The chalky escarpments around Whipsnade (now known for its zoo) were delved by lime-burners and cement-makers, whose abandoned quarries still pockmark the vales. The clay deposits of central Bedfordshire supported a vast population of brickmakers and, in the complex at Stewartby, the largest brickworks in the world (now set to become a Universal Studios theme park). Bedford itself had a small but thriving community of brewers, cobblers, toymakers and agricultural equipment manufacturers who supplied much of the south-east of England. But the county's widest variety of crafts sprang up in its miry north, around what was surely its greatest natural feature.

The Great Ouse is Britain's fifth-longest river.4 Rising in Syresham in Northamptonshire then running north-east through Buckinghamshire, Bedfordshire, Cambridgeshire and Norfolk before draining into the Wash, it's noted both for the many tributaries that feed it and the vast wetlands it saturates. The most striking part of the river's course occurs in an otherwise nondescript corner of Bedfordshire, where it meanders like a drunkard, carving a series of deranged horseshoes into the surrounding meadows. 'It changes its mind', H. E. Bates, author of *The Darling Buds of May* (and very much a man of his era) remarked, 'like a woman under the stress of some extreme excitement.'5 Local farmers meanwhile dubbed it 'the Bailiff of Bedford' because it seized their land and livestock whenever it flooded. And yet for many centuries this capricious waterway was an artery of economic activity.

CRAFTLAND

All traditional crafts emanate, in one way or another, from nature. They are rooted in their local landscapes much like the materials they use. We've seen how the dales crawled with wallers and the forests swarmed with woodworkers. But none of Britain's many landscapes supported a more diverse and economically important range of trades than its waterways. Before the twentieth century every one of its 1,500 rivers and streams was a potential industrial estate. The Great Ouse was no exception. Its banks were lined with hundreds of highly productive mills, their sloshing wheels mashing malt, making flour, powering saws, spinning yarn, fulling cloth and weaving fabric.6

Before the Fens were drained in the seventeenth century, and to some extent even afterwards, the Great Ouse was part of a wider landscape of bogs and swamps, meres and holms; a territory whose quicksilver borders were constantly being redrawn by the river. This waterworld, which echoed all night with frogsong, should have been wholly uninhabitable to humans. But it sustained a population of amphibious people who, cut off from the rest of the country, battling malaria, rheumatism and trench foot, somehow managed to survive there. They lived and worked all over the region, punting along channels, traversing marshes on stilts, skating across frozen streams, all of them wringing a living from the wetlands.

Most fenlanders practised specialist trades, each ingeniously adapted to its habitat. In the winter months reed-cutters stalked the marshes, their faces masked against ague, to scythe

materials for local thatchers. In the spring, peat-cutters trudged into the bogs, strapping wooden boards to their feet so they didn't sink to their deaths. Eel-catchers wove traps from willow, waiting for the right moment, when their rivals weren't watching, to cast them into secret stretches of water. Wildfowlers, meanwhile, spent their nights paddling through the roke, face down in their boats, targeting ducks and swans with eight-foot guns. Most of these occupations have since vanished, lost to the quagmire of time. But one of them, at least, survives.7

* * *

It's the longest day of the year and I'm heading into the heart of Bedfordshire. I drive north up the M1, past Luton, Toddington and Woburn, then exit at the Broughton Interchange. As I wind my way into the countryside I enter an overlooked England – a region that, despite its proximity to major towns and highways, seems curiously remote. If many Americans call the Midwest the 'fly-over', this area is the 'drive-through': a place most people hurry past on the motorway without even realising it's there.8 This lozenge of land, bordered by Bedford to the south, Rushden to the north, Milton Keynes to the west and St Neots to the east, is a patchwork of fields interspersed with villages, whose names – Podington, Shelton, Grafham, Molesworth, Spaldwick – are as charmingly generic as their high streets. The whole area looks like an England generated by artificial intelligence.

It's suspiciously quiet. The roads are empty, the houses lifeless. I stop briefly at the village of Harrold and park outside a shuttered fish-and-chip shop called 'Oh my Cod'. A hundred years ago this settlement was a centre for leather manufacturing, a major supplier to the shoemakers of nearby Northampton. Harrold was full of lime pits, tan pits and dye works, all fed by the flow of the river. The whole place buzzed with workers, commuting down the high street in the mornings and frequenting the local pubs (once ten, now two) in the evenings. Harrold's old manufacturing businesses started to fold in the 1970s. By the turn of the millennium all the leather workshops had gone, most of them converted into residential properties. But even residents are thin on the ground today. The only person I see is a dog-walker, brandishing a bright green poo bag.

I leave Harrold, cross the Ouse, and drive east past fields silvered with floodwater. After bumping up against the river three more times in quick succession I begin to understand why they call it 'great': in these parts the waterway is as inescapable as a feudal overlord. It wraps itself around the region, encircling meadows, roads and villages. There are a few extraordinary spots, near Radwell, Felmersham and Oakley, where the river surrounds you on every side. And even when the water itself isn't visible, you can hear it in the distance and feel it beneath your feet. Local farmers have told me that even passing thunderstorms seem to track its course.

I park my car and walk to an old bridge just south of Radwell, where the river carves a casual bend through the

meadows. Willows, oaks and white-blossomed hawthorns rise up on both sides, encircling the banks like an amphitheatre. I stand on the crossing for the best part of an hour, watching freight trains trundle across the horizon.

Then I spot her.

A white-haired woman emerges through the reeds, punting a flat-bottomed boat across the water. I raise my hand to greet her but she doesn't notice me: she's far too interested in the overgrown bank to her right. Without warning she leaps, fully clothed, into the river. She wades through waist-high duckweed, holding a long scythe above her head. When she reaches a large stand of rushes she plunges the tool into the water and makes a single cut below the surface. The plants tumble obediently into her arms. She tonks them against the hull, rinses them in the river, ties them into a bundle and piles them into the boat. She then clambers back aboard and, before I manage to say a word, continues her journey downstream.

Felicity Irons is one of Britain's last rush merchants and weavers. There used to be thousands like her all over the country, most of them living and working by rivers. They made chairs, beds, mats, baskets and children's toys, their creations touching every aspect of existence from cradle to grave: many people began their lives in rush-woven Moses baskets and ended them in rush-woven coffins. For centuries, rush was inescapable: a plastic of pre-industrial Britain. But in the modern period it gradually fell out of favour: undercut by mass-production, undermined by new materials, undervalued

by changing tastes. The country's rush weavers gave up, retired and died out, until only a handful of holdouts remained.

Irons will spend the next month on the Ouse and nearby Nene with her husband Ivor, her brother Davey and her fifteen-year-old rescue dog Molly. They'll punt all over Bedfordshire and beyond, navigating stretches of river known only to them. Their annual harvest may look romantic, but it is exhausting and sometimes hazardous: last summer Ivor almost died from Weil's disease he contracted in the water. Yet it is an essential part of their work. A whole year's income depends on the next few weeks; a poor harvest could easily end the business. Right now, Irons thinks about rush every waking minute of every day. She even cuts it in her dreams.

Today, thankfully, has been productive. By late afternoon her team has harvested two tonnes of rush and loaded it on to trailers. But before she heads back to the workshop, Irons returns once more to the river. She stops at the water's edge and mutters her thanks to the Ouse. She pauses for a moment, just long enough for her vowels to reach the other bank, then strides back up the meadow, swings herself into a Land Rover and vanishes in a cloud of rush dust.

* * *

Bulrush is a tall, grass-like plant that grows in rivers, lakes and wetlands. It originates in an underwater rhizome that in summer erupts into grey-green stems crowned by brown flowers. This

commonplace plant, often mistaken for reed or sedge, flourishes all over the northern hemisphere, as far east as Vladivostok. But the best rush in the world is said to come from England, and the best in England is said to come from the Ouse. It thrives in the river's slow-moving currents and gravelly soils, growing as much as an inch a day. In July and August it doesn't just fringe the banks but proliferates in every direction, squirting upwards like frozen fountains, thatching itself into islands, dividing the river into a network of hidden channels and lagoons. Sometimes, and in some places, rush carpets every square inch of water, making the river invisible as well as impassable.9

Ever since an infant Moses was hidden in it, bulrush has tracked the meandering course of human history. The Egyptians harvested various species from the banks of the Nile, turning them into sandals, paper and (apparently) tampons. The tribes of North America burnt it to deter biting insects and evil spirits, fermented it into foodstuffs, and used it to cure abscesses, snake bites and whining children. The Uru people of Lake Titicaca, on the border of Peru and Bolivia, employed a variety called *totora* to build boats, homes, even entire floating islands. And for the best part of a thousand years, as we'll see later in the book, European coopers wrapped it around the joints of their casks to keep the vessels watertight.

Before the seventeenth and eighteenth centuries, when flagstones and floorboards became fashionable, the people of Britain scattered the plant over their muddy floors to make them cleaner, warmer and softer underfoot. By the end of the Middle Ages some grand houses employed full-time rush-strewers. The Tudors interlaced it with fragrant herbs and flowers to disguise the filth that lay beneath.10 Not everyone was fooled: Erasmus, who visited England several times in the early sixteenth century (and also disapproved of the country's wine and weather), was disgusted by the practice:

> Almost all the floors are of clay and rushes from the marshes, so carelessly renewed that the foundation sometimes remains for twenty years, harbouring there below spittle and vomit and urine of dogs and men, beer that hath been spewed up

and remnants of fishes and other unmentionable filth . . . I am confident the island would be much more salubrious if the use of rushes were abandoned . . .11

For the English, however, rush was all but sacred. By that stage festivals were being held in its honour all over the country. Every summer excited villagers hurried to their nearest rivers, collected armfuls of the stuff and piled it atop elaborately decorated rush carts. Then, flanked by bell-ringers, flag-wavers and Morris dancers, they pulled the carts along the streets, past cheering crowds, through showers of ale and flowers. When at last they reached the local church they strewed the rush across its floors, refreshing what had been left the previous year, before making merry into the night.12

Rush wasn't only scattered loose: it could be twisted, braided and plaited into something approaching a textile. As weavers developed and refined their techniques, sharing them with each other and relaying them through the generations, they evolved into some of Britain's most versatile craftspeople: from one crude material, and with virtually no equipment, they could fashion a truly extraordinary range of domestic products, from chairs and beds to clothes and children's toys. And yet even by the standards of the time, rush weavers were underpaid and undervalued. Most 'bottomers', for instance – who specialised in the rush seating of chairs – were forced into itinerant labour, hauling their wares from village to village, pitied and derided wherever they went. The cloth-eared character

of Bottom in Shakespeare's *A Midsummer Night's Dream* was most likely a rush-weaver.

* * *

Felicity Irons found rush weaving through disaster. It was 1990 and, then in her early twenties, she was hitchhiking across the Australian outback when the car lost a wheel, flipped into the air and somersaulted into a ditch. When the vehicle finally came to a stop, Irons – who hadn't been wearing a seat belt – crawled out of an open window and, smelling fuel, dragged the driver to safety. That's when it hit: a pain so violent that it doubled her over and knocked her to the ground. She lay there in the dust, ants crawling across her face, waiting for someone to come to their rescue. Seven cars passed but none stopped; the eighth radioed through to an ambulance. Twelve hours later she was on a stretcher in Alice Springs Hospital.

Irons had broken her back in six places and suffered severe nerve and tissue damage throughout her body. It was many weeks before she felt strong enough to return to the United Kingdom. Her subsequent convalescence, at her mother's house in Kimbolton, was the most difficult period of her life. She tried every possible treatment but none seemed to work. Irons resolved to find an occupation, but her injuries limited her options: desk jobs were out of the question because she couldn't sit still for more than a few minutes without the pain becoming intolerable. She considered realising her childhood dream of

acting but was so depleted of confidence that she couldn't even face auditions. In the end, out of ideas, she decided to follow her mother into the antiques business.

By this stage the old craft of rush weaving was in its death throes. It had been declining since the nineteenth century, when demand for its rough textures plummeted in the face of carpets and upholstered furniture. Arts and Crafts designers had briefly championed and brilliantly re-imagined traditional rush seating but they couldn't save the artform from its fate. In the first half of the twentieth century imported rush from Belgium and Holland undercut local suppliers while the development of synthetic materials made it less attractive to consumers.13 By the early 1990s there were only a handful of rush weavers left in the country, most of them working part-time with imported materials.

Irons saw an opportunity. If she learned how to bottom, she could refurbish and sell antique chairs at healthier profits, while getting paid to re-rush other dealers' stock. In 1992 she bought a Batsford Craft Paperback on rush seating and pored over its pages like a seminarian studying a bible. She followed its every instruction, repeating every process until her arms ached and her fingers burned. She received her first commission a few weeks later, to replace the seat of a Victorian ladderback chair for a local antiques dealer. It took her several days and three attempts to get it right. Later that year she used a small grant from the Prince's Youth Business Trust to purchase a van. Before long she was speeding around East Anglia like a female Lovejoy.

At this stage, Irons didn't harvest her own rush. She bought it from a man who was in many respects a living embodiment of the Fens' disappearing traditions. Tom Arnold came from a long line of local rivermen (he preferred the term 'slodger') whose family had lived by and from the Great Ouse for centuries. Boat-builder, punt-gunner, hive-maker and eel-catcher, he was also the last serious rush-cutter on the 150-mile course of the Ouse (though by the time Irons met him he was in his late sixties and easing into a well-lubricated retirement). Arnold, who stood nearly seven feet tall, lived in the village of Holywell in a house built by his great-great-grandparents, but spent most of his time in the pub next door. He was such a fixture at the establishment that if Irons was ever short of cash she made out a cheque to the publican, who deducted it from Arnold's tab.14

One day in the summer of 1994 Irons drove to Holywell, as she did often, to purchase a few weeks' supply of rush. She arrived at Arnold's house and knocked at the front door. His wife appeared at the threshold and quietly broke the news: Tom had collapsed unexpectedly a few days earlier – he was dead.

Irons stumbled back down the path to the bank. She gazed out across the river, watching the wind in the reeds and the ducks on the water. Her business was surely doomed – over before it had even started. She was climbing back into her van when someone tapped her on the shoulder. It was Arnold's elderly brother Jack, who lived a couple of houses away. They talked for a few minutes about Tom, the funeral, the future. 'What's going to happen to

the rush harvest?' she eventually asked. 'We can't let this whole history die out. Someone has to carry it on.'

Jack thought for a moment, his eyes glancing out over the water. 'Well, girl,' he responded. 'Why don't you do it?' He picked up two scythes from the front garden then led Irons down to a punt by the bank. He spent the next two hours teaching her how to cut rush.

There are many forking paths in the history of culture: moments when a tradition evolves in one direction or another, when it dies or is reborn. Though she didn't know it at the time, Felicity Irons had already resolved to save a whole regional trade from extinction. She harvested alone for the next three years, earning the nickname the 'wild woman of the Fens'. But she knew she was continuing something important – as did those who watched her struggling on the river every summer. The people of Holywell even established an annual 'Blessing of the Rushes' ceremony around the time of Arnold's birthday. Every July a group of family, friends, fishermen and farmers gathered on the banks of the Ouse. The local vicar paid tribute to the rushes and those who worked with them. A minute's silence followed.

* * *

Felicity Irons' workshop occupies the ground floor of a converted agricultural building just outside the hamlet of Colesden in north-east Bedfordshire. The other units are rented by brand

consultants, music producers and web developers. It's a long rectangular space lit by humming neon strip-lights. There's a dusty desk, a barely used computer and a green Chesterfield sofa that's only ever sat on by Irons' dog. The room is dominated by a group of large workbenches propped up on bricks. All are covered with rushes, which spurt out of crates and plant pots as if they're still growing in the river.

I spot a small bird's nest on a window-ledge at the back of the workshop. Irons hurries across the room, presenting it to me like a child showing an adult a favourite toy. 'This is a reed warbler's nest,' she explains. 'I found it on the grass near the river. Isn't it extraordinary? It's made from rush!' She turns it over in her hands, examining it from every angle, running her fingers across its tangled surfaces. 'You know something?' she says. 'Birds really are master weavers: the best in the world. We can try all we like but we'll never be as good as them.'

Irons' business has expanded steadily since its establishment in 1992. She now employs five full-time and seven part-time weavers who work their way through a hundred bundles of rush (known as 'bolts') a month, producing floor mats, cushions, chairs, napkin rings, coasters, hats, handbags and baskets. Irons interweaves all of her mats with lavender, southernwood, wormwood and chamomile – just like the Tudors before her – and ensures that every finished item has at least one rush flower braided into its surfaces. 'I want people to remember,' she says, 'that whatever form it takes, it will always be a plant.'

Living bulrush is a glossy, spongy organism that smells

like cucumber. Shortly after it's cut, Irons props the plant up against a hawthorn hedge near the workshop, rotating it until all the moisture has evaporated, before tying it into bolts. The drying process extends its shelf-life by many years and fundamentally alters its nature. The supple stems become brittle and hay-like, morphing into various other colours. A sunny spell will bleach the chlorophyll away, producing browns and yellows, while moister weather converts it into a rainbow of olives, teals, violets and indigos. In all cases the rush adopts the hues of its landscape: the floodplains of the Great Ouse at the height of an English summer.

Irons stores her harvest in an old tithe barn across the meadow, a place she calls her 'cathedral to rush'. The building's oak frame is pockmarked with cuts and divots left by Tudor carpenters half a millennium ago but which look only moments old. The sunlight pierces holes in the cladding, reaching into the barn like dusty fingers. As my eyes adjust to the darkness, I make out perhaps a thousand bolts of rush slumped against the walls. I walk through the space, side-stepping owl pellets, inhaling the astringent odour of dried plants. A crumbling blackboard tallies the eight hundred bolts that have just been sent to a Scottish cooperage to caulk whisky casks. Next to it hang four rush-cutting knives, their handles swaying in the through-draught. The largest is called *Brunhilda*.

Irons' warehouse might look jumbled but she claims to know exactly where every single stem came from. I point to the bolt

directly beside me. 'Just outside Turvey,' she responds without hesitation. 'Lovely sunny morning it was.'

I cross the barn and find another: 'Easy. Field Island just after the thunderstorm, Molly got soaked.'

Then another: 'That one's from St Ives lock. Always great rush there. We had lunch at the Pike & Eel afterwards.'

Irons selects one of the bolts, carries it across the field to the workshop then soaks it with a watering can. When the water strikes the rush the river's plummy scent returns: a cocktail of floating pollen, fallen blossom, cut grass and cow pats. 'When you get a good bolt,' she inhales, 'it's just beautiful. I almost want to eat it.' But the water has another miraculous effect: it converts this wizened material into a pliable, velvety substance that can be twisted and bent into almost any shape.

Most modern manufactured products have at some stage passed through the cogs and conveyor belts of a machine. Rush, however, resists all attempts at automation. Unlike many natural materials, its stems can't be divided into thin fibres and woven on a mechanical loom. The plant is too assertive and unpredictable to submit itself to machines. Rush weaving, like other forms of basketry, involves a series of complex, multi-directional movements that require continuous modification and adaptation in response to their material's behaviour. Good practitioners need to enter a dialogue with their medium, knowing when the tension needs to be relaxed, the spacing adjusted, the next stem inserted. 'The only machines

that can do this job are these,' Irons says, raising her knuckle-knotted hands. 'They were used by the very first rush weavers in these parts back God knows when. And they're still the best tools in the business.'

In the thousands of years since their craft was invented, weavers have developed hundreds of different 'recipes', as well as an arcane language to describe them – from chasing and fitching, randing and slewing to waling and upsetting. Irons makes regular use of just a few relatively straightforward

techniques. Her check weave, which involves looping individual rush stems (known as 'stakes') over and under each other to produce a chessboard pattern, forms the base of her baskets, table mats and coasters. She usually surrounds it with a pairing weave, where two stakes dance around each other; or a chain-pairing weave, where they're pulled backwards and forwards to create a chainmail effect. Irons often makes the sides of baskets with twill weaves, staggering the start-point of each movement to produce L-shaped patterns. But her most widely used recipe, and the basis of her famous mats, is the nine end flat weave.

Irons begins by suspending nine stakes from a meat-hook on the ceiling and dividing them into groups of four and five. She then starts to braid. Her hands scuttle back and forth across weft and warp – looping over, diving under, twisting, turning, tugging – causing the rush to crackle like fire. They operate at such speed, and with such labyrinthine turns, that I can't begin to follow what they're doing. But there is method in this maelstrom: slowly, almost incomprehensibly, a strip of woven matting emerges from her hands.

Nowadays, when vast quantities of goods are produced almost simultaneously and consumers demand them without a moment's delay, we rarely consider the time it takes to make something. But time remains an essential feature of a handmade product's identity – an index of the care and skill that someone has dedicated to its creation. Felicity Irons can produce a coaster in exactly ten minutes, a table mat in a smidge below seventeen minutes and a breadbasket in two hours, while a

50-yard-long floormat, like the one made for Hardwick Hall a few years ago, took her and eight other weavers six months to complete. But in the end, all of Irons' lead times are rooted in the rhythms of nature, if only because they depend on the time it takes for her material to grow in the river. 'You can't speed that up,' she says. 'The pace of our work is driven by the weather, the elements, the seasons, the behaviour of the water. They're in charge, not us.'

* * *

At the beginning of the twentieth century a ragbag of historians, officials and busybodies collaborated on the first major scholarly history of Bedfordshire. Their finished study, published in three thick volumes between 1904 and 1912, examined almost every aspect of the county, including the indigenous art of rush weaving. The researchers travelled up and down the Ouse looking for workshops, knocking on doors and interrogating residents, but found only a few ageing practitioners, most of whom had long ceased working professionally. The authors concluded that rushwork faced certain extinction unless 'an inventive genius' came along to revive it.15

It would take nearly ninety years for that genius to arrive.

Traditional crafts are dying all the time, vanishing from our world like butterflies from our gardens and pubs from our high streets. Occasionally, however, they aren't just saved from extinction but granted a new lease of life. Felicity

Irons' company is now a wildly successful business, supplying hotels, stately homes, fashion brands, interior designers and film sets throughout Britain and across the world. Irons – who in 2017 received a British Empire Medal – has reimagined the old craft of rush weaving for a new age, using a rustic artform to create a range of covetable modern items. Her smart website is full of products that answer the most contemporary of needs, from napkin rings (£8) and sunglasses cases (£45) to yoga cushions (£99) and pouffes (£899).

Felicity Irons is living proof that craft can be commercially viable: that it's still possible to build lucrative businesses from traditional techniques, and that even now – perhaps *especially* now – people crave the imperfect beauty of the handmade. She also proves that craft can flourish anywhere. Every part of this country, no matter how quiet it is, no matter how boring it might seem, is a craft land. Every county has its own manufacturing heritage, its own vernacular traditions, its own creative potential. So if, like me, you've ever been ashamed of where you come from, why not take a second look? You may be surprised by what you find.

COMMUNITY

CHAPTER FIVE

Along the High Street

Village Crafts
Colyton, Devon

You might by now have got the impression that craft is a solitary occupation, conducted alone in far-flung landscapes. This couldn't be further from the truth. Craftspeople are inherently social types, collaborating in close-knit workshops, sharing skills and tools with each other. They have always been rooted in their communities, evolving from and fulfilling collective needs. For centuries their work supported local businesses, stocked their neighbours' homes and fashioned the physical fabric of their surroundings, shaping the unique character of each settlement.

Over time they grew so important that their communities couldn't have functioned without them.

In the pre-modern era, Britain's small towns and villages were largely self-sufficient – producers and consumers of their own goods and services. Their food was grown, reared, picked and processed locally (provided their harvests were successful). Clothes were woven with wool from sheep on the green. Pubs brewed their own ale with grain from the surrounding fields and water from nearby streams. An ecosystem of tradespeople developed in every settlement, connected by smock-frocked carters who clacked through the lanes ferrying goods from place to place. Hides passed from cowman to fellmonger, tanner to saddler; wheat went from farmer to miller to baker; timber travelled from woodsman to sawyer to wheelwright (who used it to repair the poor carter's invariably overworked vehicle). Many transactions were conducted through barter: a farrier might reshoe an orchardman's horse in return for a basket of apples; a cooper might build a cask for the brewer in exchange for a slosh of stout.

This highly localised model had its drawbacks – particularly for bargain-hunting consumers who might have benefited from competitive pricing – but it created an extraordinary distribution of economic activity across the country, filling even isolated parishes with practical knowledge and skill. A typical eighteenth-century hamlet probably contained more craftspeople than a large town does today. By the end of the nineteenth century the small Yorkshire village

of Shepley (home to the dry stone wallers we met in Chapter One) boasted thirty tailors and no fewer than twenty-four sweet shops. But as trains and motorcars accelerated connections between communities, self-sufficiency became unnecessary and undesirable. Why commission a spade from the local blacksmith when you could get one cheaper from the shop in town? Why buy a rustic bowl from the wood-turner when a lorry could deliver a shiny new product from Stoke-on-Trent?

Decline in selected rural crafts and trades England & Wales, $1901–1951^1$

	1901	1951
Blacksmiths	137,068	45,755
Boot-makers	218,581	47,511
Butchers	109,000	11,787
Coopers	15,779	4,329
Milliners	380,341	7,087
Saddlers	30,684	2,501
Tailors	237,185	85,323
Wheelwrights	63,220	3,361

As the twentieth century progressed and these questions became harder to answer, hundreds of thousands of village craftspeople went out of business. Some took early retirement; others switched to less skilled occupations; many moved to

cities in search of jobs. Britain's rural communities, once so vital, were steadily denuded of people and skills. As workshops closed and workforces vanished many became economic dead zones, inhabited only by commuters and retirees.

But in a quiet corner of south-east Devon, a small town clings to the old ways. It is home to not one but two vanishingly rare village trades, which are practised almost side-by-side.2

* * *

Monday morning, just before seven. An old man in a work coat brushes the toast-crumbs from his mouth, rattles through his back door, ducks under a walnut tree, and unlocks a gate at the end of his garden. He emerges on the other side of a high wall that's been running through the centre of Colyton for centuries. He hurries down King Street, body tensed in the crisp morning air, then turns left onto Chantry Orchard and strides past the local garden centre, his old brogues clicking across the cracked tarmac. When he reaches a large Victorian premises at the end of the lane, he checks his watch and picks up his pace, bounding through an archway, crossing a bridge over a stream, then looping back into a large slanting structure.

The old lime yard is more boat than building. The long, rectangular shed seems to be floating on the mill pond below, its floorboards suspended above the water. The interior is partially open to its surroundings, allowing curious coots to come and

go. Morning sunlight bounces off the pond, sending reflections dancing across the ceiling. As the man ties up his apron and snaps on a pair of green rubber gloves, five employees sidle into the yard, exchanging weary good mornings.

'Okay, gents,' he shouts, 'it's seven, let's get started.' Two men remove the floorboards and pull a giant white animal skin from the lime pits below. They haul it across the room and lay it on an old wooden trestle table. The foreman crouches over the hide, searching for scars, hunting for rogue hairs, assessing its quality, deciding its destiny: will it become a saddle, a shoe, a handbag? When he's made his decision, he reaches forward with a rounding knife, trims the edges, then slices the hide into pieces. Two other men take the flaps of skin away, humping them into a shadowy corner of the complex for further treatment. They repeat this process dozens of times, completing sixty hides by 8.30 am, when they pause for a mug of instant coffee.

Andrew Parr runs the last major oak bark tannery in Britain, if not the world. It has stood here in Colyton, on the banks of the River Coly, for at least 2,000 years. When his family acquired the facility in the 1860s, some five generations ago, tanning – the conversion of animal hides into leather – was a major national industry. Leather was essential to almost every sector of the economy, needed for every boot and shoe, every strap and apron, every saddle and harness. Most villages had their own tannery, which was usually located on their outskirts so the smell didn't nauseate the residents. At one point there were 180 tanneries in Devon alone, each supplying

a local population of leatherworkers. Parr's tannery, called J. & F. J. Baker (his maternal name), is obdurately traditional, its methods unchanged in centuries. Most of its processes are still powered by an eighteen-foot waterwheel that's been trundling through the Coly for four hundred years.3

* * *

Across the river, on the other side of a cow-chewed meadow, a three-sided workshop horseshoes around a yard. The site is scattered with carts, waggons and caravans, and smells of rust and smoke. In front of the building a sign sways in the morning breeze. 'By Appointment to Her Majesty the Queen', it declares, in hand-gilded letters: 'Mike Rowland & Son, Master Wheelwrights'.

The Rowlands have been wheelwrights for even longer than the Parrs have been tanners. The family's connection to the trade dates back to the fourteenth century, when Rowland-made waggons were transporting stone to builders at Exeter Cathedral. Mike's son Greg, who now runs the business, initially did everything he could to avoid it. He joined the army when he was fifteen, became a Land Rover mechanic at eighteen, then turned to blacksmithing at twenty-one, renting an abandoned forge just over the bridge near the tannery. But he ultimately couldn't resist the gravitational pull of his ancestry. Two years later he was back at the family workshop apprenticed to his father. The Rowlands are now among the

last few wheelwrights in Britain, and the only father and son master wheelwrights in the world.

The word 'wright' is of ancient origin. It stems from the Old English *wryhta*, which itself derives from the Germanic term *wurk* ('work'). It was originally used to describe any builder or craftsman, though by the thirteenth century it was widely associated with woodworkers (just as 'smith' was applied to metalworkers). By the seventeenth century there were cartwrights, wainwrights, millwrights, shipwrights and housewrights, as well as playwrights, cheesewrights and pudding-wrights.

Wheelwrights were tasked with making vehicles for other tradespeople, from waggons and carts to drays and ploughs, harrows and wheelbarrows. They initially served an exclusively local market; everything they made was bespoke and thus tailored to their immediate surroundings. 'The dimensions we chose, the curves we followed', wrote the wheelwright George Sturt in 1923, 'were imposed on us by the nature of the soil in this or that farm, the gradient of this or that hill, the temper of this or that customer or his choice perhaps in horseflesh.'4 Over time, every area developed its own vernacular: waggons were wide in East Anglia but narrow in the Cotswolds, square in Lincolnshire but curved in Oxfordshire, yellow in Kent and red in Rutland. Just as a dry stone waller could tell exactly where he was in the country from the profile of a field boundary, so a wheelwright could pinpoint his location from the style of its waggons.5

For centuries, if not millennia, wheelwrights kept society moving. They were vehicle manufacturers, mechanics,

tyre shops and garages rolled into one (it's no coincidence that many modern petrol stations and auto-repair centres occupy the sites of former wheelwrights' shops). Before the arrival of the motorcar (and for some time afterwards), most villages had their own wheelwright, who was usually located on the main road into the settlement. In 1891, there were 66,000 of them in England and Wales: one for every 500 people.6

Wheelwrights didn't only make vehicles. They provided a range of other joinery services for their neighbours: fashioning ladders, hanging field gates, patching up barns, repairing cabinets, constructing made-to-measure coffins. In smaller communities they even moonlighted as undertakers, ferrying bodies from grieving cottages to waiting churchyards. In many places they became a hub of their community, an axle around which so much else turned. The wheelwright's shop and its large yard was a place where farmers bumped into other farmers, tradespeople conducted negotiations, and travellers stopped on their way into, and out of, the village. If you wanted to plan a trip, solicit a favour or soak up the latest gossip, the wheelwright's shop was almost as good as the pub.7

* * *

Andrew Parr has finished his coffee. He charges off through the tannery, his long legs marching him across the site to a large agricultural warehouse his father built in the 1960s.

CRAFTLAND

As he enters what he calls the 'raw end' of the facility, a foul funk of carcasses punches him in the nose. He doesn't mind: after fifty years in the business he's used to it. He circles four piles of Devonshire cow hides, their piebald patterns fizzing with flies. They will spend the next fortnight in lime pits until their follicles have opened up, when they'll be carted back across the building to two fearsome machines that will strip them of hair and fat. These acrid offcuts are then scraped off the floor and converted into fuel for the biomass boiler. 'We tanners have always been master recyclers,' Parr says. 'Nothing is ever thrown away here, nothing's wasted.'

The fleshed and de-haired hides are carried to the old lime yard and placed in other pits beneath the floor. They'll resurface next Monday when, at 7 am as usual, Parr will slice them into sections and initiate the tanning process.

There is no such thing as leather without tanning. An untreated hide will decay within days, decomposing into putrid sludge. Tanning arrests that process, altering the hide's chemical structure, stabilising its proteins, converting it into a useful and durable material. Almost all modern leather is now tanned with chrome – a mineral that creates soft, supple products at speed, though often with damaging environmental consequences. Before the nineteenth century, however, all leather was tanned with plant matter. Every region developed its own blend of leaves, roots and bark, depending on its native flora. French and Italian tanners employed chestnut, Russians

used birch, while the Turks availed themselves of valonia and mimosa. English tanners, meanwhile, favoured the bark of their beloved oak trees. Indeed, before they were swept away by modern manufacturers, virtually all of the country's thousands of rural tanneries were 'oak bark' tanneries.

J. & F. J. Baker gets through twelve tonnes of oak bark a year, which it sources from barkers stalking the remote forests of Cumbria and Wales. When the sap is rising in the late spring and early summer they fell a selection of trees and carefully peel the bark from their trunks, tying it into bundles then delivering it in person (usually without notice) at some point in the autumn. When I ask Parr if these bosky people have a website, he erupts into laughter. 'A website? I'm not sure they

even have an address! They live out in the woods for half of the year. If they even want to make a phone call they need to drive across the hills to get reception.'

The bark is dried on-site for four years, shredded by the waterwheel, then mixed with river water to form an earthy brown liquid called 'tan liquor'. It is a primitive but miraculous concoction that transfigures slimy flaps of putrefying skin into exquisite, enduring leather. But unlike chrome, which achieves this transformation in a matter of days, oak bark works its magic slowly. Baker's tannage is a long, convoluted operation that involves twelve months of round-the-clock attention, dozens of manual processes and a great deal of patience. The whole tannery is built around an annual cycle, with thousands of hides following each other around the facility towards completion. It is a business without short-cuts: if a single stage is skipped or hurried, the leather will be worthless; if a hide somehow ends up in the wrong place, the whole finely tuned system could fall apart.

I proceed deep into the complex until I reach the old tan yard. It is dark and fetid, lit only by a few strips of sunlight that have somehow found their way through its meagre windows. I am just about to walk through the space when I notice it doesn't have a floor – only a network of narrow gangways separated by large pools of effluvial liquid. I squint through the gloom, surveying the terrain around me, but just can't seem to get my bearings. Then I realise the room is moving. What I took to be columns are in fact 'rockers' – ceiling-height poles that

lurch up and down to stir the liquor, ensuring the hides below are evenly tanned. Two men then stoop out of the shadows and plunge their gloved hands into one of the pits. Over the next two hours they work systematically through the yard, moving hundreds of hides from one pool of liquor to the next, barely exchanging a word.

The hides will spend three months in this room. They are moved on the same day every week, passing through thirteen pits in total, each containing slightly stronger tan liquor than the last. The process is deliberately slow and incremental. 'If you dunk a hide straight into strong liquor,' Andrew later told me, 'you'll only tan the outside, like cooking a piece of meat on too high a heat. We're aiming for a slow-roast, tanning the material from the inside out.' When the hides have completed their pilgrimage from the bottom to the top of the facility, they are lugged across the complex to the 'new' tan yard (still over two hundred years old) and layered on top of each other between scattered handfuls of oak bark, like a giant lasagne. They will remain in these 'layer pits' for a further nine months. When they finally surface, after a full year submerged in tan liquor, their molecular structure will have changed irrevocably, the collagen fibres bonded and stabilised into leather.

The process, however, is far from complete. All tanned leather needs to be laboriously refined and finished if it is to become suitable for its various uses. This practice, called currying, is so complex that despite having it explained to me several times I confess I still don't fully understand it.

CRAFTLAND

All hides are washed, drained, rolled, shaved to even thicknesses, set or flattened with a blunt blade called a stricker, treated with fish oil, hung until partially dry, then re-set, re-oiled and dried again. Some leather is treated a third time with a combination of oils, tallows and other fat liquors. I approach one of the curriers as he applies such a concoction. An old recipe-book lies open at his side, its pages browned with greasy fingerprints, its stages detailed in hand-penned cursive script. I only have time to transcribe one cryptic phrase – '1½ jugs troupon DB plus 1 scoop of salts, 30 minutes' – before he spots me stealing his trade secrets and slams the book shut.

I retreat from the building, cross the path, and climb an old narrow staircase to a garret on the second floor, cracking my head on the low door-frame as I enter. A man stands at the other end of the room, silhouetted by the window, heating a saucepan on an electric hob. He is making one of the company's twenty secret recipes for 'dubbin' – a special blend of oils and greases that is carefully 'dubbed' into every piece of leather to enhance its strength, softness and beauty. On this occasion, I decide not to ask how it's made.

He dips a bristled brush into the pan, mixes the yellow liquid on the polished worktop, works it in loose figure-of-eight movements into the surface of a five-foot-long cut of leather, then stacks the product on a shelf. After sixteen months of tanning and currying, the material is finally finished.

Before he picks up the next piece, he peers out of the little

window, noticing a plume of smoke above the wheelwright's shop.

'Looky here,' he mutters, 'old Rowland's busy.'

* * *

Greg Rowland is exhausted. He's just finished a night shift at the fire station and should be fast asleep. His handlebar moustache, which normally curls up at the corners, droops lifelessly on his cheeks. He unwraps a giant sausage roll, freshly made every morning by the local baker, and devours it in under a minute. He needs to finish four large wheels this afternoon if he's going to meet his deadline.

A traditional wooden wheel is, despite its rustic appearance, a devilishly complex feat of engineering. It must of course be perfectly circular if it's to distribute weight evenly and move freely – hardly an easy task when being made by hand. It also needs to possess prodigious strength to tolerate the many powerful forces that assault it from every angle. If any of its components is fractionally off – if a spoke is too long, a felloe (pronounced 'fellie') too straight, or a tyre too loose – then the vehicle could collapse under its own weight. And yet Rowland never makes technical drawings or written calculations. 'If you looked at a wheel and did all the geometry, you'd be there for ever,' he says. 'Quite frankly, I don't have that kind of time.'

Like many artisans, Rowland grounds his practice in what's often called 'tacit knowledge': a know-how gained from

experience and intuition, from watching and doing rather than reading and writing. George Sturt, whose book *The Wheelwright's Shop* remains a lodestar for the trade, surely described it best:

> The nature of this knowledge should be noted. It was set out in no book. It was not scientific. I never met a man who professed any other than an empirical acquaintance with the waggon-builder's lore . . . The lore was a tangled network of country prejudices, whose reasons were known in some respects here, in others there, and so on. In farm-yard, in tap-room, at market, the details were discussed over and over again; they were gathered together for remembrance in village workshop; carters, smiths, farmers, wheel-makers, in thousands handed on each his own little bit of understanding, passing it to his son or to the wheelwright of the day, linking up the centuries. But for the most part the details were but dimly understood; the whole body of knowledge was a mystery, a piece of folk knowledge, residing in the folk collectively, but never wholly in any one individual.8

Greg builds a wheel just as his father taught him – just like seven centuries of Rowlands before him. He begins with the hub, cutting it into shape, chiselling mortices into its perimeter at even intervals. He turns each of the spokes on a lathe, the exact number dictated by an ancient ratio that as far as he knows has never been written down. He then drives them into the hub, thumping their tangs into the mortices, ensuring

each one projects at a slight angle to give the wheel the concave profile, or 'dish', from which it derives additional strength. Rowland then carries the partially assembled wheel through shafts of dusty sunlight to 'the wheelmaker' – a one-off instrument his father built over half a century ago. The felloes, each of which has been hand-cut to traditional patterns, are then hammered into the spokes. Rowland usually favours two spokes per felloe: a twelve-spoked fore-wheel, for instance, will have six felloes, while a fourteen-spoked rear-wheel will have seven.

When the wooden components have been assembled and sanded, Greg turns to the most challenging job in wheelwrighting: the bonding of the metal tyres. He begins with a rare measurement, using a famous wheelwrighting tool. Grasping the

old elm handle of his father's 'traveller' – a spinning disc that measures circumferences – he runs it around the outside of the wheel, declaring the readings as he goes. He then runs the tool around the inside of the tyre, repeating the process several times to be sure. His eyes narrow with thought. 'What have we got then?' he whispers to himself. 'Ninety-six, eighty-seven. Yep, quarter-of-an-inch should do it.' Rowland wants the tyre to be fractionally smaller than the wheel so that when it shrinks it will compress all the components into a near-unbreakable bond.

'A few years ago', Greg says, smirking, 'some top engineer came to the workshop and made all kinds of calculations about how much the metal would nip. He then told me the exact size – to the millimetre – I had to make the tyre. He got it completely wrong.'

I ask Greg how *he* knows the correct size of a tyre.

'No idea,' he responds. 'But after bonding thousands of wheels over the last thirty-five years, I just do.'

When the iron has been cut and welded into a hoop, Rowland rolls it into the yard and throws it on to a large fire of fence panels donated by the local builder. He prowls around the inferno, stalking through the smoke, peering through the sparks, looking, listening, prodding, waiting for the iron to reach temperature. When its black surfaces fade to gun-metal grey, he strikes the tyre with a poker. It emits a dull thud, a sign the hot metal has stretched and softened.

It's ready.

Without delay, Rowland and his apprentice pull the tyre out of the fire with two long lifters and heave it across the yard to the bonding plate – a large circular sheet of iron that rests on a concrete slab. They place the tyre over the wooden wheel, which immediately bursts into flames. Rowland then circles the plate with a sledgehammer, smashing the tyre over the felloes, landing one brutal blow after another.

'Bond it!' he barks. 'Come on! Quick!'

Both men drop their tools and unload the contents of four large watering cans over the wheel. As the cold liquid strikes the hot metal, it bubbles, fizzes, whistles and screams, engulfing the men in plumes of scalding steam. Then come the noises – clunk, click, clack, pop: the sound of all thirty-one

wooden joints being locked into position by the compressive force of the shrinking metal.

The wheel has been bonded.

* * *

It's 4 pm at the tannery. Most employees are already walking home, with cow-stench following them through the streets. Andrew Parr heads back to his desk to complete some overdue paperwork. As he crosses the yard, Greg Rowland's sledgehammer can still be heard thumping away in the distance.

He passes through an old wooden door bearing the sign 'Mr J. H. Parr'. 'That's actually my father Harry,' he says nonchalantly. 'Died almost thirty years ago, haven't got round to replacing it.'

Parr's office has a tired bookish grandeur, like the headmaster's of a minor public school. He sits at a large mahogany desk, a carriage clock on the fireplace behind him, a portrait of a solemn ancestor above his head. 'This,' he says, finding an old copy of the *Leather Technician's Handbook* beneath a pile of invoices, 'is the *bible*. Though of course it's been out of print for decades.'

Britain's leather industry has declined dramatically over the last century or so, a victim of one ruinous blow after another: the disappearance of the local saddlers and shoemakers who once constituted its most loyal customers; the rise of cheap foreign leather imports; the proliferation of synthetic substitutes like vinyl and polyurethane; and the mounting concerns over animal welfare and environmental degradation.

These developments, and others, have diminished what was once Britain's second-largest manufacturing industry (after wool) into a small and ever-shrinking niche. There are now just twenty-three tanneries left in Britain, most of which are barely clinging to the remains of their market. But when I ask Parr if he sees a future for the product, his phlegmatic face lights up. 'Humans have been making leather for thousands of years and we still haven't improved on it,' he says. 'You can invent all the plastic imitations you like but there's nothing like real leather.'

Not all leather, of course, is equal. Most of it is now manufactured in large factories overseas, its hides doused in toxic chemicals, scoured of their original surfaces then printed to look like skin. Even a product labelled 'genuine leather' is likely made from scraps of waste material glued together but stained to look like the real thing. Baker's full-grain product, by contrast, is produced with natural, sustainable materials, its strength and beauty deriving from its origin as a single hide. Many consider it the finest leather in the world.

It is also among the most expensive. The company's bridle butts, sole bends, girth straps, heel lifts and winged toe-puffs (I'll let you guess their purposes) would be unaffordable to the average village craftsman, even if he existed. Most end up with Savile Row tailors, Japanese boot-makers and French fashion brands, all of whom swear by their quality. But Parr's company still sells some of its wares to local leatherworkers, just like all rural tanneries used to.

Jasper Highet is a seventy-one-year-old master saddler and belt-maker who lives three miles north of Colyton. When he's not maintaining his prize-winning allotment, he's in his garden workshop creating handmade leather goods – the kind once owned by everyone but now by almost no one. His oak-bark belts are masterpieces, each one fashioned using dozens of different processes and forty hard-to-find tools. He's been visiting the tannery every month for half a century. After chatting to his friends in the tan yard, he ascends the staircase to the stockroom and forages for the perfect butts. 'Most modern leather is bland and characterless,' he says. 'But every piece of Baker's leather is different from the last, with its own pattern of scars and wrinkles. This can be a real pain when you're working with it. But it means every product is as unique as the animal it first came from.'

At the end of the day, as Greg Rowland finishes the freshly bonded wheels in the yard, a sweaty tourist dismounts his rented bicycle and ambles over. 'A wheelwright!' he laughs. 'Good for you, old chap, good for you, keeping the craft alive!'

Every muscle in Rowland's burly body tenses up. The usually genial man turns his back on his visitor and walks away. I wait a few minutes, then follow him to his office where he's pretending to do some paperwork. I can tell he's still furious. 'Bloomin' grockle,' he says, swatting a fly from his face. 'When someone

says "craft" to me I think of a church fayre or a bearded hippy carving spoons. I'm not a craftsman, this isn't a hobby, and I'm not keeping anything "alive". This here is a *trade*. I'm running a business, and, much like everyone else in the country, I'm trying to make a living.'

It isn't, in truth, the easiest living to make. Wheelwrighting, like tanning, has been in decline for over a century. Between 1900 and 1950, Britain lost 95 per cent of its wheelwrights, a thousand leaving the industry every year. The survivors can now be counted on a single hand. The Rowlands barely made it through the '80s and '90s, when they were repeatedly advised to go bankrupt. But as they updated their practices and remodelled their products, a modern market began to reveal itself. They are now busier than ever, making corporate handcarts, decorative barrows, gun sets for cadets, cannons for military museums and coaches for the Royal Households. Rowland thinks the firm's survival reveals a profound truth about traditional trades. 'The only reason you had a wheelwright, a tanner and a blacksmith in every village was because they were serving a genuine need,' he says. 'If our trades are to survive – not just as curiosities rolled out at county fairs, but as proper businesses – we have to respond to the needs of *today*. If they don't do that, they'll die – and they probably deserve to.'

It's getting dark when I leave Rowland's workshop. On my way back into town I make a detour into Chantry Meadow, a long strip of grazing land running along the north bank of the River

Coly. I wander through a herd of cows until I reach a solitary oak tree in the middle of the meadow. From here I can see both the tannery and the wheelwright's shop – two stubborn holdouts facing off across a field. Why *both* survive in Colyton, rather than anywhere else in the country, is a mystery to their practitioners, to their neighbours, and I confess also to me. But survive they do. Indeed, for now, at least, both firms are thriving.

* * *

On my last morning in Devon I walk through Colyton a final time. I set out from the bakery at Dolphin Street with a warm pastry in my hands, then cut through to the Market Place, where the butcher is stuffing his award-winning sausages and the hairdresser is trimming her first customer of the day. I glance up at the heraldic banners around me, each representing a different local family or trade guild, then make my way past the hand-carved war memorial into the parish church, where a florist is arranging dahlias by the altar.

I continue south down Church Street and buy a jar of homemade jam from a shelf on a garden wall. The narrow road twists and widens into a pretty junction dominated by an auto repair business that has been operating on the site for more than a century. Two blue-overalled mechanics – the wheelwrights of our age – rummage beneath a bonnet while the man from the next-door bicycle shop gives his opinion on the previous night's football.

A hundred yards away, Colyton's curtain-maker, the person responsible for its famous flags and banners, is sitting in the window of her soft-furnishings store, sewing a Peter Pan costume for the Christmas pantomime. In a cottage on the other side of the snooker club, the local bookbinder – just back from the school run – is hard at work in her spare bedroom repairing the vicar's bible.

I follow the road to the Town Hall and pore over the crowded noticeboard, a palimpsest of leaflets and flyers for local events and projects. A silversmith is offering jewellery classes, a seamstress is seeking members for a slow-stitching group, and a part-time potter is advertising an open studio sale.

Britain's rural communities will never fully rebuild their old artisanal constitutions, but they are still full of people making things by hand. Craftspeople – countless numbers of them – are working in small towns and villages all over the United Kingdom. Most of them are modest operators, selling their wares at gift stores and market stalls, running workshops for interested locals. None, however, should be underestimated. They aren't just following their inner creativity but spreading it all around them: beautifying high streets, filling church halls, enriching the lives of their neighbours, and binding populations into communities.

CHAPTER SIX

The Making of a Mariner

Fishing Crafts
Devon, Cornwall & the Isles of Scilly

I drive south-west out of Colyton, through fields grazed by cattle. As I head deeper into Devon, the light becomes brighter and bluer: a sign that the sea is near. I descend a long, shallow slope into Budleigh Salterton, where little boats line the shingle beach, then loop up and across the River Exe before heading south again to Torbay. In the nineteenth century this sheltered bend of coast was known as the English Riviera, a playground for the rich and famous. The town of Torquay, at the northern edge of the bay, was said to be one of the wealthiest places in the world. It certainly doesn't seem so today: I continue along a dual carriageway

lined with low-cost supermarkets and fast-food outlets, then crawl through suburbs to my next destination.

At first glance, Brixham seems to be a typical seaside town. Its streets are lined with amusement arcades and ice-cream parlours, fish and chip shops and nautical gift stores. But on the other side of the harbour, beyond the seal-trip sandwich boards and the crabbing children, behind a wall most visitors aren't permitted to cross, a large fishing fleet is at work. Fifty or sixty commercial trawlers bob and creak in their berths, their crews washing down and loading up, all the while shielding their lunches from seagulls. Men in dungarees wade through drifts of gear, mending nets and braiding ropes, seemingly immune to the smell. One of them stands at a splicing rig, repairing a damaged bridle wire while his Jack Russell sleeps on his shoulders.

The harbour is even busier after dark. Trawlers come and go through the night, hoping to land in time for the market or set sail before their rivals. Each one triggers a mechanical ballet of flashing lights, cranking cranes and scurrying forklift trucks. In buildings behind the quay dozens of people work under strip-lights, yellow boots splashed with cuttlefish ink, grading and boxing the fleet's catch. On a good night they'll process eighty tonnes of fish before sunrise: brill, hake, sole – sometimes a tuna the size of a man.

The fish merchants arrive just after 4 am, scouring the boxes, examining their contents, steeling themselves for the sale ahead. The auction, which begins at 6 o'clock sharp, is attended by wholesalers, restaurateurs and food manufacturers, all

competing for the prime lots. A convoy of refrigerated trucks tumbles into town before dawn, ready to haul their goods across Europe. The fishermen, many having spent a whole week at sea, stagger home through the daybreak, falling asleep as their families wake.

At its industrial peak about a hundred years ago, Britain's coastline was full of places like Brixham. Its ragged shoreline sustained dozens of major industries and hundreds of different livelihoods.¹ On the eve of the First World War Britain manufactured more than 60 per cent of the world's ships (the figure today is less than 0.5 per cent). The country's many shipyards,

which rose from its estuaries like giant steel forests, were then the biggest industrial complexes in the world, their 200,000-strong workforce manufacturing the most complex machines that had ever been made.2

In major ports such as Hull, Grimsby, Chatham, Portsmouth and Southampton, ancillary trades sprang up on the quaysides. Carpenters turned oars, spars, masts and flag-poles in specialist joinery shops; sail-makers stitched bolts of canvas in cavernous lofts; and apron-wearing curers smoked fish in cowl-topped smokehouses. In the quieter back streets, instrument-makers squinted through loupes at sextants while cartographers hunched over charts. Ropes were manufactured in enormous ropewalks, along which trolleys clanked back and forth, braiding yarns of hemp as they moved. When Chatham's 346-metre ropewalk opened in 1790 it was the longest brick building in the world. In Liverpool, the trade dictated the street pattern of an entire neighbourhood, known today as the Ropewalks.

Before the advent of mass-produced gear, every fisherman was by necessity also a craftsman. He spent the winter months varnishing decks, making nets, splicing ropes and weatherproofing sails in preparation for the season ahead. His wife was even busier. When she wasn't gutting, brining and hawking her husband's catch, and performing a thousand other domestic duties, she was hard at work knitting his clothes. Her masterpiece was the gansey: a woollen sweater so robust that it could be worn every day in atrocious conditions and still last much of a lifetime. Techniques were passed from mother to daughter,

each community developing its own pattern. In Cornwall, for instance, Bude was known for its ladders, Looe for its eddy stones, Port Isaac for double ropes, St Ives for double twists and Polperro for vertical rows of diamonds. Those patterns were part symbolic, part grimly functional. If a fisherman went overboard and washed up along the coast, his finders could identify his village from the gansey and return the body to its rightful home.3

The most widespread craft was basket-making. It took place in every port city, every coastal town, every fishing village, in all but the most indolent seaside cottage. Most communities even had their own 'withy gardens', where they cultivated the long stems of willow, or 'withies', needed for the vessels. Most baskets were ingeniously tailored to their habitats. The herring swills of Great Yarmouth, for instance, were just slim enough for two women to pass each other as they moved through the

town's narrow rows. Over time baskets became so essential to the fishing industry that the authorities started to regulate them. In 1852 the government made a larger basket called a cran (the equivalent of three swills, 37½ gallons or 1,100 unfortunate herrings) a standard unit of measurement across the country.

* * *

Right up until the 1960s almost every coastal community in Britain was overrun with willow constructions of another sort. They looked a little like baskets, albeit of a somewhat bizarre kind, but served a rather different function. Britain's fishermen had been using them for centuries, if not millennia, to trap lobster and crab.4 The contraptions, called 'withy pots' in England and 'creels' in Scotland, adopted subtly different forms across the country, but all worked in the same way. Each one was crowned by a funnel-shaped mouth through which a hungry crustacean, lured by bait, could easily enter but would struggle to exit. They were usually made in the winter, when willow was pliable and fishing impossible. Fathers, sons and brothers – and occasionally mothers, daughters and sisters – worked together, often outside their front doors, singing shanties as they wove. Every family had its own way of making them, its own tricks and secrets, the recipes passed unchanged through generations.5

Potting season traditionally commenced with the cuckoo's call. On the first mild day of the year, usually at some point

in April, fishermen loaded up their boats, paddled out to the rocks beyond the harbour, baited their pots with dead fish and shot them into the sea. What a sight it must have been: hundreds of small vessels racing across the water, the sea air thick with insults, as weather-worn men jostled for the best spots. The pots typically remained in the sea throughout the summer, their owners returning most days to collect, re-bait and re-shoot. Potting was a simple and inexpensive occupation, available to pretty much anyone with a rowing boat. But it was also fraught with danger, as one journalist noted in the 1880s:

> A crabber's life is full of disappointments and of personal risks. Passing ships carry away his sunken pots, or a sudden gale dashes them on the rocks; an 'off shore' storm suddenly rises and villagers peer anxiously through the driving mist, and wives become widows and children fatherless.6

The practice continued well into the twentieth century, until an unrelated set of inventions transformed it. In the 1950s and '60s plastic polymers transformed the basis of manufacturing, changing the landscape of consumer products. Nylon, vinyl, polyester, polypropylene and many less pronounceable substances were used to create durable and versatile products for a fraction of the price of their counterparts. Plastic, which by the late 1970s was already the planet's most used material, accelerated the decline of many traditional crafts. Tanners and curriers were undercut by leatherette, bowl turners and potters by Tupperware, basket-makers by polyethylene bags.

In the 1960s a new generation of mass-produced parlour pots made from plastic-coated steel, polypropylene mesh and recycled tyre rubber entered the market. On the face of it, they were superior in almost every way to the withy pots they emulated. They lasted not one season but many, could be stacked more efficiently on boats, strung together in their hundreds, and were impossible for shellfish to escape.

Most fishermen ditched their willow constructions at the first possible opportunity, tossing them into bonfires, letting them rot in the sea, abandoning the withy gardens that generations had cultivated before them. In the space of just a few years a centuries-old practice receded from the coastline like an ebbing tide. Having given up the craft themselves, Britain's fishermen didn't see the need to teach its primitive methods to their descendants. There are now only half a dozen traditional pot-makers in Britain – in Dorset, Devon, Cornwall and the

Scilly Isles – and as you might expect most are men of advancing age and deteriorating health. Sadly, in the time I've spent writing this book, two of them have died.

* * *

Pinewood Close might seem an unlikely habitat for an ancient craft. But this residential cul-de-sac in suburban Plymouth, with its pebble-dash houses and neat lawns, is home to one of Britain's most celebrated craftsmen. He works in his driveway next to the clothes horse, stores his tools in the garage behind the lawnmower, and keeps his willow in a wheelie bin on the patio.

David French is a fifth-generation withy pot-maker. Born into an old fishing family from Budleigh Salterton, he remembers his gansey-clad relatives making pots in the back garden every winter. He even has a photograph of himself as a baby being cradled on one by his grandfather. Dave remembers the arrival of plastic pots in the 1960s, and the speed with which his family embraced them. He wanted to stick to willow, but his seniors were determined to abandon it. 'Leave it in the past, boy, leave it in the past,' his great-uncle once told him.

Dave didn't listen. He has made more than a thousand pots over the last few decades, much to his neighbours' amusement. As he sorts his withies in his driveway one morning, a one-legged fisherman who lives a few doors away (and who is known locally as Captain Pugwash) shouts from the

pavement: 'Dave! I've found some twigs in the garden. Can you make me another leg?!'

Withy pot-making is slow, tiring and often very painful. I've yet to meet an experienced practitioner who hasn't developed arthritis. At full speed Dave can make a pot in about three hours, stopping only to rest his hands or re-bind them with plasters. He begins by inserting twelve nine-foot stems of willow into holes at the top of his homemade pot stand. He then weaves other stakes around the verticals to produce a cylindrical form that's roughly a hand's width high. This will be the mouth of the pot: the front door through which an ill-fated crustacean will crawl. When Dave is happy with the dimensions he trebles the number of verticals then bends them back on themselves, tying them to hooks at the base of the stand. The structure now looks something like an amphora, its generously rounded top tapering inwards at the bottom.

Dave now embarks on the spiral weave that will bind the whole pot together. He selects four stakes of slightly slimmer willow and wedges them into tiny gaps within the existing weave. This isn't easy. As he jams and jiggles them into position, he rubs his hands on his trousers, whispering 'dry hands dry hands dry hands' before each attempt. When they're finally secure he weaves the two pairs clockwise around the verticals, corkscrewing downwards as he goes. He is constantly adding new material: inserting more verticals wherever possible and feeding new stakes into the binders to keep the weave

continuous. When it's the right size, Dave flips the frame over and trims the snags with secateurs. 'Crab and lobster are clever buggers,' he says, as if describing his nemesis. 'They'll grab anything they can get their claws on. If I don't trim these loose bits, they'll have a field day.'

When he's finished the frame, Dave turns to the base. This is by far the most tiring and tedious part of the process – a job traditionally delegated to children. The dangling verticals are folded at right angles over the bottom rim and tied into position. Four-foot withies are then woven clockwise around the structure, over and under, as tight as possible, until a solid base slowly congeals from the stakes. Dave spends at least an hour on this part of the pot and hates every knuckle-scuffing minute. 'Argh, you sod!' he shouts to a wilful stem of willow, flapping his hand in agony. 'Come on, get in there!'

After four hours of weaving, three mugs of instant coffee, two bacon sandwiches and one brief rain break under the garage door, the pot is complete. I circle it for a few moments, examining its curving contours, running my hands along its braided surfaces, then say something I immediately come to regret. 'Beautiful, Dave! It's a work of art!'

There's an awkward silence, then a raised eyebrow. 'A work of art?' he laughs. 'Come off it, it's a bloody crab pot!'

There's a wonderful passage in Alan Bennett's *The History Boys* when, at the end of the play, the inspiring teacher returns from the dead to extol the value of education. 'Pass the parcel,' he implores his pupils. 'Take it, feel it, and pass it on. Not

for me, not for you, but for someone, somewhere, one day.'7 If anyone has lived by this commandment, it is David French. He has spent the last few decades of his life travelling the country to promote the art of withy pot-making. He isn't motivated by fame ('you must be joking!'), money ('believe me, there isn't any') or even the pleasure of making ('sometimes I bloody hate it'), but by a fiercely felt duty to transmit his skills to the next generation: to find someone, anyone, to whom he can pass the parcel.

* * *

Sarah Ready is one of Britain's only commercial fisherwomen. She has always lived with the sound of the sea in her ears; she grew up in a small fishing village on the south coast, and, like David French, remembers playing with withy pots as a child. She met her husband, who has fished professionally since he was fourteen, on a pungent quay in West Sussex. They have lived and worked together ever since. They spent the early part of their marriage whelking out of Shoreham-by-Sea, but life – as for so many inshore fishermen in the 1980s – was desperately hard. For several years, they couldn't afford to turn on their heating, fill their car with petrol or even buy basic groceries. At one point they were eating whelks three meals a day, seven days a week. The nadir came when, just after failing to renew the insurance, their thirty-foot boat sank into the murky waters of the marina.

In the 1990s the Readys moved from West Sussex to East Devon in hope of reviving their fortunes. They acquired two small trawlers and built a modestly successful inshore fishing business out of Brixham. But Sarah grew increasingly alarmed at the state of her industry. She watched as scallop dredgers flattened rich seabeds into featureless wastelands, as mile-long trawl nets emptied the seas of life, thousand-pot lines plundered native populations of crab and lobster, and even the most careful fishermen polluted the waters with plastic equipment. After thirty years in the business, Sarah decided to change her working practices altogether: to fish in a more modest and responsible way, to catch no more than she needed, and to minimise her impact on Britain's marine ecosystems.

At that point, Sarah had never knitted a scarf, let alone woven a basket. But one summer's day, when she was returning home after a long shift on the water, she spotted David French making a withy pot on the quay. After a brief conversation, she persuaded him to teach her how to do it. The apprenticeship has been far harder than either of them could have anticipated. Sarah's training has been disrupted by two bouts of breast cancer, which weakened her hands and devastated her immune system. At one point an infection caught from the willow hospitalised her for a week. But Sarah persisted, despite protestations from everyone she knew. And now, after an eight-year education, she's not only making her own withy pots but fishing with them commercially.

CRAFTLAND

David French has at last fulfilled his life's goal: he has passed on before he passes out. Indeed, when I ask him to name his greatest achievement in a long career of pot-making, he answers, with tears twinkling in his unsentimental eyes, 'having someone like Sarah find me'.

* * *

Fishing used to be one of Britain's pre-eminent industries. A hundred years ago the British Isles was home to 125,000 fishermen, who thronged our native waters and plied their trade across the Atlantic. Many places were all but monopolised by the trade. Some Cornish villages were sustained for a whole year by a single moment, when a cry of 'Hevva!' announced a shoal of pilchards was passing through their cove. On the other side of the country a string of busy ports was enriched by North Sea cod, herring and haddock. Grimsby, then the largest fishing port in the world, swaggered with wealth and confidence. Fishing wasn't only economically important; it became, more perhaps than any other British business, a metaphor for the nation itself.

But in the decades after the Second World War, this thriving sector endured the same miserable fate as Britain's other great industries. A century of intensive fishing had denuded native stocks, leading to smaller catches and lower revenues. British fishermen re-focused their attentions on distant, under-exploited waters but faced growing resistance from the

countries that bordered them. After a series of clashes with Iceland between 1952 and 1976, widely known as the 'Cod Wars', Britain's fleet was excluded from the rich North Atlantic waters it had fished since the fourteenth century. In the 1980s its crews were further hobbled by the Common Fisheries Policy, which opened British waters to European trawlers and imposed quotas limiting their catch. Thousands of fishermen grounded their boats, discarded their oilskins, and joined the lengthening queue at the Job Centre.8

Britain's leviathan of a fishing industry has now shrunk, in economic terms, to a mere rounding error. The whole sector accounts for just 0.03 per cent of the country's economy – less than Harrods.9 The deployment of ever more sophisticated technology has done little to counteract the catastrophic decline in fish-stocks that 150 years of technological progress has brought about. For all their modern equipment, today's trawlers are less than 6 per cent as productive as the sailing trawlers of the late nineteenth century.10

There are now just 10,000 fishers in Britain, a number that has halved since the mid 1990s and continues to shrink every year. We shouldn't be surprised. Why, when most people get to choose their careers, would anyone opt for a job that has a fatality rate six times higher than any other occupation?11

The decline of British fishing has damaged many coastal communities. Grimsby's extraordinary docklands, named the 'Kasbah' after the crowded Middle Eastern markets that in all but climate they once resembled, are now an eerie wasteland.

The splendid Victorian brickwork has been overrun by weeds, the proud shop signs encrypted by fallen letters, the cracked windows adorned with phone numbers that haven't been reachable since the 1970s. Other towns, particularly in the south, have reinvented themselves as tourist destinations, converting chandleries into bistros, sail lofts into art galleries and old fishermen's cottages into holiday lets. Brixham is one of the few where fishing remains an actual industry. There are six hundred professional fishers here and about a hundred commercial vessels. Its fish market is now the most important in England and Wales.

* * *

Just across the water from the fish market, on the eastern edge of Brixham harbour, Sarah Ready plods along the pontoon. She climbs into a blue Plymouth Pilot, straps on a life-vest and presses the ignition. The boat coughs itself awake. Sarah unwinds the ropes from the cleats, unfastens them from the moorings and throws them back on deck. The boat slips across the harbour, cutting through reflections that wriggle in the water like fish on a hook. As she passes a group of trawlers, deck-hands wave and shout. 'At the pots again, Sarah!' exclaims one white-haired fisherman, stifling his laughter. Sarah, head shaven after yet another course of chemotherapy, chugs on. As she reaches the mouth of the harbour, a lazy seal on the quayside briefly looks up, then rolls back to sleep.

Boy Daniel exits to the north-west. As the vessel heads into open water, the distant vista of Torquay vanishes into a rainstorm, then re-appears, clean and shiny. Ready guides the boat towards a rocky cove patrolled by seagulls. She squints into the autumn drizzle, scanning the sea's surface, until she spots a bright orange buoy ahead. She cuts the engine, lets the boat dawdle to a stop, then leans over the deck and starts pulling. This is the moment of disclosure: a moment that, even after decades of fishing, is still charged with tension and excitement.

The pot is heavy, the willow waterlogged from months at sea. Sarah keeps hauling until it surfaces. She has caught a large lobster, its shell blue and shiny, its scarlet antennae roving in confusion. Over the next hour Sarah pulls a dozen more pots, collecting three more lobsters and a cock crab, which she sells to a local seafood restaurant for a grand total of just over £100.

Most of Brixham's fishermen – her husband included – think Sarah is mad. But she believes in withy pots, and visits fishing colleges all over the south coast to evangelise on their behalf. She tells her students that they cost a fraction of the price of their factory-produced counterparts, and not being plastic, are even eligible for government grants; that in the future they might gain access to protected waters around seagrass beds and offshore turbines prohibited to larger commercial vessels; and that, as consumers are increasingly drawn to sustainably sourced fish, they'll also obtain a premium for their catch. Sarah herself receives almost twice as much for a

lobster caught in willow (about £33 per kg) as she does for one caught in plastic (£18 per kg).

Every year an estimated 650,000 tonnes of fishing gear – including 25 million pots and traps, enough net to cover Scotland and enough line to reach the moon and back – are lost at sea.12 Most of this equipment is plastic, and won't degrade for centuries. Until it does, the nets and traps will continue to catch and kill animals, while their eroded microplastics choke fish and poison food chains. If, however, a withy pot disappears into the ocean, there is a decent chance its catch will eventually escape; and being constructed from biodegradable materials, it will safely decompose into the seabed, as if it had never been there at all. It's therefore well suited to the low impact, low-pollution fishing needed to restore and preserve our marine ecosystems. 'Sometimes the old ways are the right ways,' says Sarah. 'Sometimes the past is actually the future.'

Sarah is no longer alone. A movement, small but unstoppable, is building. Dedicated people all over south-west England are now striving to save the humble withy pot from extinction. In the Cornish village of Gorran Haven, which a century ago manufactured 3,000 pots a year – three or four for every inhabitant – the community has come together to transform two unused fields into withy gardens, and to offer pot-making classes to anyone who cares to attend. In the space of just a few years, Gorran Haven has multiplied its native population of pot-makers from two or three to about thirty, returning a

critically endangered practice to common knowledge. If you wander through its whitewashed lanes, you'll see handmade pots everywhere.

Fifty miles down the coast, near Penryn, a broad-shouldered shipwright and his son have planted hundreds of willow cuttings in a field near the River Fal. They harvest every January, spending the rest of the winter making pots in an open-sided shed, their fingers numb and heavy from the cold. The pots are offered, on a trial basis, to fishermen all over Cornwall in the hope of persuading even a handful to permanently adopt them. They believe that withy pots can return small but profitable yields from underfished stretches of coastline, enhance the reputation of an undervalued industry and generate other sources of revenue from tourists and craft enthusiasts. Some fishermen – perhaps motivated by memories of their forefathers – are already using them.

At the most southerly point of the British Isles, on the remote Scillonian island of St Agnes, one Cornish fisherman has embraced the craft with uncommon commitment. Every spring Jof Hicks rows out to the Western Rocks – often considered the most dangerous waters in Britain – and shoots about a hundred pots into skerries and kelp forests unreachable to engine-powered vessels. He returns every few days to collect his catch, which he sells on the quay under a hand-written sign: 'Live Lobster Lobster Lobster Caught with Totally Entirely Completely Zero Plastic Fishing Gear by Sail and Oar No Engine Zero Emissions'. His business is modest in size (the

island, after all, only has eighty full-time residents) but is so far earning its keep. 'We've been brainwashed into thinking that we can't do anything without plastic, without carbon emissions,' he says. 'But we *can*. In fact, for most of history, this was the only way to do things.'

This isn't sepia-tinted nostalgia; it isn't even craft for craft's sake. All these new-found advocates are responding to the social issues of our own time in order to model a fishing industry fit for the future. They understand, like others in different trades, that craft can offer ready-made, tried-and-tested pathways towards more sustainable forms of production and consumption. There's no question that withy-potting, like dry stone walling and pole-lathe turning, is less efficient than its modern alternatives. But is that really a bad thing? 'Most of the world's problems have been caused by our obsession with speed, growth, profit and productivity,' says Jof Hicks, as the Atlantic wind ruffles his hair. 'Maybe it's time to realise that progress isn't actually progress.'

CHAPTER SEVEN

The Ringing Isle

Bell-Founding
Loughborough

Antony Stone didn't sleep last night. He tossed and turned for six sweaty hours, tormented by all kinds of nightmare scenarios. He arrived at the factory much earlier than usual, long before any of his colleagues. Face swollen with exhaustion, stomach clenched with nerves, he paced up and down the workshop, checking, then double-checking, every tool and component. Were the moulds completely dry? Were the clamps completely tight? Were the alloy ratios correct? When at last he felt reassured that all was as it should be, he hurried through a warren of corridors to the

locker room, where he ate a packet of crisps, drank a mug of tea, then changed into protective clothing: heat-proof overalls, elbow-length gloves, a helmet with a cracked perspex visor.

The foundry has barely changed since the nineteenth century. Vast, vaulted and flanked by two banks of arched windows, it looks like a dystopian cathedral. It is now 9 am. Antony fidgets through the space, disappears behind a halo of green flames, and switches off the furnace. There's a brief silence, followed by the whirr and clank of a large metal ladle being craned across the room to the crucible. As the crucible tilts over, a torrent of molten bronze gushes into the ladle, sending steam into the air and sparks across the floor. Antony picks up a branch of willow and plunges it into the liquid to purify the metal.1 As he rakes the dark dross off its white-hot surfaces, his body is consumed by a golden haze. When all the impurities have been removed, Antony and his assistants escort the ladle, now brimming with liquid metal, down the nave like pall-bearers at a funeral. They pass through a shaft of smoky sunlight, then stop at a small square hole in the sand beneath their feet.

Twenty feet above them a dozen onlookers wait on the balcony. A vicar withdraws a scrap of paper from his pocket, clears his throat, then shouts a prayer over the clanking machinery.

Grant we pray that this bell, destined for your holy Church, may be hallowed by the Holy Spirit through our lowly ministry so that when it is tolled and rung the faithful may be

invited into the house of God and to everlasting recompense. Let the people's faith and piety wax stronger whenever they hear its melodious peals. We pray this in the name of Jesus Christ our Lord. Amen.

Antony isn't listening. His eyes are locked on the molten metal in front of him. He prods and stirs its seething surface, assessing colour and viscosity, determining temperature by eye alone. When it has cooled to 1,000 °C he whispers an instruction to his colleagues. They rotate the ladle and the liquid tumbles into the opening. This is a decisive moment: a mistake now could undo months of work or result in a life-changing injury.

They pour for a single, breath-held minute, their limbs rigid with effort. When at last they are finished, the congregation erupts into applause.

Their bell has been cast.

* * *

Before amplified music, before sirens and alarms, before internal combustion engines, and before steam-powered machinery, Britain's towns and cities were quiet places – well, quieter at least than they are today. The soundtrack of most pre-modern settlements was a muffled mix of jabbering voices, clacking hand-tools and clopping horseshoes. In these environments, genuinely loud noises – those above, say,

80 or 90 decibels (the volume of the average lawnmower) – were rare, and thus had thunderous power and meaning. Apart from cannons and explosions – which most people mercifully never heard – the world's loudest manmade sounds were produced by bells. In the right conditions a large and well-made bell could resound across an entire city and reverberate for miles into the countryside.

Bells have since lost their sonic supremacy, drowned out by their many clamorous rivals. Nowadays they're little more than background noise – genteel echoes floating lazily through a Sunday morning. It can be hard to believe that these instruments once governed people's lives. Before mass literacy and mass information, they served as clocks, timetables, push-notifications, newsflashes, emergency alarms, emails and clergymen all rolled into one. Church bells were rung for daily services and annual holidays, baptisms, weddings and funerals, to repel bad luck and evil spirits. Civic bells told people if a fire had broken out, a criminal was on the loose, an army was approaching, or a citizen's assembly had been called. Some rang dozens of times a day, nagging away at their residents from morning till night. They announced the opening of the city gates at dawn, the commencement of animal slaughtering, the start and finish of trading hours, and the various points in the evening at which the gates had to be closed, fires had to be extinguished, wheeled traffic had to stop, music had to cease, taverns had to shut, and nightly curfews came into effect.

Bells didn't just regulate communities. They *created* them. These large and expensive objects, often made with local donations of money and metal, connected the public to their institutions, the governed to their governors, the people of one period to those who came before and after them. A bell's sound marked out the physical limits of a settlement just like its perimeter walls: defining shared territory, shaping collective identity. And because every bell has a unique pitch and timbre, it became the singular voice of a place that to locals always sounded like home. These instruments may have lost much of their social power, but they continue to shape people's identity. The traditional definition of a Cockney refers to anyone born within earshot of the bells of St Mary-le-Bow on Cheapside.2

Arriving in Britain at some point in the very late sixth or seventh century, bells soon became an indispensable feature of Christian worship. By the end of the eleventh century church towers were being erected all over the country to house them. As urban areas expanded in the late Middle Ages, town halls, guild halls and universities enlisted the instrument for a range of secular functions.

Though bells proliferated all over Europe, no people embraced them quite like the English, who in the seventeenth century made them the focus of a wildly popular activity. 'Change-ringing' is the art of ringing a set (or 'peal') of bells in a particular sequence of permutations ('changes') to produce a vast range of melodies. By the eighteenth century the practice was so widespread that the German-born composer Handel (fingers

no doubt firmly in his ears) is said to have dubbed England 'the ringing isle'.3 In some respects it still is. There are more than 5,000 change-ringing towers in England alone and just 300 in the rest of the world.

Bells reverberate through Britain's collective consciousness. They echo in our ears every time we 'have a ding dong', 'go like the clappers', advise someone to 'ring the changes', or reflect on something's 'death knell'. They resound across our cultural history, swinging effortlessly between high-brow and low, one artform and another. From John Donne's 'for whom the bell tolls' to the nursery rhyme 'Oranges and Lemons', bells are resonant metaphors for joy and sorrow, life and death, the passage of time and the value of place. They are also essential ingredients of our national identity. Whenever we arrive at a significant national milestone – whether it's a coronation, an anniversary or the start of a major sporting event – we invariably reach for the bell ropes. This, after all, is a country whose defining landmark is a bell few have ever seen but whose voice everyone knows: a voice that announces the nightly news and rings in every New Year.

There are about 38,000 church bells in Britain. Every one of them has a story to tell – about the people who paid for it, the men who made it, and the many generations who were baptised, married and buried beneath it. Most bells are hidden from us, suspended in locked towers, visited only by pigeons. But they are remarkable objects in their own right: usually beautiful, often poetic, occasionally mischievous.

A few years ago I visited the Oxfordshire village of Blewbury, where my family had been evacuated during the Second World War. I walked through daffodils to the parish church, then did as I always do: I tried my luck on the bell tower door. Finding it open, I ascended a narrow stairway to the top, where I saw a family of eight bells. The largest had been cast by a local blacksmith in 1825 – his fourth attempt after three previous efforts had cracked. Examining it carefully, I found a small but revealing inscription on the waist: *Nil desperandum* – 'never despair'.

Due to the atrocious condition of most English roads, early bells were typically cast as close as possible to their intended churches. If you know of a 'Bell Lane', 'Bell Common', 'Bell Meadow', or even a pub named 'The Bell' in your area, it's likely that at some point in history a bell was cast on that site. Many were made by itinerant founders, who trundled from parish to parish looking for business. They usually enlisted support from the local population who, knowing the generational importance of a new bell, were invariably willing to provide it. Parishioners donated metal, built furnaces, gathered clay and collected firewood, while clergymen recited prayers to repel evil spirits during pouring. When the bell was cool enough to handle, the whole community came together to haul it into position, then rang it with jubilation.

In the later Middle Ages permanent bell-foundries began to appear in large and ecclesiastically important towns and cities, such as Norwich, Bury St Edmunds, Colchester, Nottingham, Salisbury, Gloucester, Worcester, York, Lincoln and London.

CRAFTLAND

Billiter Lane in the City of London is believed to have got its name from the many bell-founders (then called *belyeters*) who once operated there, servicing the hundred-or-so churches that rose like a forest around them. Most bell-founders augmented their income by making other metal goods, including buckles, candlesticks, cauldrons and cannons. They became wealthy and often well-respected members of their community, and for centuries no major settlement could manage without them.4 Three or four hundred years ago there were hundreds of bell foundries in Britain.

Today, there is but one.

* * *

Deep in the heart of England, smack bang in the middle of the Midlands, lies the market town of Loughborough. It's best known today for its thriving university, which makes up more than a third of the town's total population. But this industrious place also has a long and distinguished history of manufacturing. A hundred years ago its red-brick streets teemed with small, family-run hosiery workshops whose tights, socks and stockings were exported all over the Empire.5 It boasted, in Herbert Morris Ltd, one of the largest crane companies in the world, and in the vast Brush complex (also known as Falcon Works), a pre-eminent producer of trains, turbines and aircraft. Loughborough was also home to nationally important chemical plants, medical instrument-makers, perfume purveyors, and,

in a small facility in the town centre, the printers of the much-loved Ladybird books.

Most of these firms have since vanished, their proudly painted names slowly peeling off their brick façades. Herbert Morris's crane factory is now a climbing centre and gym. The Ladybird headquarters have been swallowed by a shopping mall. The Brush complex, which sprawls magnificently across the north-east of town, is soon to be demolished.6

One of Loughborough's greatest Victorian factories, at least, is in rude health. John Taylor & Co. is Britain's last bell foundry, and said to be the largest in the world. This fortress-like complex of buildings, crowned by rust-red chimneys and elaborate bell towers, occupies a whole block of the town centre, assailing its neighbours with a din of roaring extractor fans, screaming machines and clanking bronze. But Loughborough's residents have grown so accustomed to the noise, so attached to it in fact, that they only complain when it unexpectedly ceases. The interior is straight out of Dickens. A labyrinth of cobwebbed corridors snakes through the building, connecting one soot-black workshop to another – forge to foundry, joinery shop to clapper shop – before ascending creaking staircases, past trapdoors and strong rooms, to a cluster of tiny garrets where sallow men hunch over lamplit drawing-boards sketching church towers.

John Taylor & Co.'s origins can be traced back to the fourteenth century, when a distinguished *belyeter* called Johannes de Stafford established a foundry in nearby Leicester. His business

passed through five families over the next four hundred years until Robert Taylor, the son of a Bedfordshire grocer, took it over in the 1780s. The Taylors first came to Loughborough in 1839 to cast a set of bells for the local church. They intended to leave once the work was complete but decided that the town, which was conveniently located at the heart of a prosperous industrial region in the very centre of the country, was as good a place as any to set up base. In 1859 Robert Taylor's grandsons bought a cherry orchard just outside town and built a large modern foundry which, apart from a few later Victorian additions, is almost unchanged today.7

The company reached its apogee in the second half of the nineteenth century when, thanks to the rapid growth of Britain's cities and a great boom in church-building, it could barely cope with demand. At its peak in the 1870s and '80s the firm was casting dozens of large bells every year for high-profile customers all over the country. It was also supplying churches, cathedrals, post offices, train stations, factories, town halls, universities, government buildings and carillons (enormous musical instruments in which sets of bells are played with a keyboard) around the world, its bells ringing out in Mumbai, Singapore, Sydney, Christchurch and all over the United States. But of all its many splendid Victorian creations, Taylor's crowning achievement was a monumental sixteen-tonne bell for St Paul's Cathedral in London.

It was a daunting commission. Bells of that size (including the first two iterations of Big Ben) had an irritating habit

of cracking. In November 1881, after four months of ruinously expensive pre-production, Taylor's successfully cast the bell. The bigger challenge, however, was getting the massive object to London. The foundry considered using trains, boats, even a squad of elephants, but ultimately opted for two steamtraction engines.

'Great Paul' left Loughborough on the afternoon of 11 May 1882 to a fanfare of church bells. It trundled through Leicestershire, Northamptonshire, Bedfordshire and Hertfordshire, roads and bridges literally buckling as it went. Crowds assembled at every village, cheering it on, following it for miles, eager to play their part in its historic odyssey. The bell reached St Paul's Cathedral after an eleven-day voyage, where it was wheeled up a ramp greased with whale fat and hoisted through the partially dismantled dome. Great Paul finally rang out on 3 June 1882, saluting hundreds of thousands of delighted Londoners.8

* * *

All crafts require patience, but none demands quite so much of it as bell-founding. Most major projects have lead times of many months if not years, especially given the complex demands of planning permissions and fundraising. The Whitechapel Bell Foundry spent some forty-three years negotiating with St Albans Cathedral before proceeding to casting in 2010.9 The manufacturing process likewise can't be hurried. Every properly made bell

is unique, its every component designed and built from scratch. Once Taylor's agree the size of a bell with a client, the bellmaster climbs the narrow stairs to the pattern room and looks for a corresponding 'strickle': a curved piece of metal that outlines the internal and external profile of every bell the company has ever cast. He uses the strickle as a guide to construct two moulds: one for the inside of the bell, called a 'core'; the other for the outside, called a 'cope'. The core is made from bricks and chemically bonded sand; the cope is made from loam, sand, goat's hair and horse manure. Both are built layer by layer over a period of weeks. Once complete, the moulds are dried, filled, dried again, then coated in mud. The founder adds the inscription, pushing one letter-stamp after another into its soft surfaces. The

moulds are then doused and sprinkled with plumbago (a form of graphite), which gives every completed bell its shiny finish.10

Then comes casting day.

The foreman arrives early in the morning to load the crucible with bell metal (77 per cent copper, 23 per cent tin) and fire up the furnace. While it heats up (it takes two or three hours for half a tonne of bronze to reach 1200 °C), the foundry staff prepare for the casting. They place the core inside the cope then clamp them both firmly to a base plate. This is critically important. When molten metal meets water it produces a great deal of steam. If the mould is moist or the clamps aren't secure, the apparatus could explode like a bomb. The mould is then buried, as moulds always used to be, in the sand of the foundry floor. When the alloy reaches the correct temperature, it is transferred to a ladle then carefully poured into the mould. 'A few years ago we successfully cast a 7.5-tonne bell for a building in Canberra, Australia,' one employee proudly recalls. 'It was massive: fifteen times larger than your standard church bell; the weight of five or six family cars. I don't think we walked out of work that afternoon. We floated.'

All Taylor bells are left to cool slowly in the ground (the Canberra bell was still too hot to touch almost three weeks after casting). The company believes this prolonged, subterranean process alters the molecular structure of the metal and improves its acoustic properties. When finally cool enough to handle, the object is exhumed from the soil, loaded on to a trolley, heaved out of the foundry, past the company's own bell tower and

through a pair of burgundy gates into 'the Works': a cavernous complex of workshops that rains with angle-grinder sparks and throbs with heavy metal music. The trolley rattles past hundreds of other bells, which slump on the floor like pumpkins in a field, then squeaks to a stop at the fettling station. Here the bell's surfaces are carefully cleaned and scoured, their excess metal (called 'flash') removed with an electric grinder. It takes about a day to fettle a medium-sized bell.

Elsewhere in the factory dozens of other craftsmen are at work. A wiry blacksmith, his face stained with soot-sweat, toils at a forge, pounding an iron clapper into shape. In the Joinery Shop, whose walls are lined with fading posters of Leicester City's league triumph in 2016, a team of carpenters refine a set of headstocks (which hold the bells) and wheels (which enable them to be swung for ringing). In the Fabrication Shop, a copiously tattooed man builds a steel frame to support a peal of bells and their accessories. But the most mysterious room in the complex lies at the western end of the Works, behind tall blue doors plastered with warning signs. It is the Tuning Shop: the place where these large lumps of metal are transformed into harmonious instruments; a place whose processes are so impalpable, so alchemical, that most of Taylor's own employees don't understand them.

'Be careful,' said the foreman as I strapped on my safety googles at the threshold, 'it's all Mr Miyagi in there.'

* * *

A struck bell emits as many as a hundred different frequencies, which wash over each other like rolling water. But the main sound we hear is dominated by five principal notes, called 'partials' or 'overtones', each corresponding to a different part of the bell. The most obvious is the 'strike note' (often called the 'fundamental' or 'prime'), which determines the bell's pitch. This pitch is made up of four other notes that enrich and complicate its overall profile. A minor third above the fundamental is the 'tierce', which gives a bell its sad, haunting character; a perfect fifth above the fundamental is the 'quint', which strengthens and stabilises its sound; and an octave above the fundamental is the 'nominal', whose high

frequency amplifies its range and power. The deepest partial, a full octave below the fundamental, is the aptly-named 'hum', which resonates long after the others have faded into silence.11

For most of history, bell founders didn't know how to harmonise these various partials (which is why so many old bells sound out of tune).12 But in the second half of the nineteenth century the Taylor family became determined to succeed where their counterparts had failed. They studied some of Europe's finest bells, collaborated with musicologists and campanologists, experimented with different bell profiles, redesigned most of their strickles, and ultimately invested in expensive new equipment. The Taylors established a modern tuning workshop within their factory where a dedicated team measured the frequencies of every partial with calibrated tuning forks. By 1895 or 1896 the company was producing the first perfectly tuned bells of the modern era.

John Taylor's current master tuner is a sixty-three-year-old Gujarati called Girdar Vadhukar, who, after training as an engineer in his native India, settled in Britain in the 1980s. He spent three years at the foundry from 1986, nineteen years at Herbert Morris (until that great local business collapsed), then returned to Taylor's in 2010. He is now one of the only people in the world who can do this rarefied job – though he considers it more of a calling. Vadhukar is a devout Hindu. His messy desk, which is piled with clothes, papers and equipment (as well as a faded photograph of him embracing David Cameron), is crowned by an image of a cross-legged Shiva encircled by the sun. 'These English people, they ring bells for fun,' he tells me. 'But I always

say to them: "Bells aren't fun. They are sacred. They are going to places of worship. They are going to temples."' Whenever he starts work on a new bell he grabs a piece of chalk and writes *'Om Namah Shivaya'* ('Oh greetings to the Auspicious One') on the metal, soliciting good fortune for the difficult work ahead.

Vadhukar flips today's bell upside down and hoists it onto a ten-foot-high vertical boring lathe, which he has decorated with mantras and crucifixes. He clears a space on his desk, unfolds an old silver laptop, plugs in a microphone, places it near the bell, then strikes the bell with a clapper. An ugly sound jangles around the workshop.

He cringes. 'Lots of work to do, lots of work.'

Vadhukar leans into the computer screen, eyes narrowed, scrutinising the numbers in front of him:

Hum	550.53 Hz
Fundamental	1308.65 Hz
Tierce	1314.13 Hz
Quint	1776.68 Hz
Nominal	1790.95 Hz

He wants to increase the frequency of the nominal to 2038 Hz and bring the other four partials into harmony with it. The only way to do that is to remove metal from the inside of the bell, effectively changing the shape and size of its interior. This, as you might imagine, is rather difficult. 'I need to know exactly where on the bell I make the cut and exactly how much

to remove,' he explains. 'If I cut even a little too much, I'll ruin the bell. We would have to break it up and make it all over again.' Vadhukar's job is further complicated by the fact that every partial is interconnected: change one and you change them all. 'It's like 3D chess,' I say, foolishly. 'No,' he replies, wagging his finger, 'it's like 5D chess.'

After a brief prayer, Vadhukar straps on ear protectors and a face-mask, then switches on the lathe. The bell starts to rotate. Vadhukar leans over the revolving object, his left arm on the lathe rail, his right on the control wheel. With two deft movements he lowers the cutting tool into the bell's mouth and slides it over to the internal wall. The blade meets the metal in a spray of sparks, skinning the grey surface, throwing ribbons of glistening bronze all around. Vadhukar moves the cutting tool slowly up the bell – crown to shoulder, shoulder to waist, waist to sound bow – removing a few millimetres from every area. He switches off the machine, strikes the bell with the clapper, then heads to the laptop.

'Getting there,' he whispers, looking at the read-out.

He does this many more times over the next few hours: laptop to lathe, lathe to laptop; striking, listening, cutting.

As the bell approaches its target pitch, the cuts become smaller and more precise. Sometimes Vadhukar removes only fractions of a millimetre from a narrow band of material, making near imperceptible alterations. I ask him how he knows where to cut. 'Experience,' he says. 'It's eye, ear and hand together. And a lot of patience.'

After seven hours of breakless work, Vadhukar strikes the bell a final time. It emits a rich and harmonious sound, a sign the partials are all correct.

Before finishing, he removes a felt-tip pen from his breast pocket and writes a little character inside the crown of the bell. 'No one will ever see this,' he smiles mischievously, 'and if they do, they don't know what it means.' It is an ॐ ('Om'): the Sanskrit symbol for sacred sound.

* * *

The business model of bell-founding has one fatal flaw: its products are too long-lasting. Unlike many modern manufactured objects, whose deliberately short lifespans impel consumers to keep buying replacements, a well-made bell can last centuries. Bell-founders have therefore always depended for their business on large-scale church building and restoration programmes. But with religion in decline, imperial markets drying up and bells no longer serving urgent needs, the pool of clients is shrinking rapidly. In 1900 there were fourteen major bell foundries in Britain, three of them within just a mile of each other in the City of London. But as the century advanced, these mighty firms fell like horses at the Grand National: two disappeared in 1905, another in 1908, a fourth in 1916, five more in the recessions of the 1920s, two at the outbreak of the Second World War, and another – the great Gillett & Johnston of Croydon – in 1957. Only two major British bell foundries survived into the

twenty-first century: John Taylor in Loughborough, and the Whitechapel Bell Foundry in East London.13

The closure of Whitechapel is widely known and deeply controversial. It was until recently the oldest manufacturing firm in the country, having operated continuously since 1570. But this distinguished old business, which cast the Liberty Bell in Philadelphia in 1752 and Big Ben in 1858, finally closed its doors in June 2017, its owners selling the site to property developers who planned to convert the foundry into a boutique hotel. The transaction triggered a public outcry that became a drag-anchor on the proposed redevelopment. Eight years on the building still sits empty, its equipment rusting, its yellow façades begrimed with graffiti.

John Taylor & Co. narrowly escaped a similar fate. Drowning in debt, the company slumped into administration in 2009. When the factory was put up for sale, eleven property developers made immediate offers. But before any of them could be accepted, a tenacious group of bell enthusiasts managed to persuade English Heritage – the organisation then responsible for protecting the country's historic architecture – to grant the foundry a Grade II* listing, prohibiting any alterations to its structure. All eleven developers withdrew overnight. The campaigners then pooled their savings and bought the site themselves, with the aim of keeping the bell foundry operational. They are now constructing a major museum and visitor centre at the complex, in the hope of making Loughborough a global hub for bell-founding crafts.

In some ways it already is. Bells have been an essential part of Loughborough's identity for at least a century. The town's main First World War memorial is not a statue, cross or cenotaph but an ornate 47-bell carillon tower, which a hundred years later remains its most famous monument. The shopping centre (Carillon Court), cricket team (Loughborough Carillon C. C.) and at least four of its pubs are named after the instrument. If you wander the streets of Loughborough, as I have many times, you can't help but hear the sound of bells. They yap and gossip over the rooftops, barely pausing to catch their breath. The tower at Taylor's is said to house the most pealed bells in the world.

But the Taylor legacy extends far beyond the limits of Loughborough. No other traditional workshop has left so extensive a mark on our country. From Truro to Aberdeen, Aberdyfi to Hull, Taylor's bells resound all over the United Kingdom. It's said that 20 million Britons – almost a third of our total population – hear one every day. Bells may have lost most of their former social functions, but they continue to play a role in British life. They are an unmistakable and essential part of this country's soundscape, the aural equivalent of pub signs and phone boxes. Moreover, they still have the ability to bind communities together, to voice their hopes and fears, to chronicle their triumphs and disasters, to project their unique personalities into the world.

CRAFTLAND

Alconbury, in Huntingdonshire, is a quintessentially English village. It has an old, pretty centre surrounded by a new (and less pretty) perimeter, a church, a pub, a minimart, an underused cricket pitch and an overused doctor's surgery. It even has the same street names as other villages across the country, some of which (the Maltings, Mill Road) refer to the trades once practised there. But one thing sets this otherwise unremarkable place apart: Alconbury's bells haven't been heard for almost sixty years.

The parish church of St Peter and St Paul has six bells in total: five were made by Taylor's in the nineteenth century; the other, dating back to 1673, may have been cast in Bell Lane just around the corner. The bells themselves were in good condition but their beams and headstocks had become so riddled with woodworm that they were too treacherous to touch, let alone ring. The church had been trying to raise funds to restore them for decades but hadn't come close to reaching its target until, in 2020, a local schoolteacher unexpectedly bequeathed the full amount for just that purpose. The parishioners hired Taylor's to clean and tune the bells, replace the headstocks and clappers, and build an indestructible steel frame for the tower.

The company collected the bells on a wet December day and returned them almost three years later. Their homecoming was big local news, with posters going up across the village. One afternoon in October a hundred residents (far more than normally attend church) hastened through the lanes to pay their respects to the objects, which were lined

up in the nave like holy relics. The vicar conducted a short service, thanking all involved in the restoration, then blessed each bell in turn. The service concluded, as customary, with the Lord's Prayer.

Installation began the following day. Two young bell-hangers, both enthusiastic change-ringers, worked with two local volunteers to hoist five tonnes of bells and fittings into the tower with ropes and pulleys. They spent two whole days securing them in the belfry, the hollow steeple rising above them, the autumn wind whistling through the quatrefoils, the riffle of pigeon wings echoing all around.

A few weeks later the long-awaited moment arrives. Six local bell-ringers – three men and three women – gather at the base of the tower, forming a circle on its floral carpet. Each one grabs a rope, flexing their fingers around its sally. They stand in silence for three or four minutes, waiting for the vicar to give the order.

'Look to!' one of them finally shouts. 'Treble's going . . . She's gone!'

The ringers lurch into action, one pulling after another, round and round in bouncing circles. The bells peal above their heads, tumbling down a succession of descending scales. The sound hurtles out of the belfry windows, over the old yews in the churchyard, past the vicarage, then out into the unsuspecting High Street, where passers-by stop to listen.

For the first time in living memory, they can hear their village speaking.

CHAPTER EIGHT

The Alphabetician

Lettercutting
Cambridge

I'll never forget the day I first arrived in Cambridge. Like others from modest backgrounds, I felt like a gawky imposter. As I stumbled through courtyards towards my purported bedroom, I wondered if it had all been a clerical mistake – and whether I'd soon be driving back through Bedfordshire to a life I'd never deserved to leave behind. But then, at the end of a panelled corridor on the northern fringes of Emmanuel College, something stopped me in my tracks. Just above a door-frame, in white letters on a black background, I saw my name.

I could scarcely believe my eyes. I'd never seen it in a public place before, let alone somewhere so old and distinguished. I reached up to touch it, as if to confirm I wasn't hallucinating. As I ran my hand across the sign, I noticed the letters stood slightly proud of the surface. Leaning in, I saw, subtle but undeniable, the imperfect trace of a brushstroke. My name had been painted by hand.

In the twenty-five years I've been at the University since then, Cambridge's dwindling team of signwriters has painted my name outside rooms and offices all over the city, as they have for thousands of other students and staff. If you stroll through the courts and cloisters in September, just before the start of the new academic year, you'll spot two old men in overalls tottering from staircase to staircase with tins of enamel paint. It continues to surprise me that even now, in the twenty-first century, many colleges still hire someone with a paintbrush to write their students' names by hand.

Signwriters belong to a large family of craftspeople who specialise in making inscriptions – a group that also includes typographers, heralds, engravers, glassworkers and neon benders, to name just a few. Theirs might seem like niche vocations, especially in our screen-saturated world, but their influence is widespread and enduring. In some ways they do much the same thing as bells: they *speak* on behalf of their communities – though of course with words rather than sounds. They too have spent centuries honing civic space and shaping collective identity, mediating people's relationships with their

surroundings, telling them where to go, what to buy, and in the case of memorials, how to feel. Next time you're heading to the office, doing the school run or walking through town to meet a friend, take a closer look around you. You'll see their work everywhere – painted over shop windows, gilded into façades, carved into gravestones, glazed above front doors.

We rarely pause to appreciate these inscriptions, let alone the anonymous people who made them. But they are a truly vernacular artform, capable of enriching even workaday places. A great number of British pubs, for instance, are still crowned by actual paintings that swing and creak above our heads, each one made by a specialist sign artist. Many ostensibly plain establishments, even in deprived neighbourhoods, boast truly Byzantine interiors: mirrors gilded with cursive script, door panels etched with words, walls swarming with beverage brands encrusted across hand-cut glass. I've been to pubs where even the toilet signs are typographic masterpieces.1

The most ancient text-based craft is probably lettercutting – the carving of inscriptions into stone and other durable materials. It emerged four or five thousand years ago with the first Western civilisations, leaving its mark on cuneiform tablets, Egyptian columns and classical monuments. Lettercutters were tasked with work of momentous importance: telling their people's stories, celebrating their gods, preserving memories for the benefit of their successors. Without them much of their culture – and our history – would be lost to us. Their number has declined over the last century, a process hastened

by computerised cutting and digital imaging. But their old craft lives on, as beautiful and valuable as ever. After all, if something *really* matters to us, and if we genuinely want it to endure, we still can't do much better than carving it into stone.

* * *

Cambridge crawls with carvings. If you walk the half-mile route from the Fitzwilliam Museum to the Round Church – to my mind, the most beautiful stretch of road in urban England – you'll see inscriptions in every direction: there are plaques, tombstones, war memorials, founders' names, lists of benefactors and more coats of arms than you can throw a sceptre at. If you stroll into Gonville and Caius College you might even spot a memorial to Stephen Hawking which I played a small part in commissioning. Etched into an easily overlooked flagstone are the words: 'Remember to look up at the stars and not down at your feet'. I've always found it far too beautiful to obey.

The city's many inscriptions span the eight-hundred-year history of the University, the work of generations of masons and engravers whose names are lost to time. Today, however, almost all lettercutting is conducted just outside the city centre, in a converted Victorian schoolhouse next to a bus stop. At first glance the property looks suspiciously suburban: it has a gravel driveway, a garage around the back, and a vase of fresh flowers in the window. But just to the left of that window,

partially hidden by a hedge, a slate sign hangs on the wall. It reads 'David Kindersley's Workshop'.2

David Kindersley was one of the most influential typographers and lettercutters of the twentieth century (he preferred the moniker 'alphabetician'). His vast body of work has touched the eyes of many millions of Britons without them ever realising. In the 1950s, dismayed by the signs on Britain's nascent motorway network, he created an alternative typeface of capital letters with subtle serifs. Kindersley never quite ousted the 'Motorway' typeface – it's still in use today – but his elegant, legible design was picked up by town councils and local planning authorities for commercial and residential use. It now graces street signs all over the country. There's a very good chance that you grew up – as I did – on a road spelled out by David Kindersley's letters.

Like most typographers of his and later generations, Kindersley traced his artisanal ancestry back to the artist Eric Gill, to whom he was apprenticed in the 1930s. Gill, who ran a quasi-medieval workshop in the Chilterns, and created the abidingly

popular Perpetua and Gill Sans typefaces, taught Kindersley the principles of good design, the value of practical education, and the many virtues of working in a team of craftsmen.3 Kindersley established his own business near Cambridge in 1945 when he was thirty, profiting from the glut of memorials that followed the Second World War. Like Gill before him, he took on many apprentices over the next few decades, some of whom became fine stone-carvers in their own right. None, however, changed his life quite like a young girl from the Netherlands.

In 1975 Lida Lopes Cardozo was a graphic design student at the Royal Academy of Fine Arts in The Hague. When she heard the renowned David Kindersley was attending a typography conference in Warsaw she resolved to go there and meet him. In the early autumn, when she was just twenty-one, Lida crossed the Iron Curtain to Poland, enduring multiple strip-searches along the way. She eventually found Kindersley at the accompanying exhibition, approached the tall, bearded figure and nervously introduced herself. He mumbled a few words of acknowledgement, barely looking up from the display. Lida, however, was overwhelmed. 'I met my destiny,' she later wrote. 'I was in love with him at first sight. His work and all he stood for. I felt like an idling powerful engine pushing into gear, thrusting forward. Everything became crystal clear as the beauty of life revealed itself.'4

Lida asked to be his apprentice. He said no. She wrote to him repeatedly thereafter, sending rubbings of her work, but never received a response. A few months later she sailed to England to force herself on the great man once again. They met

in a Cambridge pub, where her nerves brought on a nosebleed. Again she asked to work for him. Again he turned her down. In 1976 she followed Kindersley to another conference, this time at the University of Reading, putting up posters all over the campus that read: 'Dutch Girl Looking For English Lettercutting Workshop'. Realising the young woman was never going to leave him alone, Kindersley at last relented, offering her a brief spell of work experience in Cambridge.

Lida moved to England that autumn, renting a small room near the workshop. She spent eight weeks doing little else than preparing slides for Kindersley's imminent tour of America. But a few days before he was due to leave, she received what she had been waiting for: a one-to-one lettercutting tutorial from her hero. Kindersley told her how to grip the chisel and swing the hammer, the best angle at which to strike the stone, and the correct sequence in which to carve a character. He then bade the girl farewell, fully expecting never to see her again. But when he returned to England in December, Lida was waiting at the airport with a smile carved across her face. He finally agreed to take her on as an apprentice, at a salary of £15 per week.

It wasn't easy being the only woman, not to mention the only foreigner, in such a traditional workshop. But a bond soon grew between the apprentice and her master. As the months rolled on and her talent began to manifest itself, Lida's initially unrequited feelings were increasingly shared by her mentor. Though David was more than forty years her senior – and married with children – the two alphabeticians tumbled into

an unlikely romance. They married in 1987, had three children together, and worked as business partners until David's health began to decline in the early 1990s. One day in September 1994 he put down his pencil a final time and entrusted his workshop to his wife. He entered a coma the following February, taking his last breath in Lida's arms.5

* * *

When you visit the Cardozo Kindersley studio, the first thing you notice – even before you cross the threshold – is the sound. The usual noises of a twenty-first-century workplace are absent. There are no humming computers or bleating phones, no chugging printers or clacking keyboards. Mobile phones are prohibited in the workshop – as is everything else with a screen. If an email arrives from a client it is printed out in a separate room then annotated by hand. This is a defiantly analogue place, fighting an increasingly lonely rearguard action against mechanisation and digitisation. The sounds one does hear are exclusively pre-industrial: the tock of tapping mallets, the clink of chisels on stone, the meandering scratch of pencils on heavy-gauge paper. If you had wandered into a stone-carving workshop in ancient Rome, it would have sounded just the same.

To enter the building isn't just to travel back in time but to fall into what looks like a cryptographer's subconscious. Every surface is crammed with letters, which dance around the room in myriad typefaces. The walls are covered with alphabets, the

tables scattered with wax rubbings, the easels stuck with Post-it notes that read like truncated riddles: 'Yes platinum sun, no rabbit, no gold star'. The workshop is surrounded by stone tablets whose carvings enshrine the creed of the craft. There's a dictionary definition: '*Manufacture*: to make, originally by hand, now usu. by machinery: to produce unintelligently in quantity'. There's a small roundel on which John Donne's famous line about letters mingling souls turns into green stems that blossom into white roses. And directly above Lida's easel there's a phrase that has become the company's unofficial credo: 'Hasten Slowly'.

This workshop has always been the manifestation of an ideal. 'It is in many ways like a temple,' wrote David Kindersley, 'a place of rethinking and dedication'.6 Its members are expected to leave their egos at the door, to work in collective anonymity, to become more than the sum of their parts. All six lettercutters – including Lida, two of her sons and her daughter-in-law – collaborate on every stage of every project, pooling their imaginative resources, combining their physical energy. Theirs is a community without hierarchies – a place where distinctions between old and young, master and apprentice, employer and employee, are subordinated to the act of creation. This ethos is best expressed by the sign in front of the building: it was carved not by David or Lida but by an unnamed apprentice, with the help of his more experienced colleagues.

The Kindersley workshop is an old-fashioned business even by craft standards, its principles originating in a very different age. But it rests on a broader philosophy of work that many

of us might benefit from following. The company reminds us that career success isn't just about climbing the greasy pole or winning the rat race, being promoted above one's peers or earning more than one's neighbours. It can also be about surrendering oneself to one's vocation, subsuming one's ambitions to the collective good, and committing oneself to excellence for its own sake. Those principles aren't of course unique to craftspeople but they are shared by everyone described in this book. All of them would agree with Ralph Waldo Emerson: 'the reward of a thing well done, is to have done it'.⁷

The Kindersley workshop is grounded in the sharing rather than hoarding of knowledge, its transmission from master to apprentice. That model has governed traditional trades since at least the Middle Ages, being the main mechanism by which skills have been passed from one generation to the next. But where most craft businesses have reluctantly given up on apprenticeships (which are still woefully lacking in government support), Lida's commitment has never wavered. She has trained thirty or forty people since she started, providing three years of intensive, hands-on instruction to each of them. Every apprenticeship is a major commitment of time and money that isn't guaranteed to pay off: only half of Lida's incumbents have continued as masons. But she knows the future of her craft depends on them:

I believe in progress and human evolution: in the fine-tuning of energy. However wonderful you are at lettercutting, you die. And then, if you haven't trained someone,

it needs to start from the beginning again. I like the idea of an upward spiral. You hand it on, then the next person refines it and makes it better. When I look at my son and my daughter-in-law I can see they're already ahead of me. They'll push it forward. If they don't, then what's the point?8

David Kindersley once wrote that the first principle any apprentice had to master was 'a complete change of attitude to time'.9 A lettercutter shouldn't dwell on the past or fixate on the future; she shouldn't worry about looming deadlines, and must never, *ever*, hurry to get something finished. She must exist solely in the here and now, focused exclusively on the task at hand.

Such mental discipline is facilitated by a routine that is all but carved into stone. The cutters start at 8.30 am. They work for exactly two hours (it is unwise to work without pause for longer), before taking a coffee break at 10.30, when for precisely fifteen minutes the whole team sits together around a large pine table. They work until lunch, which runs from 12.30 to 1.30, then continue for a further two hours, at which point they return to the table for a fifteen-minute tea break. Work ends every day at 5 pm sharp. All chores are shared. Every staff member, Lida included, takes turns to make the drinks, wash the cups, put out the bins and wind the grandfather clock. All employees clean the workshop together on Friday afternoon so it's neat for Monday morning, when the routine begins all over again.

* * *

CRAFTLAND

Every Kindersley project begins with drawing, though even this simple practice is governed by draconian rules. 'Anybody who cannot or will not sharpen a pencil properly,' proclaims one workshop maxim, 'had better take up another profession.' Purpose-built pencil-sharpeners are strictly forbidden, and use of them considered an abomination. All lettercutters are taught to prepare their pencils by hand, carving back the wood with a penknife, then sandpapering the point until it looks like a tapered spear. This bizarrely laborious process is of existential importance, as Lida explains in one of her many instructional texts:

1. Cutting a sharp point takes time and concentration – essential qualities for a lettercutter. It can be seen as a kind of meditation before we commit ourselves.

2. Drawing a letter requires a very fine point. A sharp point makes your thinking sharp and shows very clearly where your line is and therefore where your thinking is.

3. If you become frustrated, the tendency is to force what you are doing, rather than let the letters flow. If you put too much pressure on a delicate pencil, the point will break, which sends you the message that you are not in control. Stop. Step back and sharpen your pencil again. This will allow you to take control once more.

4. Sharpening a chisel is intimidating, but it is really much the same as sharpening a pencil. So this is good preparation for us.10

When the pencil is sharp the design process can begin. Lettercutters start by sketching an overall composition, including the size and layout of the text, before turning to the letterforms themselves. This is far less straightforward than one might imagine. Unlike the rest of us, traditional lettercutters rarely select their characters from a drop-down menu of fonts.11 Most modern typefaces are designed to be read on screens or paper, and can look insipid, even illegible, when carved into stone. Lida's lettercutters therefore need to design every character from scratch, in a form specifically suited to their destined material. If they lose their way or suffer a crisis of confidence they seek guidance from the work of their predecessors. Their lodestar – and the benchmark for almost all Western practitioners – is the inscription on Trajan's Column in Rome. These 148 Roman capitals are possessed of such flawless clarity, such immaculate proportions, that 2,000 years after being carved into marble they remain perpetually modern.12

Letters, as the great Roman alphabeticians understood, are complex organisms: they have arms, legs, feet, shoulders, waists, ears, even crotches. Lida is convinced they also have their own personalities: Y is 'even-tempered', S likes to 'show you up', and Z has 'a big ego and needs to be suppressed'.13 If these characters are poorly formed, or their anatomical

relationships are inharmonious, then, in Lida's view, they will never truly come to life. All letters, she insists, need to possess their own vital rhythm, animated by curved tension and internal purpose. She teaches her apprentices that a serif, for instance, isn't a pointless projection at the edge of a character; it must emanate from deep within the letter then curl almost imperceptibly back towards it – a graphic journey the workshop calls 'home-going'.

Proportion is likewise essential. All lettercutters use a 'ticker' – a scrap of paper inscribed with several hand-drawn lines – to ensure the thicks and thins of each letter are consistent, and the gaps between them are correct. 'However beautiful your letterforms are,' another workshop doctrine runs, 'it is the spacing that matters above all else. A beautiful letter is ruined

if spaced badly.'14 A lettercutter might finally choose to embellish the text with decorative features, including 'nesting' (where one letter sits inside another), 'ligatures' (where two letters share a stem) or 'flourishes' (where a letter concludes with a decorative swirl).

Good design doesn't always come from a conscious place. A few years ago Lida was working on a series of carvings for a local church, commissioned to commemorate a young vicar killed in a traffic accident. She had struggled for weeks on the project but hadn't come close to finding a satisfactory design. One day she was driving through Cambridge in a thunderstorm when her car ran out of petrol on a roundabout. While waiting to be rescued she grabbed some paper from her bag and started sketching. The ideas gushed straight out of her, one perfectly formed design after another. In the space of fifteen miraculous minutes, as rain battered the vehicle and the windows steamed up around her, Lida mapped out the entire project. She later

learned that her inspiration had arrived at the exact spot on which the vicar had lost his life.

Once they've agreed a design, Lida's team sources their stone. This isn't as simple as it used to be. A few centuries ago every community in Britain had its own quarry, which supplied local masons and gave each place its particular character. But over the last hundred years, as building stone has become less popular, more than 90 per cent of Britain's quarries have closed or been re-purposed. Lettercutters, like other stone-carvers, have been forced ever further afield, often travelling great distances to select their materials in person.

Every stone has its own character. Scottish granite is hard and unforgiving, its crystalline structures wreaking havoc with inscriptions. Yorkshire sandstone tends to crumble while being carved, blunting blades at alarming rates. Dorset limestone surprises masons with buried shells and fossils, which jerk chisels in unwanted directions. Green slate from the Lake District is tough on the shoulders but rings rather beautifully when struck. The finest stone of all is said to be Welsh slate: a smooth, durable substance that cuts crisply and legibly, the chisel leaving a brilliant white trace in its dark grey surfaces. 'If I had divine power, I would have laid down more,' Lida says. '[It] is the most wonderful material for cutting letters.'15

Every stone is sawed, hacked, shaved and sanded into shape, the design then drawn (always freehand, never traced) across the face.16 Every member of the workshop examines

the sketch carefully: searching for asymmetries, debating final adjustments, erasing and redrawing any imperfect forms. When all are completely satisfied with the design, the carving itself can begin.

The act of lettercutting itself is fraught with jeopardy, its practitioners facing the same pressure as a footballer in a penalty shootout or a gymnast mounting the rings. Unlike most crafts – indeed, most professions – lettercutters can't undo what they have done. If a blacksmith makes a mistake he can return his creation to the forge and re-shape it; if a basket-maker mangles her weave she can unpick the stakes and start again. But once a lettercutter makes a mark there is no going back: their error will endure forever, etched quite literally into stone. 'We are responsible for our creations like Frankenstein,' Lida says. 'If we create a monster it will haunt us to the grave.' This demands enormous reserves of mental and physical effort:

> Lettercutters must be disciplined, totally focused, attentive, precise and concentrated. They must give their complete being – body, mind and spirit – to creation. There are no re-tries at this stage. This is the point of commitment where the hand is declared. They lay themselves open for all to see – they cannot be cowards and must be perfectionists.17

Lida sits down at a stool and carefully arranges her tools: three sharp pencils, two tungsten-tipped chisels, a ruler, rubber, compass, hammer (often called a dummy) and ticker. In front

CRAFTLAND

of her, mounted almost vertically on an easel, is a large slab of Welsh slate the colour of a thundering sky.

She adjusts the position of her seat, squinting back at the window to check the light is falling over her right shoulder, then brushes the folds from her jumper. She picks up a chisel with her right hand, secures it in her palm with her fingers, and gently lifts the tip to the stone. She takes the dummy with her other hand, holding it just over the chisel. The 'incisive moment' has arrived – the moment she has spent the best part of a lifetime preparing for. Lida straightens her back, mutters something beneath her breath, then begins.

THE ALPHABETICIAN

Stone carving is often believed to be a violent business, all hammer blows and brute force. This is rarely true. Lettercutting, for its part, is a craft of gossamer delicacy. Chisels are grasped as gently as possible ('as if holding a butterfly you are about to release'), and dummies only ever used with soft, economical movements. If you grip your tools too firmly or swing them with too much energy, the chisel will skid uncontrollably across the surface or cleave the stone in two.

Lida cuts with almost mechanical rhythm. She taps the dummy up to 200 times per minute, each strike a little detonation that explodes into a cloud of dust. She works her way across the slate, slower than a snail, making tiny recalibrations as she goes: moving the chisel along the inscription, adjusting the cutting angle, rotating the bevel, constantly re-tooling for the task at hand. She makes dozens of unexplainable decisions every second, which after decades of practice are close to automatic.

I sit beside her as she works, barely daring to breathe and certainly too scared to talk. Lida has just started on a large serpentine S – said to be the single most difficult character to cut. She advances from serif to serif, carving a swirling V-shaped valley into the slate's surface. Over the next two hours a vital form, restless and voluptuous, comes alive beneath her hands, stretching in the light after millions of years buried within the stone.

'That'll do,' Lida says, glancing at the grandfather clock. 'Time for a coffee.'

CRAFTLAND

At a time when most letters are made by tapping keys or touchscreens, and when many of us go days without writing anything down on paper, it can be difficult to appreciate the time and care that goes into carving inscriptions. A sentence you or I could type in a couple of seconds might take even the most efficient lettercutter a full week to recreate in stone. On one visit to Lida's workshop I spotted a young cutter preparing to carve the R in 'GRATEFUL' into a commemorative plaque. I asked him how much work it would be to complete the character. Just over an hour later he handed me a scrap of paper.

It read '2,890 cuts'.

* * *

We are said to live in ephemeral times. Most products are manufactured at unfathomable speeds, spirited away to faraway shops, virtually obsolete by the time they reach the shelves. Many goods have such short lifespans that they are effectively created in order to be destroyed – used once, for a few bathetic moments, before being replaced by equally throw-away successors. Much of the world's culture now takes place in virtual rather than physical space, stored in remote server farms, rooted only in binary code, of unproven longevity.

Lettercutters belong to the resistance. They stand for materiality, for slowness, for permanence – immovable rocks in a gathering virtual storm. Like dry stone wallers and

bell-founders, their creations are made to outlast them and their patrons, often by many centuries. This necessitates a form of long-term thinking that, in Lida's view, is valuable in and of itself:

> In our fast-moving world we need these reference points; they give us assurance and stability from which we venture forth. We need them more than ever at present, as alienation is now so fashionable and dangerous. Words can shed some light in our world of darkness . . . Words cut in stone will outlive us and be part of future generations as well as part of our own and past generations.18

Since its establishment over seventy years ago, the Kindersley workshop has created thousands of 'reference points' across the British Isles. Its lettercutters have chipped away on city streets and village lanes, in crowded squares and lonely churchyards, making plaques and memorials, signs and headstones. Their work graces many of our country's most famous buildings: Westminster Abbey, St Paul's Cathedral, the National Gallery. It is so ubiquitous, so elegantly embedded in its surroundings, that most of us fail to recognise it. I confess, I must have passed the British Library sign thousands of times before realising it was theirs.

Their creations have etched beauty and poetry into our worlds, enhancing the public realm, enriching the lives of those who notice them. But they do more than just delight us. They chronicle – as they always have done – what society

most values: the things we've deemed sufficiently important to engrave into durable materials and preserve for a distant future. Most of us will of course never be able to afford their work. Theirs is an expensive business, as Lida is the first to admit. But this doesn't mean we don't understand it. The urge to carve words into stone isn't only shared by every one of us: it originates in our deepest emotions.

* * *

After a day in the workshop I cross the lane and enter the churchyard next door. The borders sway with autumn anemones, busy with spiders swaddling flies. As I eat my sandwich on a damp bench, I glance across the gravestones. Some have been swallowed by moss or strangled by ivy; others have lost definition, their words blurred by centuries of rain. Few are visited any longer, but each continues to tell its story: of Richard Layton, who died during the Christmas of 1885, having outlived both of his children; of Albert Hibbitt, who expired in 1921 after twenty-six years a widower; of Thirza Clark, who 'fell asleep in Jesus' at the age of forty-six. But they also tell the stories of the people who made them: the long-forgotten lettercutters who chiselled memories into stone.

As I head out of the churchyard, I notice another gravestone. It lies flat in the overgrown grass, next to a cluster of pink crocuses beneath a spindle tree. It is David Kindersley's

own grave, just metres away from his beloved workshop, within earshot of his successors' clinking tools. The stone, which I later learn was carved through a blur of tears by Lida herself, reads:

REMEMBER
DAVID GUY
BARNABAS
KINDERSLEY
SCULPTOR
LETTERCUTTER
INVENTOR
BORN 11 JUNE 1915
DIED 2 FEB 1995
HUSBAND OF LIDA HELENA
LOPES CARDOZO
LETTERCUTTER

Beneath the epitaph, around the base of the stone, Lida carved a line from the *Rubáiyát of Omar Khayyám* – part of a famous quatrain about the lasting power of words:

The Moving Finger writes; and, having writ,
Moves on: nor all thy Piety nor Wit
Shall lure it back to cancel half a Line,
Nor all thy Tears wash out a Word of it.19

Most of us go through life without ever thinking of carving words into stone. But when someone we love dies it invariably

becomes one of our first thoughts. Half a million gravestones are commissioned every year in the United Kingdom. You may have faced the difficult task yourself – of selecting the stone, agonising over the words, overseeing the installation, then returning regularly to clean it, replace the flowers and pay your respects. Most gravestones are now carved by machines rather than humans – the designs coordinated by computers, the letters seared into their surfaces by lasers and sandblasters. But the impulse is always the same: to mark someone's life with a physical object; to etch their name into a forgetful universe; to tell the future that a mother or father, son or daughter, husband or wife, once existed.

INDUSTRY

CHAPTER NINE

The Watchmaker's Apprentice

Watchmaking
Isle of Man

Roger had always been fascinated by how things worked. He spent most of his childhood building models in his bedroom, using anything his parents would let him touch. One day he was rummaging through a chest of drawers when he found the first watch he'd ever owned: a Timex his father had given him when he was eight, whose glow-in-the-dark numerals he used to stare at under the covers long after his parents thought he was asleep. Roger turned over the chrome-plated case and set to work with his screwdriver. But as he removed the back, the object exploded in

his hands – the mainspring bouncing out of the barrel, sending a dozen tiny components flying across the room. Roger groped through the deep-pile carpet in search of the parts but couldn't get the watch working again. He bundled the pieces back into the drawer, vowing never to tell his father what he'd done.

In the autumn of 1986, when he was sixteen years old, Roger enrolled in a clock and watch repair course at the now defunct Manchester School of Horology. Three years later he was working at a Tag Heuer service centre fitting straps, replacing batteries and making other simple repairs. That Christmas, however, he received a present that changed his life. His father had found in the local Waterstones a lavishly illustrated book about watchmaking written by George Daniels: a self-taught horologist who had risen from the London slums to become perhaps the greatest watchmaker in the world.1

Roger read the book obsessively. While his family watched the festive television, he was upstairs poring over Daniels' text; while his friends rung in the New Year he was at home studying its illustrations through a magnifying glass. After finishing the volume for a fourth time, Roger decided on a course of action: he would follow Daniels' example and make a watch of his own. In early 1990 he left his job, borrowed some money from his father to buy a lathe, and converted half of his parents' garage into a workshop. Ginger hair swept back from his forehead, white eyelashes flickering in the lamplight, Roger cut and polished into the night, oblivious to the passage of time. He finished the pocket watch eighteen months later. He

was so excited when it first ticked that he leapt up and down in the garage, punching the air in triumph.

There was one thing left to do. A few days later he caught a flight to the Isle of Man and drove to a grand house on the outskirts of Ramsey. He walked up its tree-lined driveway and knocked at the large front door. An old man in a waistcoat appeared at the threshold.

It was his hero – the great George Daniels.

Roger was led through the hallway, his trainers padding across the Persian rugs. When both were seated in the Georgian dining room, Daniels asked how he might be of service. Hands shaking with nerves, Roger withdrew the watch from his pocket and slid it across the mahogany table.

As Daniels examined the object, a grimace spread across his face. 'A good watch should never look "made",' he pronounced, in his gravelly baritone. 'It should look *created*. It should seem to have appeared from thin air, as if nature herself had willed it into being.' He advised the young man to abandon his crude creation and start all over again.

Roger was somehow emboldened. He hurried back to Bolton and immediately set to work on another watch, completing it in under a year. But with Daniels' words chiming reproachfully in his ears, he concluded that it wasn't nearly good enough. He decided to re-work the entire timepiece, replacing and refining every component. By this stage Roger's perfectionism had grown almost pathological. He sat at his bench for hour after hour, battling bouts of glandular fever, working until his eyes ached

and his fingers throbbed, determined to hone every part. There were long periods when he thought of nothing else, when even his dreams were haunted by chatons and pinions. Roger made the watch five times over before he was completely satisfied. In all, the project consumed five and a half years of his life.

Roger's second timepiece was far more advanced than his first. The case, which he'd shaped and soldered from a single bar of 18-carat gold, enclosed a silver face whose five dials displayed the seconds, minutes, hours, days, dates, months and leap-year cycles – every numeral incised and inked by hand. One dial even contained a moon-phase indicator, its rich blue backdrop glittering with golden stars. Behind the face lay the movement, an elaborate whirl of polished steel and frosted

brass that oscillated exactly 18,000 times per hour. On the back of the watch Roger inscribed the words 'R.W. Smith. Bolton, No. 2', his cursive characters dancing like windblown silk.

In the summer of 1997, nearly six years after his first visit, Roger returned to the Isle of Man. Again he walked down the driveway; again he knocked at the front door. This time, however, he wasn't received with the same warmth. Daniels, his hair slightly greyer, his movements slightly slower, barely acknowledged his guest. He shuffled back to his kitchen and buried himself in paperwork. Roger waited by his side until, at last, the great watchmaker put the lid back on his fountain pen and peered up from his documents. 'Right then,' he grunted, 'let's see what you've been up to all this time.' Daniels led Smith out of the house to a purpose-built workshop at the edge of the garden, using the journey to remind him how appalling his first effort had been. He sat at his bench and switched on the lamp. 'Come on then,' he growled, 'let's take a look.'

Daniels examined the watch carefully. He bent over the little object, scrutinising its surfaces, listening to its sounds, then turned the case over, opened the back and inspected the mechanism through an eyeglass. Roger stared at his deadpan face, searching for a glimmer of appreciation, yearning for a word of approval. He knew that a second failure would likely end his dreams of becoming a watchmaker. Time stretched between them, every second running painfully slow. Roger had all but given up hope when Daniels punctured the silence with a question.

CRAFTLAND

'Who made the escape wheel?' he asked.

'I did,' Roger muttered.

'Who made the balance?'

'I did,' Roger repeated.

'Who made the spring detent? The tourbillon cage? The dial? The hands?'

To every question Roger gave the same answer: he had made everything.

Daniels paused for a moment, absorbing the information, then broke into a toothy smile. 'Congratulations,' he beamed. 'You are now a watchmaker.'2

* * *

A mechanical watch is a chain reaction: an engine of wheels, levers and jewels that converts the invisible forces of the universe into a metronomic beat. Every watch is powered by a mainspring, a small metal helix that stores a hand-twist's worth of energy in its tight coils. As the component unwinds, it drives a series of gears whose wheels dance circles around each other, their tiny teeth relaying the spring's energy from one carefully ratioed part to the next. At the heart of the watch lies the all-important escapement: the intricate device that controls and divides the flow of energy into regular intervals, working together with a balance wheel to rotate an hour hand once a day, a minute hand once an hour, and a second hand once a minute.

The first portable watches appeared in sixteenth-century Germany, emerging from the workshops of Nuremberg and Augsburg. These early timepieces were elaborate and bulky contraptions, worn around necks rather than wrists, or hauled from place to place in leather purses. They often resembled drums, eggs, pomanders, skulls, insects encrusted with jewels. Status symbols more than anything else, their main purpose was to impress and delight. As timekeepers they were of limited use. They required near constant winding, and even then ran slow – time slipping through their sluggish hands as the day rolled on. And that was when they were functioning correctly. 'If you want to make trouble for yourself,' ran one German saying, 'take a wife, hit a cleric or buy a watch.'3

In the seventeenth and eighteenth centuries English horologists improved the technology considerably. A succession of enterprising watchmakers – among them Robert Hooke, Thomas Tompion, Daniel Quare, George Graham, John Harrison and

CRAFTLAND

Thomas Mudge – made one remarkable innovation after another, transforming a crackpot contraption into a precision instrument. Mudge's lever escapement, first invented in the 1750s, remains the basis of almost every mechanical watch to this day. As portable timepieces became more precise and more widespread, they began to reshape modern life: structuring people's days, governing social and economic patterns and, in aiding the calculation of distances travelled at sea, facilitating the nautical voyages that fuelled the Enlightenment and drove the Empire.4

By 1800 England led the world in watchmaking. It produced about 200,000 timepieces a year, roughly half of all global output. The industry was built on a network of interdependent craftspeople, linked together like the parts of a watch. The majority of movements were made in the village of Prescot in Lancashire (since absorbed by nearby Liverpool). Tiny components tinkled through the lanes from spring-maker to wheel-cutter, wire-drawer to escapement finisher, before being coached down to London on a rigorously maintained toll road.5 Most movements fetched up in Clerkenwell, the watchmaking capital of the world, where they were fitted with dials, slipped into cases, decorated, signed and sold. In the early 1800s more than 7,000 watchmakers lived and worked in the space of just a few urban blocks, their neighbourhood ticking and chiming like a giant clockwork machine.

Their supremacy didn't last. As the nineteenth century advanced – and so many other British industries prospered – the nation's watchmaking sector collapsed. Swiss and American manufacturers, spotting the huge commercial potential, built

large factories and assembly lines capable of producing standardised watches for a fraction of the price charged by their English counterparts. By 1862, Britain's market share had plummeted from 50 per cent to less than 7 per cent. By 1900 its decrepit watchmaking industry was on the verge of extinction.6 But instead of adapting and modernising, Britain's makers dug their heels in, stubbornly sticking with their outdated methods. 'The British simply missed their chance,' observed the great economic historian David Landes, 'and the more they lost ground, the more they consoled themselves with the thought that they were right and their customers wrong.'7

Britain's decline continued through the twentieth century, hastened by the rise of Asian manufacturers after the Second World War. The development of quartz and digital watches in the 1960s and '70s, which were powered by mass-produced electronic circuits rather than intricate mechanical systems, vanquished what remained of the industry's artisanal basis. As consumers embraced cheap, simple timepieces, tens of thousands of traditional watchmakers around the world – including in Switzerland and the United States – lost their jobs. A five-hundred-year-old artform had been destroyed by what George Daniels called 'damned electricians'.8

* * *

A few months after Roger Smith's triumphant visit to the Isle of Man, the phone rang in his parents' house. 'Roger!' his mother

shouted up the stairs, 'it's for you!' Her son emerged from his workshop – now located in the spare bedroom – and picked up the plastic receiver. The gravelly voice at the end of the line was instantly recognisable. George Daniels was working on a series of watches for the Swiss brand Omega but needed help completing the project. He asked if the young watchmaker might consider moving temporarily to the Isle of Man and becoming his first and only apprentice. Roger's ginger complexion flushed red, the excitement surging through his body, an impossible dream materialising around him on the landing. He said yes without hesitation. 'It isn't every day that God phones you up,' he later recalled.

A week later, Smith loaded his Ford Sierra with tools and caught the ferry to the Isle of Man, renting a small house near Daniels' home. The master and his apprentice made for an unlikely pair: Daniels, at seventy-two, was a suave and wealthy Londoner who only dressed in handmade suits, while Smith, just twenty-eight, was a shy Boltonian who wore the same cheap fleece every day. But the two men ran like clockwork, both powered by a relentless pursuit of perfection. They spent thousands of hours together in Daniels' workshop, polishing bridges, blueing screws, engine-turning dials. Once a week they took the Bentley for a spin to the local pub, where the young man bombarded his mentor with questions over fish and chips. At that point, in the late 1990s, these two horologists were pretty much all that remained of Britain's watchmaking industry.

When the Omega project was finally complete in 2001, Smith decided to go it alone. He converted his spare bedroom into yet another makeshift workshop and began working on his first self-designed wristwatches. It wasn't an easy transition. Wristwatch components need to be two or three times more accurate than those in pocket watches, each one having to meet tolerances of thousandths of a millimetre. He locked himself away from the world, pulling fourteen-hour shifts at the bench seven days a week, breaking only to visit Daniels, whose health was steadily declining. Smith struggled on for ten years, his small business barely generating enough revenue to cover the cost of materials. But slowly, methodically, he was changing the course of modern British watchmaking.

As his confidence grew and his skills developed, Smith's timepieces improved exponentially. Inspired by the eighteenth-century golden age of English horology, Smith created a small number of immaculate, often bespoke watches whose beauty and accuracy rivalled the best Swiss products. As his company crept into its second decade, recognition finally began to arrive. George Daniels' death in 2011 prompted a flurry of interest in the work of his only protégé. The orders flooded in, the honours piled up, and Smith's hitherto modest reputation began to grow. In 2023, his second pocket watch – the piece he'd made at his parents' home in Bolton in the 1990s – fetched $4.9 million at Phillips, New York: the most expensive English watch ever sold at auction.

Twenty-five years after temporarily relocating, Roger Smith still lives on the Isle of Man, operating from an unassuming

workshop surrounded by sheep. You could drive past the building hundreds of times without ever guessing that it was Britain's answer to Switzerland: birthplace of some of the world's most exclusive manufactured items. Thirteen highly skilled people work here, each of them selected and trained by Smith. Between them they make fewer than twenty handmade timepieces a year, each starting at £300,000.

* * *

Watchmaking is an art so precise, so technical, so manifold, that for a long time no one thought any single craftsman could fully master it. Even at the primitive beginnings of the industry five hundred years ago, most timepieces passed through the hands of multiple specialists. By the nineteenth century watchmaking was said to consist of thirty-four discrete trades, each an exacting occupation in its own right (you can find a list of them at the end of the book).9 After all, how could any one individual possess the skills required to design a mechanism, cut a wheel, make a spring, paint a dial, engrave an inscription, gild a case, cut a gemstone, shape a watch crystal, and so on? It was an all but impossible feat, like a musician mastering every instrument in an orchestra.

George Daniels was the first to prove everyone wrong when, in 1969 – the very year the quartz watch was born – he built a mechanical timepiece entirely by himself, making every part by hand. His undertaking had been born of necessity.

'Because there are no specialist manufacturers of components waiting to fulfil the ambitious watchmaker's demands he must satisfy them himself,' he wrote in *Watchmaking*. 'The only way to certain success is to become proficient in all the crafts represented in the complete watch and work without regard to so-called conventional hours of work.'10 Roger Smith obeyed the passage like a holy commandment. He spent the 1990s mastering each watchmaking trade in turn, teaching himself more than thirty different crafts: the equivalent of 224 years' worth of apprenticeships.11 And though now, a quarter of a century later, his watches are made by a team of specialists, the 'Daniels Method' is still followed to the letter.

Apart from the making of the springs, jewels and straps, Roger Smith's workshop conducts virtually all manufacturing processes on-site. The facility is built on a simple but now rather rare principle: raw materials enter one end and finished products exit the other. Bars and sheets of gold, steel, brass and beryllium are hauled into the machine room at the back of the building, where two CNC engineers – both named Andy – begin the process of cutting them into parts. Every watch contains hundreds of different components, most of them much smaller than a fingernail. The margins of error are so small that the area needs to be rigorously climate controlled. If the temperature creeps even a little above 20 °C, thermal expansion could misalign the cutting tools and produce faulty components.

Since its introduction to mainstream manufacturing in the 1950s, Computer Numerical Control (CNC) technology

has been widely associated with the loss of manual skills, since it automates work previously done by human machinists. Yet CNC engineers are among the most skilled people in Britain's manufacturing workforce. Roger Smith's technicians, who cut their teeth in the aerospace industry decades ago, don't simply insert a block of material and press 'start'. They interrogate every 3D drawing they receive from the designer (also called Andy), before devising a cutting strategy that governs the precise movements of every carbide-tipped tool. A single cut into a mainplate (the metal base to which all movements are attached) contains 7,340 lines of code, each of which has to be carefully scrutinised. The stakes are high. A mistake won't only destroy a component; it could damage the entire machine, which costs more than most people's homes.

Once the components have been machined and prepared, they pass through double doors to a spotless workshop. Seven watchmakers sit at their benches, squinting through loupes, fingers fussing in pools of lamplight. A girl is riding a horse in the paddock outside the window but none of them notices. Each is lost in their own miniature world, a mechanical universe smaller than the palm of a hand. The room is more monastery than workshop. There's no idle chat, no background music, no bleating phones – nothing to distract the workers from their task. Some of the watchmakers have even taken to wearing slippers so their footsteps won't disturb their colleagues.

A watchmaker will typically spend two months pre-building a watch, modifying parts and resolving problems as they arise.

When he's satisfied it's fully functional, he disassembles the whole device and builds it all over again, this time even more carefully, finishing and polishing every component in turn. It can take a proficient watchmaker three or four months to complete a single timepiece. The work demands vast quantities of tunnel-visioned tenacity. Some watchmakers won't take their eyes off a component for hours at a time, forgetting to eat lunch, oblivious to the call of their bladders. A momentary loss of concentration – a dropped jewel, a scratched wheel, a chipped pinion – can undo weeks of work.

The hands alone involve days of labour. Their steel forms are heat-treated, cleaned, filed, papered, then polished, re-polished and re-polished again, the watchmaker monitoring their progress through a microscope. Only then can he proceed with 'blueing' the components, a process that creates the rich violet colour long associated with traditional English timepieces. One of Smith's young watchmakers is readying himself for the task. He heats up a brass plate with a blow-torch then carefully places the little hand on the plate's surface. He leans close, the warmth on his face, staring at the component through an eyeglass, waiting for the metal to change colour. Slowly, as if by magic, its silver surface fades to yellow then blushes purple. As soon as it begins to turn blue, he snatches it off the plate, quenches it in fluid, and holds it up to the light.

'Fuck,' he whispers. The hand sat on the heat for half a second too long and is now the wrong hue.

He will have to start all over again.

The most exacting finish is 'black polishing' – a treatment so difficult that few manufacturers are brave or foolhardy enough to attempt it.12 Steel components are rubbed in abrasive pastes against tin blocks for days until their surfaces become so perfectly flat, so flawlessly shiny, that they turn into magical mirrors, appearing brilliantly white until the moment you look directly at them, when they suddenly flash black.

The technique cannot be mechanised. 'A machine can't black polish,' whispers another of Smith's watchmakers. 'There's too much feel involved. You can sense if the friction's changed, if the paste is getting hard, if the surface is catching, if something doesn't sound quite right. You're constantly having to vary your pressure and change your oscillation in response to the material. You can only do that through instinct and experience.'

Black polishing is a dark art – its principles poorly understood, its processes mysteriously erratic. Some components polish quickly and easily but others resist for days, wearing down their polishers before the polishers wear them down. 'Sometimes,' the watchmaker continues, still whispering, 'everyone in the workshop is struggling with it at the same time: all of us getting nowhere, going backwards, tearing our hair out.' I ask him what makes the process so unpredictable. 'That's the million-dollar question,' he smiles. 'Some think the polish is affected by the warmth and humidity in the room,

but no one really knows. Maybe the sun's been shining through the windows at the wrong angle. Maybe a butterfly flapped its wings in Nepal.'

All the polish in the world won't make a watch work; and if it doesn't work, it isn't worth having. Smith's employees devote the majority of every build to the movement: the engine at the heart of the timepiece. The escapement alone isn't much larger than a five-pence piece but comprises twenty-two different components: a balance wheel, spring and staff; a roller table; a pallet frame and its arbor; an escape wheel and arbor; four weights and pins; five jewels, one of which is less than a third of a millimetre wide; and a guard pin that's virtually invisible to the naked eye. This little mechanism contains so many moving parts, so many dynamic dimensions, that it inevitably

throws up problems. Many watchmakers have lost months of their lives to the device, trapped in a miniature labyrinth. 'When things go wrong with an escapement, you're on your own,' one of them tells me. 'All the theory in the world won't help you – you can only rely on your wits.'

* * *

A watchmaker is crouched at a workbench by the window, the autumn drizzle tapping at the pane. He has just finished assembling a movement which for some reason is running slow – far below the target 18,000 oscillations per hour. He double-checks every part, re-finishes every tooth, then cleans every surface with a dust-blower.

No change.

Scratching his head with a rubber-gloved hand, he decides to run some tests. He straps the mechanism to an articulated arm and moves it through ten different positions: flipping it upside-down, swinging it from side to side, rotating it 360 degrees. He carefully monitors the beat as it goes, noticing it slowing at certain orientations. 'Aha!' he exclaims (under his breath). 'That's the bugger.'

One of the weights in the balance wheel is a fraction too heavy, slowing down the device.

He extracts the item with a pair of tweezers and begins removing material from its underside, shaving off a few

thousandths of a millimetre with an abrasive pad. He returns the weight to the balance and runs the test again.

Still slow.

He repeats the whole process again, then again, each time removing microscopic quantities of material, until, at last, the movement is at 18,000 vibrations per hour.

It takes him a week to bring it to time.

When the movement is fully functional and every part is immaculate, the rest of the timepiece is put together. The dial, which has been engine-turned on Victorian machines then grained and inked by hand, is fastened to the front of the mechanism. The watchmaker flips the object over and attaches three silver plaques to the bridge: the first reads 'R. W. Smith'; the second contains the unique identification number and completion date; the third contains the triskelion shield – the three-legged symbol of the Isle of Man that, to me at least, resembles a watch. He fits the hands and slips the object into the case, repeatedly checking for dust and debris.

'When all of that is done, after months of work, you can sit back and breathe,' the watchmaker tells me.

'And then the following morning you start on the next one.'

* * *

What is it that makes mechanical watches so seductive, so endlessly captivating? There is of course a beauty in precision

machinery – in the dance of cogs and wheels, in the kinetic logic of cause and effect. That allure has arguably only grown in the digital age, when so much technology is invisible to us, hidden in microchips and encoded in algorithms. But we're also drawn to these devices because of the ingenuity of their makers: their ability to transmute inanimate metal into perpetual motion, to create objects that, though small enough to strap to a wrist, can impose a kind of order on the universe. 'A watch is one of the most astonishing machines ever created,' Roger tells me. 'It works twenty-four hours a day, seven days a week, without electricity, without batteries, staying accurate to the second for generations. How can anyone think that isn't extraordinary?'

Watchmaking, like lettercutting, is an art as well as a craft. It demands not only technical skill but imaginative vision – a talent to see what others can't, to solve problems in novel ways, to create objects of striking originality and beauty. It's no surprise, then, that of all the craftspeople we've met in this book, Lida Kindersley and Roger Smith are probably the most celebrated. Like the most successful contemporary artists, their work is famous around the world, commanding high prices and long waiting lists. If you are one of the few people who can afford a Roger W. Smith watch, you'll need to wait five or six years for it to be delivered.

Smith's work is hardly representative of the wider British craft scene, but it offers one potential path forward for other traditional trades. In a world awash with mass-production,

handmade objects have cachet. Their uniqueness is an antidote to uniformity, their labour-intensive origins a guarantee of exclusivity. This is exactly why so many luxury brands use terms like 'crafted' or 'artisanal' to sell their goods. The marketing spiel might ring hollow, but it responds to a desire shared by most of us: to live, like preceding generations, among things made by human hands.

CHAPTER TEN

Cask Strength

Coopering
Bushmills, County Antrim

It is the first ceremony in a generation. The last survivors of the trade have travelled from all over the country to participate in the ancient ritual, which they know might be their last. Four barrel-chested men march across the yard to the workshop. One kindles a fire in an old iron bin, the others set to work on a 54-gallon cask. They refine the planks, truss them together, then place the vessel over the fire until the oak is soft enough to bend. When the cask is ready, the men form a line across the concrete and signal the start of proceedings. Each one strikes his driver against his side-axe, the steel ringing all

around. They toll in ominous unison, taunting, summoning, until a young man emerges from the workshop, his face green with fear. He knows what awaits him.

His master, and his master's master, lift him up by his haunches then lower him into the cask. He crouches into a foetal position, the staves scolding his arms, the steam burning his eyes. The men set to work with their hammers, landing one ferocious blow after another, driving down the hoops that bind the cask, tightening the vessel around its captive. Then they turn to the ritual humiliations, drenching their victim with refuse: a bucket of rancid beer slops, a tub of slimy yeast, a sack of bug-filled woodchips swept from the workshop floor.

The young man holds still, eyes shut, lips sealed, as the filth rises around him. His tormentors then flip the cask onto its side and roll it around the yard, shouting and swearing as they go. When the container finally sloshes to a halt, the initiate surfaces, slimy and fearful. He limps towards his master, who fires him on the spot. His five-year apprenticeship is over. He is now a journeyman cooper.1

* * *

Thirty miles north-west of Roger Smith's workshop, a mere paddle across the Irish Sea, lies the coast of Northern Ireland. On a clear day Roger can see it from the beach near his workshop, its hills rising dark and ragged over the waves. A few miles inland from Giant's Causeway, in a shallow valley of bright green fields,

CASK STRENGTH

a village straddles a fast-moving river. The roads here are austere and colourless, enlivened only by Unionist bunting. Its High Street has some cafés and charity shops, a Chinese takeaway and a minimart, but most of the premises are empty, boarded up long ago. And yet the village vibrates with tour buses, carrying excited visitors from all over the world.

Bushmills has long been identified with its trades. It's named after the many mills that once flanked the River Bush here, all of which closed decades ago. The village is now internationally famous for its whiskey, which it claims is the oldest in the world. A landowner received a licence to distil the spirit here all the way back in 1608, when the first English settlers were dropping anchor in North America and Shakespeare was finishing up *Coriolanus*.

Production ebbed and flowed over the next four centuries, the company surviving fires, famines and world wars, not to mention decades of sectarian conflict. It now dominates the village like a benign overlord. The distillery covers half of the settlement's total area and with a workforce of 140 is by far its largest single employer.2 It even seems to control the area's atmospheric conditions. On my first morning in Bushmills I am wandering through the market square when a gust of wind carries a strong smell up the High Street. Two elderly women are standing next to me, hands on shopping carts, waiting for the bus to Coleraine. Their nostrils widen. 'They're already fermenting, so they are,' one says. 'Aye,' says the other. 'Seems to get earlier every day.'

Production methods have barely changed since the seventeenth century. Irish-grown barley is germinated and dried (a

process known as malting), milled into grist, then mixed with heated water in large igloo-shaped containers called mash tuns. When all the starches have been converted into sugars, the resulting liquid (called 'wort') is pumped into fermentation tanks. Yeast devours the sugars for several days, producing alcohol and carbon dioxide, causing the fluid to bubble like a volcanic spring. The fermented product, now called 'wash', is transferred to a group of giant copper pot stills where the alcohols are evaporated, re-condensed and collected. Unlike in Scotland, where 'whisky' (there spelled without an 'e') is distilled twice, Bushmills is distilled three times – each process purifying and strengthening the spirit. The first distillate is called the 'low wines' (20–25% ABV) and the second, the 'feints' (50–55% ABV). During the third distillation, the prime cut of the distillate – the 'hearts' (80–85% ABV) – is separated from the 'heads' and 'tails', then diluted down to cask strength and matured in wood for at least three years before finally being blended, bottled and drunk.

Apart from the growing of the grain, every stage of the process takes place right here in Bushmills. I follow my nose to the distillery gates, turn left through a car park and collect my security pass from a window on which an optimistic employee has written 'Countdown to Christmas – 144 days'. I step through a turnstile into a large rambling complex of chimneys and warehouses, the place abuzz with forklift trucks and high-viz vests. It certainly doesn't look like a natural habitat for craft. But first impressions can be misleading. As we'll also see

in the next chapter, many crafts don't simply co-exist with but *depend* on industrial production.

As I make my way through the site, the hoppy aromas of fermenting barley give way to the stewed apples and Christmas puddings of distillation. I weave through a labyrinth of casks until I reach a large windowless building whose white walls are stained with black fungus: a common sight in distilleries around the world.

I have arrived at the cooperage.

* * *

'If you had never seen a cask,' the great American arborist William Bryant Logan once wrote, 'you might not believe in their existence.'³ These objects are so familiar that it's easy to forget how remarkable they are. They look like pot-bellied cylinders, their bulging sides corseted by rusty hoops. Their curves are somehow built from rectangles, which have been bent into submission then locked into place. Well-built casks are full of internal tension, straining inwards, outwards and against themselves all at once. This is what gives them their strength, allowing them to survive the rough and tumble of transit, impregnable to water and air. Their surfaces are stamped with symbols, like tattoos on the arms of a mariner: the marks of the men who made them, the goods they've contained, the ports they've passed through on their voyages around the world. Their mystique is only enhanced by their

names, some of which sound like monsters dreamed up by Tolkien. I'm not sure I'd want to bump into a Hogshead, a Kilderkin or a Puncheon down a dark alley.

Casks are ancient in origin. They were being made by the Egyptians many thousands of years ago. The Romans were the first to use them in industrial quantities, popularising them all over Europe. The appeal was obvious. Casks were air-tight, waterproof and rodent-resistant, could be rolled on and off boats with ease, were stronger than sacks and less frangible than clay amphorae. If they did break they could be repaired and re-used at little cost.

CASK STRENGTH

Long before decimalisation, casks helped standardise international measurements. A ship's 'tonnage' didn't originally refer to its weight but to the number of 210-gallon casks, known as 'tuns', it could carry. The containers came in many other shapes and sizes, all rigorously monitored and strictly enforced. Though we often use the terms 'cask' and 'barrel' interchangeably, a barrel is strictly speaking just one kind of cask, containing 36 gallons.

CAPACITIES ARE APPROXIMATE, VARYING BY REGION & CONTENTS

By the end of the Middle Ages the whole mercantile economy depended on casks. Without them many staples couldn't have been stored or preserved, let alone transported or traded. For the best part of a millennium these plump receptacles rolled around the country and sailed across the world, carrying grain and spices, tea and tobacco, gunpowder and alcohol, feeding sailors and whalers, enriching

merchants and smugglers, connecting producers and consumers in an endless chain of transactions. It is hard to imagine the development of modern capitalism, the rise of international trade, the discovery of the New World, indeed the emergence of Europe's empires without them. The cask is one of history's most consequential and long-lived inventions, its design almost unchanged in a millennium.4

Casks are made by coopers (from the Latin, *cupa*, for 'tub'), a people no less formidable than their creations. They were already throwing their weight around in the thirteenth century, when three of their number were imprisoned for price-fixing. The Worshipful Company of Coopers, founded in 1501, was for many years one of the most powerful livery companies in the City of London. The guild was constantly lobbying parliament, hunting imposters and taking the fight to any trade that threatened its supremacy. It spent much of the sixteenth century warring with the Brewers' Company, whose members had just started making their own casks in-house. After bribing the Lord Chancellor with half a butt of malmsey, the Lord Chief Justice with twenty gallons of sherry and the Speaker of the House with a ten-gallon runlet of sack, they came tantalisingly close to defeating their rivals – until they were outmanoeuvred at the last minute.5

As business boomed in the seventeenth and eighteenth centuries, the trade became increasingly specialised. 'Wet coopers' – arguably the most skilled practitioners – gravitated towards breweries and distilleries, making water-tight

containers for ales and spirits. 'Bond coopers' worked on the docks, supervising the loading and unloading of cargo, checking goods conformed to customs and excise regulations. 'Ship coopers' (often nicknamed 'jolly jack tars' and 'groggers') accompanied naval fleets, merchant vessels and whaling crews around the world, building and repairing casks at sea. 'White coopers', by contrast, rarely left their villages, making water buckets, washing bowls, butter churns and cheese tubs for their neighbours, who typically purchased them as newlyweds then cherished them for the rest of their lives.6

Coopers, in short, were everywhere. We could fill Wembley stadium twice over with Britons who've inherited their surnames from them. Just over a hundred years ago tens of thousands of coopers were operating around the British Isles. Six hundred were employed by one cooperage alone, in the great brewing town of Burton-on-Trent. But as the twentieth century advanced their wares were displaced by steel drums, tin cans, cardboard boxes and plastic tanks. Their decline accelerated in the middle of the century when the shipping industry, itself once transformed by casks, turned to pallets, forklift trucks, ship-to-shore cranes and of course shipping containers, each one 166 times larger than a standard barrel.

As demand dwindled, so did Britain's coopering industry. Brewery coopers were swept away by metal kegs in the 1950s and '60s: there are now only a couple left. Spirits coopers are likewise thin on the ground. In Northern Ireland, where

distilleries and shipyards once swarmed with such craftsmen, just two remain, in a single workshop.

They are father and son.

* * *

The men of the Kane family have been building casks at Bushmills for as long as anyone can remember. Alastair, now sixty-four, is a third-generation cooper at least. 'We probably go back much further than that', he says phlegmatically, 'but I never thought to ask.' His grandfather Jimmy entered the cooperage in 1935; his father Johnny followed him in 1951. The three men have together given 150 years of service to the company: the equivalent of a third of the firm's entire existence. When Alastair joined in 1976 there were ten coopers at Bushmills, who rowdily trussed him in when he qualified. But as the years rolled on and business models changed, his colleagues slowly disappeared. By 2007 Alastair was the only cooper left at Bushmills, and was convinced he would be the last. He spent the next nine years alone in the cooperage, accompanied only by memories of more convivial days. Everything changed in 2016 when his son Chris became the first newly qualified cooper on the island for nearly forty years (the last being his cousin Gordon in 1977) and took up a job at Bushmills. The two men have worked together ever since.7

For them, the Bushmills distillery isn't just a workplace but a second home. Both grew up within shouting distance of

the facility. Alastair's grandfather even knew how many steps it was from his front door to the cooperage. 'When I started,' Alastair recalls, 'my father, mother, grandfather, grandmother, my uncles, aunts and cousins were all working here, at different parts of the distillery.' Many formative experiences occurred on site. Long before strict security measures were introduced, he used to creep into the warehouses at night and play in the mountains of grain. He even caught his first fish – a finger-sized trout – in the distillery dam. Though times have changed, and his forefathers have gone, he and Chris continue to feel their presence. Both men use their predecessors' tools every day, some of them a hundred years old and worn down by successive Kane hands.

If a bad workman blames his tools, a good workman treasures them. Everyone in this book seems to love their tools like children: taking them everywhere, cradling them in their arms, repeatedly bringing the conversation back to them. Yet in almost every case their tools predate them – sometimes by more than a century. Why do so many craftspeople favour old tools? It isn't just nostalgia or sentimentality – though both may play their part. The truth is that many traditional tools aren't being made any more – or at least aren't being made very well. I have lost count of the number of people who've told me how steel used to be so much better, and how, despite all of our technological advances, tool-making has gone backwards. Alastair is one of them. He holds up his antique driver, a metal wedge used to force hoops over the staves. 'If I lost this I don't

know what I'd do,' he wistfully remarks. 'I guess I'd just have to give up the job.'

Over the last few years I have observed every step of the coopering process, examined every tool and technique, but still can't quite understand how they do it. The cooper's work seems to defy the laws of physics and flout the rules of common sense. Without screws and glues, machines and measures, these men build vessels that aren't only water-tight but precise units of measurement. Using methods that haven't changed for a millennium, relying on eye alone for guidance, they make joints accurate to thousandths of an inch and volumes accurate to a dram. It is this accuracy that ensures their creations can withstand enormous pressure, endure the wear and tear of international shipping, and, if looked after, outlast the people who make them.

Most casks are made from oak, above all because it is both water-tight and porous: the wood's dense grain structure prevents liquid from leaking, while its natural pores allow small quantities of oxygen to pass back and forth through its surfaces. The wood is extracted from mature trees that in some cases were planted centuries ago for precisely that purpose. It is dried outdoors for up to five years, the rain washing away its astringent tannins, airborne fungi converting the lignin into aromatic compounds.

The cooper's first and arguably most important job is to fashion the cask's staves – the slats that form the sides of the vessel. He uses a range of specialised tools – side-axes, drawknives, planers and jointers – to cut and shape (or 'list') these

CASK STRENGTH

components, creating a gently bulging profile that narrows at both ends. If the cooper deviates from the correct curvature by a single degree, or if one of his bevelled joints is off by a tiny fraction of an inch, the cask will lose all structural integrity.

When the staves are complete – a standard cask usually contains about thirty – they are flipped upright and placed side-by-side, slotting into an iron hoop to form a complete

circle. The cooper hammers another hoop over them to hold the cone-like structure together. The 'raised' cask is then placed inside a steaming chamber or put, wet, over a smouldering fire, until the wood is soft enough to bend without breaking. When the time is right the cask is pulled from the heat and worked on again. The cooper now needs to move quickly – before the timber hardens. As steam blurs his eyes and scalds his skin, he goes round and round in circles, hammering hoops over the cask, compressing the elements together until the staves begin to bend. Precision is once again essential. If the cooper doesn't force the staves close enough, liquid will be able to seep through the joints and render the resulting cask useless.

The vessel is thrown back over a fire of oak shavings to dry the still-damp timber and 'set' the curve of the staves. This stage of the process, called 'toasting' or 'charring', is an exacting craft in itself. Every second on the fire alters the interior surface irreversibly, producing different combinations of compounds, imparting various flavour profiles to its future contents. When the main structure of the vessel is complete, the cooper cleans, trims and levels the cask's surfaces, bores the bung hole and builds the lid, known as the 'head'. He concludes his work at the 'bick iron', a free-standing T-shaped anvil, where he fabricates a number of steel hoops, each with a different circumference depending on its position on the cask. With a swing of the hammer and a smash of the driver, he rams each one – bilge hoop, quarter hoop, chime hoop – into place, tightening his cask a final time.

Very few British coopers need to make casks from scratch

any more: most of their time is spent repairing them. The vessels are usually manufactured abroad, in Spain, France, Portugal and the United States. American coopers, most based in Kentucky, build two million bourbon barrels a year. In France, where wines have been aged in wooden *tonneaux* and *barriques* since the Middle Ages, vast state-owned forests are managed solely for their production. Bourbon, wine, sherry and port producers only use barrels once, after which they sell them to beverage producers who favour second-hand containers. This multi-billion-dollar market is a marvel of the global economy, a model of mutually beneficial recycling. British distilleries purchase hundreds of thousands of second-hand casks every year at around £200 per unit. They are permitted to use them three times to store whiskey and a fourth time to hold grain, before selling or repurposing the exhausted vessel.8

* * *

The Kanes begin work at 8 am, when they receive a delivery of second-hand casks in need of repair. All items are labelled with colour-coded tags. Green squares are reserved for bourbon barrels, red for sherry butts, purple for port pipes. The number of tags indicates how many 'fills' each vessel has received since it arrived on the property. Alastair and Chris start by assessing the condition of the casks, scrutinising every stave and joint. Many have cracked or splintered, some have dried out and degraded, others are riddled with woodworm. They are expected to repair

twenty-four casks a day between them, though they usually process more. They often have to leave the cooperage at short notice, hurrying to one of the company's maturation warehouses to find and fix a 'leaker' before hundreds of thousands of pounds' worth of product drips away. The two men work on as many as ten thousand casks a year. Alastair alone has probably repaired a quarter of a million during the course of his career.

To watch them work is to witness a brutal ballet. Father and son toil side-by-side, mirror-images of each other: both bald, both tattooed, both sporting the same felt aprons. They manoeuvre the casks with surprising grace, rolling them back and forth across the workshop floor, spinning them on the spot, flipping them skywards like compliant dance partners. They make their repairs at adjacent anvils, framed by a wall of esoteric instruments: thumpers, bung hammers, flails, flagging irons, pluckers, crozes. Their movements are repetitive and percussive. They swing their arms and strike their hammers a hundred times a minute, up and down, again and again, like two synchronised automata. Their routines are so well-rehearsed, so clearly choreographed, that a whole day can pass without them making eye contact, let alone exchanging words.

At one point Alastair notices that a cask – a forty-gallon American bourbon barrel he calls a 'Yankee' – needs a new end. He hammers the metal hoops off the staves and wedges a crowbar beneath the damaged head. As the cask creaks open, a blast of bourbon fumes escapes into the workshop.

Alastair inhales.

CASK STRENGTH

This is as close to the spirit as he'll ever get. Like his father before him, Alastair doesn't drink whiskey. 'It's a bad road to go down, being a drinker in a distillery,' he says. 'It's ruined many a man before us.'

He scours the workshop for a replacement head, using an old cooper's compass to calculate the required size, then slots it into place. He caulks the cask with a long stem of bulrush – still the best sealant around – spinning it into twine and wedging it into the narrow gap between the chime and the head. He finishes by chiselling a small cross into the wood. I ask him what it means.

'It's my signature,' he says. 'I sign every cask I work on. Every cooper does. Everyone has a different symbol. Sometimes, even now, a cask comes into the cooperage with my father's mark. Brings back memories.'

The cooper's techniques are ancient and unwritten, the trade still governed by the rule of thumb. Quarter hoops are separated from chime hoops not by some numerical measurement but by the width of a cooper's two stout fingers. If a cask needs a new bung hole, its correct location is identified not with a tape measure but with another piece of rush, which is cut to the length of the vessel then folded in half to indicate the centre point. To assess the condition of a cask, coopers play by ear. When a new group of vessels enters the workshop, the Kanes begin by striking them with a hammer, listening carefully as they go. If a cask is water-tight, it will emit a bright, tart crack. If it's 'slack' – if the wood has dried out or the staves

have separated – it will make a dull thud. A cask that passes scrutiny is said to be in 'sound condition'.

Craftspeople are often compared to their creations, just as dog-owners are likened to their pets. Coopers, like casks, tend to be stout, barrel-chested and battle-scarred. When Alastair started in the 1970s, before the introduction of health and safety measures, a cooper's life expectancy was fifty-six. Their work was so physical, their days so full of lugging and hammering, that their hearts often gave out before retirement. Alastair himself has a heart condition, like his father and grandfather before him. He and his son also suffer from impaired hearing, thanks to the daily racket. The trade leaves lasting marks on its practitioners' bodies. In the past, a cooper could be identified from his black fingers, caused by his repeated handling of charred wood. That is, of course, if he managed to keep them. Chris lost half of his thumb in an accident a few years ago. 'When people ask my working hours', he says, holding up his incomplete hand, 'I say Monday, Tuesday, Wednesday, Thursday – and a half day on Friday.'

After a full day of limb-swinging work, the Kanes lead me to their office: a sparse, ceilingless space cut from a corner of the cooperage. There are three fold-up chairs in the room but both men refuse to sit down. We talk for several hours about their occupation. But like so many craftsmen, the Kanes don't consider their work noteworthy. I ask how it feels to be the only people in Northern Ireland continuing such an ancient trade. 'I never think on it,' says Alastair. I ask Chris what it's like to be working alongside his father. 'It never enters my head,'

he responds. I ask Alastair whether he's enjoyed his near-fifty years as a cooper at Bushmills. 'It's what I've been doing – as simple as that,' he replies, without a trace of a smile. 'It's just a matter of accepting my fate.'

* * *

Across the car park, in a vast corrugated building that serves as one of the firm's twenty-seven maturation warehouses, another master craftsperson is at work. She traipses the aisles most mornings, dwarfed by walls of whiskey. She is looking for a specific group of casks that were set down years ago and are now scattered across the facility. When she finds an item on her list she removes the bung and uses a 'whiskey thief' – a tapered copper tube that looks like a torture device – to siphon off a small amount of golden liquid. She decants the fluid into bottles and labels them carefully. Sometimes she'll only lift samples from one cask; other times she'll extract more than a hundred. Some days she'll be sampling a cask for the very first time; other days she'll be returning to ones she's been checking on for years.

She wheels the samples through the drizzle to a small laboratory on the other side of the complex and subjects them to detailed analysis, assessing their colour, measuring their alcohol content, using a gas chromatographer to test the compounds within. If the whiskeys pass those tests, she carries them down the corridor to her office.

Alex Thomas is the Master Blender at Bushmills (and one

CRAFTLAND

of the only female blenders in the United Kingdom). She spent seventeen years preparing for the role but knows her education will last a lifetime. She prefers to conduct tastings in her office. The task demands absolute concentration and is therefore best done in a quiet, well-lit place with a flow of fresh air and minimal disturbance. She closes the door softly and lines up a dozen teardrop-shaped glasses on her desk.

Her stomach groans. Though it's almost noon, Alex hasn't had a thing to eat or drink since she woke: she can't if she's to do her job properly. She begins by 'nosing' the first glass, pushing her nostrils deep into the narrow rim (all tasting glasses taper upwards in order to compress and intensify the ascending aroma). She lifts the glass to her lips and takes a small sip, sloshing the whiskey back and forth across her tastebuds, drawing small quantities of air into her mouth to aerate the liquid. She picks up her pen and writes 'bitter' in a notepad. She adds a drop of water, tastes again, and writes 'milk chocolate, rose petals, almond'. She pauses for a moment, body still, eyes closed, then adds 'leather on the finish'.

Alex repeats the process many times over the next hour, diluting each sample down from cask strength (about 54% ABV) to about 20% ABV, charting its evolving characteristics. 'I'm asking the whiskey to tell me its story,' she says. 'It's like a person telling you where she grew up, where she went to school, when she got married – her journey through life. Every whiskey has its own secret backstory, its own hidden personality. My job is to discover it.' Alex's detective work is conducted exclusively

by eye, nose and tongue, all of which need to be highly trained, finely tuned and closely calibrated. Alex is convinced that those senses have been sharpened by her partial deafness, having lost almost all hearing in her left ear twenty years ago.

Once she has tasted and assessed every sample, Alex begins the difficult task of blending. She mixes the contents of different casks together in a range of combinations and ratios, aiming for a specific colour, alcohol content, balance of notes and aromatics. She must ensure that everything she blends – whether it's an Original, a Black Bush, or a 21-year-old single malt – conforms to the product's historic profile established by blenders before her. She has to ensure that every single bottle in a given range will taste exactly the same as every other, despite originating in hundreds of subtly different casks. She also has to reflect on the product's afterlife, and the people drinking it decades hence. I ask her if she considers this work a craft. 'Definitely,' she responds. 'I may not be using my hands, but I'm using my body – my senses – to create something with natural materials in time-honoured fashion. That's craft, isn't it?'

Challenging as her job is, Alex thinks it's far less important than the work of the cooperage. A cask, after all, isn't just a container but an ingredient. Irish law stipulates that whiskey must spend a minimum of three years in wooden casks for it to qualify as such. Strictly speaking there is no such thing as whiskey without a cask.

Casks are responsible for most of whiskey's aesthetic properties, giving colourless spirits their amber hue while enriching

their flavours significantly. Casks absorb the distillate's more volatile compounds, replacing them with sweeter notes derived both from their charred wooden interiors and the liquids they have previously contained. Bourbon barrels, for instance, generally impart vanillas, caramels and milk chocolates while oloroso butts produce notes of dried fruit and spiced honey.9 In the end, however, every cask is one of a kind. 'Each one is as unique as you and me,' says Alex. 'Even if the trees have been cut down in the same forest, the wood has been air-dried in the same location, the staves have been built by the same coopers, and the inside has been toasted for exactly the same length of time, they can still behave completely differently.'

Whiskey-making is not one craft but many. It is the sum total of dozens of different practices – cultivation, harvesting, brewing, distilling, coopering, maturing, blending, bottling, branding – that extend across years if not decades. And like so many other ancient products, it makes us wonder how we ever learned to do it in the first place. 'It's almost like a miracle,' says Alex. 'To think: who first decided to do a distillation? Who decided to put it into wood? Who decided to make the barrel the shape that it is so that the interactions and the oxidisation happen as they do?' She stops abruptly, lost in awe, then gathers herself again. 'It's just . . . it's a marvel to think how it all started, where we are now, and how that knowledge has been passed down from one blender to the next, one distiller to the next, one cooper to the next, for so many hundreds of years.'

CHAPTER ELEVEN

Steel City

Tool-making
Sheffield

If Detroit is the home of the motorcar and Bangalore the capital of call centres, then Sheffield is – or at least was – the city of steel. It has been a metalworking mecca since at least the Middle Ages, thanks largely to its natural resources. Sited at the confluence of five rivers and built – like Rome – across seven hills, the settlement was blessed with vast deposits of iron ore, limestone, coal and firewood, all of them critical for smelting. Its valleys gushed with steep-falling streams fuelled by Yorkshire's plentiful rain, each powering a string of mighty machines. Sheffield contributed to every major breakthrough

in the history of metal production, from crucible steel in the eighteenth century to stainless in the twentieth, forging the components which themselves forged modernity. The city's factories laid our railways, built our bridges, munitioned our armies and erected our skyscrapers. They even helped carry astronauts to the moon.

Before the emergence of these so-called 'heavy trades', Sheffield's metalworking industry centred on the manufacture of knives, blades and other cutting instruments. By the middle of the seventeenth century, 60 per cent of local men were cutlers and every other property in the town was a smithy. Forges were even more common than pubs, which accounted for a mere one in six or seven households.1 As the industry expanded and developed, the surrounding villages specialised in different products. Wadsley became associated with spring-knives, Stannington with razors, Ecclesfield with nails, Norton with scythes, Eckington with sickles, Shiregreen with forks and Hillsborough with sheep shears.2

Unlike the cotton trade of Lancashire, which relied on vast factory workforces, Sheffield's cutlery industry was built on a network of self-employed artisans: specialist sole traders who rented hole-in-the-wall workshops around communal yards, or toiled in tiny lean-tos at home. These men, known locally as 'little mesters', usually dedicated their lives to just one metalworking process. Every piece of Sheffield cutlery therefore passed through the hands of many craftsmen, making a Daedalian journey through the streets and gennels, from forger

to borer, hardener to temperer, grinder to hafter, assembler to polisher. Sheffield, as one Victorian journalist observed, was itself a giant workshop, 'which scatters its separate departments in different parts of the town, but still retains them all, like so many links in a chain'.3

It's tempting to romanticise the Sheffield system, to assume its artisanal methods were superior to those employed by the 'satanic mills' across the Pennines. But metalworking was a hard and unforgiving vocation, and no less fraught with personal peril. Grinders, who set and sharpened blades on rotating stones, fared the worst. Theirs was one of the most dangerous jobs in Victorian Britain – after coal miners, rat catchers and chimneysweeps. A brief lapse in concentration could cost them a finger, a hand, even a limb. Their work produced clouds of abrasive dust that lacerated and inflamed the lungs, making young men wheeze and cough like decrepit chain-smokers. In the first half of the nineteenth century, only 10 per cent of the town's fork-grinders reached the age of forty.4

By the middle of the century, Sheffield had vanquished its rivals within and beyond England to become the capital of the metalworking world. Its knives, saws, axes, scissors, files, planes and razors were used by millions of people all over the globe every day, the phrase 'Made in Sheffield' almost as ubiquitous as 'Made in China' is today. The town itself grew at a maniacal pace, turning riverbanks into mills and fields into factories, gobbling up nearby hamlets, engulfing the hills in coke and smoke. By the time George Orwell visited in the

CRAFTLAND

1930s, Sheffield – now officially a city – was a vulcanian metropolis, a Frankenstein's monster sired by steel:

> If at rare moments you stop smelling sulphur it is because you have begun smelling gas. Even the shallow river that runs through the town is usually bright yellow with some chemical or other. Once I halted in the street and counted the factory chimneys I could see; there were thirty-three of them, but there would have been far more if the air had not been obscured by smoke . . . Sometimes the drifts of smoke are rosy with sulphur, and serrated flames, like circular saws, squeeze themselves out from beneath the cowls of the foundry chimneys. Through the open doors of foundries you see fiery serpents of iron being hauled to and fro by redlit boys, and you hear the whizz and thump of steam hammers and the scream of the iron under the blow.5

Growth continued for a while, fuelled first by military contracts and then by the post-war boom. But as the economic bonds of the Empire weakened and international competition intensified, Sheffield lost its once invincible supremacy. In the 1950s and '60s cheaper Asian cutlery carved up its export markets. By the mid 1970s even British consumers were eating their dinners with implements made in Japan and Taiwan. But unlike their European counterparts (and just like the English watchmakers of the nineteenth century) Sheffield's cutlers refused to invest and innovate, clinging to their old artisanal methods. Their decline was swift and

thorough. Businesses folded, factories closed and thousands of skilled men were laid off by the only trade their families had ever known. Between 1960 and 2020, Sheffield's population of cutlers fell from over 12,000 to little more than a hundred.6

When I started this book a few years ago there was said to be just one little mester left in Sheffield: a self-employed grinder called Brian Alcock who had followed his father into the trade in the 1950s. Though well into his eighties, he still spent five days a week in his Dickensian workshop, nose quite literally to the grindstone, shaping and sharpening blades by hand. I first contacted him in the summer of 2023 and we agreed to meet.

I travelled to Sheffield a few weeks later and walked across the city to his workshop, but found the lights off and the door locked. I knocked: no response. I tried Brian's mobile: no answer.

As I peered through the window, I saw a phone number taped to the glass, its ink browned and blurred by condensation. I called it.

I was told that Brian had died a few days earlier.7

* * *

Modern Sheffield doesn't look very industrial. Its centre thrives with shops, cafés and museums, the leafy streets alive with international students. The city has spent the last three decades

pivoting towards the growth sectors of our own age: retail, leisure, tourism, education – and what its Council calls the 'cultural industries'. Sheffield is now packed with entertainment complexes, music venues, sports arenas, science parks and shopping centres, the first of which – Meadowhall – was built with deliberate symbolism on the site of an old steelworks. The only remotely industrial sounds you'll now hear in the city centre come from espresso machines.

But move north-west towards the river, where the streets are paved with actual grindstones, and the city's manufacturing heritage reveals itself. The area around Kelham Island is dominated by giant Victorian factories whose imposing walls are crowned by clock towers and crenellations. All of them have since been re-purposed for the post-industrial age – their sootstained façades rubbed clean, their cavernous interiors converted into flats and offices. The Samuel Osborn steel factory has become a vegan restaurant and events venue, Globe Works has been commandeered by hairdressers and tattooists, while Alfred Beckett's saw and file facility has been reincarnated as a varicose vein clinic. I enter a vast cutlery works by the river, now the largest food hall in the north of England, and order a coffee. As I wait for my drink to be prepared, I pick up a knife from the counter and turn it over in my hands. Its blade, thin and near weightless, is stamped with the phrase 'Made in China'.

Sandwiched between the shops and cafés of the city centre and the smart units of Kelham Island, a tatty neighbourhood scrambles down a steep slope. Its potholed streets are lined by

dilapidated workshops, their windows shattered, their doors boarded up. Some buildings have been taken over by squatters, others by drug addicts and sex workers. But the area is also home to a few dozen metalworking businesses that are just about clinging on. A small, stubborn population of steel fabricators, tool-makers, silver-platers and engravers arrives here every morning and leaves every afternoon, working long hours behind graffitied walls. Listen carefully as you pass their workshops and you'll hear the hiss of grinding wheels and the seismic thump of drop forges. This is how the rest of Sheffield used to sound.

One of the area's survivors has been making cutlery since the eighteenth century. John Adams, the current manager, inherited the firm from his father, who worked every day of the year except for Christmas, when he clocked off early for tea. John started helping his father at the age of seven, putting screws into decorator's scrapers after school. He officially entered the industry in the 1960s, when Sheffield's streets were so dense with smog that he sometimes couldn't see more than a few feet ahead of him. As other cutlers declined and disappeared, J. Adams Ltd expanded, absorbing other manufacturers and moving to ever larger premises in the city. John now employs twenty-three people at his Scotland Street site.

J. Adams is the only major company in Sheffield, if not Britain, that makes knives from start to finish on a single site. The company's output is extraordinary. It manufactures

hundreds of different bladed tools, which are then sold under different brand names. 'I'd wager that every adult in Britain has used something from this here factory,' John says. 'They just don't know it.' His face black with soot after a morning on the machines, John guides me through an overflowing stockroom. There are commando knives, butcher's blades, throwing axes, ship scrapers, cleavers, machetes, chicken choppers, grape clippers for French vignerons, swords for the British army, and odd-shaped knives made exclusively for oil rigs. I ask him why they're curved at the end. 'Ah!' he responds, clearly delighted I've noticed. 'So if they go stir-crazy, they can't stab each other.'

The factory looks like a sepia photograph of itself, its colours buried beneath decades of grease and grime. Antique machines whirr, crunch, whistle and bang. One of them has been running continuously since the nineteenth century. I walk through the changing room, where rusting lockers are inscribed with nicknames ('Piggy', 'Nosey', 'Jenny's Tat Parlour'), enter a storeroom full of antlers (destined, I presume, to become penknife handles), then emerge on the workshop floor, where women punch rivets into handles and linishers polish blades amid sparks. In the basement, mutton-chopped men hunch over grinders they've sat at for decades, while a foreman, whose right hand was flattened by a fly press decades ago, sits at a lamplit desk ticking off jobs on a greasy notepad. Only one thing here is truly up-to-date: pinned to the wall next to the polishing machines there's a laminated printout of Sheffield

United's upcoming fixtures. The team is known locally as 'The Blades'.

Though the company is busier than ever, its future is increasingly uncertain. John, now in his seventies, is at last thinking about retirement but hasn't yet finalised a succession plan. His eldest son has settled in London, his daughter in Bristol, and his youngest son – recently returned from the Royal Marines – isn't certain he wants to fill his shoes.

There are other challenges. Sheffield City Council wants to redevelop this shabby neighbourhood into a smart urban quarter, and so connect the city centre with Kelham Island. Over the last decade or so, a number of old workshops have been replaced by high-rise student accommodation. 'Once a month I get a letter from somebody wanting to buy us out,' John says, rubbing a three-fingered hand (the result of another workplace accident) through his grey hair. 'Last offer was £1.5 million. I chucked it straight in t' waste paper bin.' But despite the bravado, John knows the headwinds are building. When I ask if the company will still be here in ten years, he averts his eyes and changes the subject.

* * *

Just around the corner from J. Adams, behind a much-loved Indian restaurant, lies another traditional workshop. The building dates back to the 1930s, when small family-run

CRAFTLAND

factories proliferated in this affordable part of town. It bears the same architectural features as many of its neighbours, its four-square, red-brick façade pierced by long strips of windows. But unlike J. Adams, indeed unlike almost every other factory in the area, this building is in pristine condition. Its walls have been repointed, its windows replaced, its front door revitalised with scarlet paint. A stylish concrete sign on the front reads: 'Ernest Wright: Handmade Scissors and Shears'.

Sheffield once abounded with scissormen. At one point in the nineteenth century there were at least sixty manufacturers in the city, employing thousands of individual craftsmen. Ernest Wright is one of just two companies still operating.8 The firm was founded in 1902 and grew steadily thereafter, thriving in the consumer boom of the 1950s and '60s. By the 1970s it was one of the world's leading scissor brands, exporting its products all over the globe. Decline followed. The company made it through to the twenty-first century on the very thinnest of margins. In February 2018, Nick Wright – the fifth generation of the family to run the business – became so overwhelmed by the challenge that he ended his own life. Over a century after it was founded, Ernest Wright Ltd fell into administration.

The company was well on its way to becoming yet another casualty of Sheffield's de-industrial revolution when, just a few months after Nick Wright's death, two Dutch entrepreneurs caught a ferry from Rotterdam to Calais and drove across England to Sheffield. Paul Jacobs and Jan Bart Fanoy knew nothing about cutlery – they'd never even been to Sheffield before – but within

an hour of entering the workshop, they decided to save the company. They acquired the brand name, leased the premises, re-purchased the tools, re-hired the staff, then made a series of long overdue investments: creating a website, renovating the building, upgrading the machinery, and doing everything within their power to improve the quality of the products.9

A good pair of scissors is a marvel of razor-sharp synchronicity – a dance of two perfectly calibrated parts that touch but don't touch, meet but don't meet, their movements aligned to within a hair's breadth. No wonder scissormakers tend to scoff at their peers: most cutlers only make single blades, and rarely need to worry about a mechanism. Even a basic pair of scissors is bafflingly complex, with an arcane anatomy known only to the people who make them.

CRAFTLAND

The blades alone are possessed of an elaborate geometry. Each one curves along its length and twists across its width to form an almost imperceptible concavity, called 'the hollow', which ensures it only ever kisses its counterpart on the cutting edge.

Every pair of Ernest Wright scissors is the result of at least seventy discrete processes. High-carbon stainless steel is heated to 1200 °C and forged by thumping drop hammers into 'blanks': rough, unfinished scissor blade forms. The blanks are then inserted into an avocado-green machine – known in the workshop as 'The Viotto' after the Italian company that manufactured it – which carves the hollow into every blade. The parts are carried to the front of the workshop, where burr or scale (excess metal left by the forging process) is removed by grinders, sanding belts, scurf wheels and linishers that rotate thousands of times per minute, sending sparks across the room.

Ernest Wright's grinders work in a sequence established generations ago: inside bow, outside bow, shank, nail hole, blade. An accomplished practitioner can get through fifty items a day, provided he isn't interrupted. The blades are then hardened in a furnace so they're strong enough to take and keep an edge, re-heated to a lower temperature (a process called annealing or tempering) so they're soft enough to manipulate without snapping, 'rumbled' smooth by porcelain beads, dried in a warm bath of maize and walnuts, and burnished with Italian cotton until the polisher can see his

sweaty face in their surfaces. They're then passed to the other side of the workshop, where they are handed to the sorcerers of scissor-making.

'Putter-togetherers' ('putters' for short) have one of the most exacting jobs in British manufacturing. They are tasked with assembling every pair of scissors – connecting and aligning the two blades. In the past, a putter had to complete a five-year apprenticeship before he could attempt the main processes by himself, and several decades of practice if he wished to master them. But as Sheffield's scissor manufacturers folded, this rarefied trade came close to vanishing. A decade ago there were only two master practitioners left in Britain, both employed by Ernest Wright. Eric Stones and Cliff Denton had more than a hundred years of experience between them, having assembled more than 3 million pairs of scissors since the 1950s. When the company fell into administration in 2018, both men started planning their retirements. Jacobs persuaded them to stay on for a few more years and pass on their skills to a new generation.

The putter's bench runs along the south front of the factory, beneath a bank of casement windows overlooking a new block of student flats. Its carpeted surface is scattered with tools: a vice, a scissor-maker's anvil (called a 'stiddy'), a box of screws and washers, three subtly different hammers, and an amber pipette jar that wouldn't look out of place in a West End apothecary. A rack of scissor blades waits on the window ledge, the polished steel glinting in the morning

sun. Neil Wilson is one of Ernest Wright's four new putters, a position that once exceeded his wildest ambitions. As a young grinder in the factory he often gazed over at the bench, watching Eric and Cliff with awe. When Jacobs asked if he wanted to succeed them, he didn't know how to respond. 'It took me two years to agree to start the training,' he says bashfully. 'I was too intimidated to sit at the putter's chair. I didn't feel worthy of it.'

What makes the putter's job so difficult? Surely he just screws two blades together and moves on to the next pair? 'If only it were that simple,' laughs Neil. A correctly assembled pair of scissors needs its bows aligned, its blades curved, its points crossing, the cutting tension firm and even all the way along. If these relationships are even marginally off, the scissors won't cut properly. Such subtle calibrations can only be made by hand, once the two halves have been joined. To complicate matters further, every pair of blades is unique: a singular problem demanding a bespoke solution. 'No machine can handle that,' Neil says. 'You can't even learn it in a book.' Like so many craftspeople, the putter's practice is grounded in tacit knowledge, his work guided by sight, touch, instinct, experience.

Neil's first job of the morning is a pair of seven-inch kitchen scissors, a design that hasn't changed for over a hundred years. After screwing the parts together and fixing them with a rivet setter, he shuts his eyes and begins his assessment. He opens and closes the scissors several times,

listening to the rasp of the blades, feeling the friction change from pinch to point. He then lifts the tool to the window and inspects it from every angle, studying the line of light between the blades.

Neil knows what to do.

He loosens the screw by a degree, pipettes a drop of oil into the joint, then places the tool on the stiddy. He taps the blades with a soft-faced hammer, beating a gentle inward curve into their profiles. Every strike is carefully judged: if the hammer lands in the wrong place, or with too much force, he could damage the scissors irreparably.

He examines them again, squinting into the sunlight, then returns them to the stiddy. He taps once more, then opens and closes the scissors again.

After two minutes of consuming concentration, he tests the tool on a piece of cotton: it slices through the fabric effortlessly. It is now ready to be sharpened, re-polished and engraved, before being dispatched into the world.

'A pair of scissors,' Eric Gill once wrote, 'no less than a cathedral or a symphony, is evidence of what we hold good and therefore lovely, and owes its being to love.'10 Gill's observation might sound idealistic: most scissors today are mundane, mass-produced objects, often cheaper than a cup of coffee. Many of us own unknown numbers of them: the hair-trimmers in the bathroom, the nail-clippers in the bedside table, the ones with the orange plastic handles we lost years ago. We use them with little affection, complaining when they inevitably malfunction,

replacing them when they invariably get mislaid. But anyone who has used a really good pair of scissors knows that it's the difference between trudging through mud and gliding across ice.

* * *

I cross the River Don, duck under a railway bridge, loop past a wall graffitied with knives (not, I think, in reference to the cutlery trade), and climb a steep road to the north. At the top of the hill a complex of derelict buildings is surrounded by a deserted car park. This used to be the British headquarters of Stanley Tools, makers of the eponymous Stanley knife, until it was abandoned in 2008. The empty offices hosted 'Zombie Apocalypse' parties for much of the next decade, their cobwebbed corridors stalked by teenagers with paintball guns. The buildings were abandoned again in 2021 after a major fire tore through the site.

I step over the charred detritus, slip through the safety hoardings, and peer through the revolving doors into what was once the lobby. A large mural of the world still adorns the back wall, its Formica surfaces emblazoned with the slogan: 'STANLEY: TOOL BOX OF THE WORLD'. Looking closer, I notice Britain has fallen off the map.

Sheffield's metalworking industry is a fraction of its former size and will never regain its supremacy, but there is life in it yet. Some firms are still operating; a few, as we've seen, are

thriving; and occasionally – *very* occasionally – new ones are appearing.

One of the city's youngest manufacturing businesses is in fact right next door to the burnt-out Stanley factory – the future emerging from the ashes of the past. Its one-storey concrete premises has none of its neighbour's grandeur. There are no shiny lobbies, no confident signage, no maps of global markets – just two simple words hastily spray-painted above the door: 'Wood Tools'.

Robin Wood is one of Britain's most celebrated craftsmen – though not generally associated with heavy industry. In 1995 he took over a dilapidated forge in Edale, turning exquisite wooden bowls on a foot-powered lathe and establishing a programme of popular spoon-carving courses in the village hall. Within five years, largely due to his teaching, Britain's spoon-carving population grew from barely a dozen to several thousand. But this burgeoning community soon exceeded the supply of available tools. With no one in Britain making the high-quality carving knives and axes required for the craft, its practitioners were wholly dependent on the work of a handful of Swedish blacksmiths – all of whom were approaching retirement.

Wood resolved to satisfy the demand he had unwittingly helped create. One day in 2014 he drove across the Pennines to Sheffield and asked a tool-maker to copy his Swedish implements. The experiment was a failure. After dozens of deficient prototypes, Wood concluded that Sheffield itself was to blame. 'This is the one problem with the "little mester" system,'

he explains, stirring a homemade stew with a hand-whittled spoon. 'Sheffield's skills have always been dispersed across the city, divided up between different specialists who only do one thing really well.'

Wood decided to relocate to the city of steel and produce his own tools within the system. In 2015 he established 'Wood Tools' with his daughter JoJo, also an accomplished wood carver, and two years later bought the building next to the Stanley headquarters.

Wood now spends his days driving around the city hauling components from one specialist to the next. His popular hook knife – a curved cutting tool designed specifically for spoon-carving – passes through half a dozen local workshops. It starts life in a grey business park in Rotherham, just outside Sheffield, where a family-run laser-cutting firm prepares the blanks. Wood takes the blanks to J. Adams Ltd where specialist grinders refine their surfaces, then drives them across the river and up the hill to his workshop. He shapes the blanks in an old fly press given to him by Sheffield's last penknife-maker, using bespoke tooling made by elderly machinists in a workshop behind the station. The blades go to yet another company for hardening and tempering, J. Adams again for rumbling, then return to Wood's workshop to be sharpened, polished and fitted with handles. If this sounds absurdly inefficient, Wood won't have it any other way. 'This is Sheffield!' he exclaims, his eyes gleaming through his thick spectacles. 'This is how things have always been done here.'

CRAFTLAND

Wood's latest product is a fifteen-inch steel carving axe. He and JoJo have spent the best part of eight years designing it. They studied a host of old English axes, made a number of clay maquettes, then forged dozens of prototype heads, refining their curves and adjusting their weight distribution until the profile was just right. They devoted years of thought just to the handles, whose undulating contours are designed to dovetail seamlessly with their users. Progress was hindered by a dearth of local knowledge. Though Sheffield was once famed for its axes, there was no one left in the city who knew how to make them. And yet the laborious process transformed Wood's attitude to his trade. 'I used to think that craft was all about one-off pieces, that that was where the real care and effort lay,' he says. 'But when you start manufacturing hundreds or thousands of a single product, you need to think even more carefully about every detail.'

On the last day of my final trip to Sheffield, I travel to the south-west of the city to see Wood complete his first batch of axe-heads in his new grinding shop. As I pass through the archway and walk across the yard, something feels strangely familiar. By the time I reach the door I know exactly where I am: this is Brian Alcock's old workshop, the one I'd tried and failed to access earlier in the year.

Robin took on the lease after Brian's death, determined to save the little mester's lair from redevelopment.

I glance over to the window: the note is still stuck to the glass, its numbers now almost illegible.

STEEL CITY

The room itself is dark and dungeony, full of dangling blades and jangling chains. At its centre lie two giant grinding troughs, virtually unchanged since the nineteenth century, surrounded by craggy drifts of grit and filth. Robin is straddling one of them like a motorbike, head down, arms forward, pressing a blade against a revolving grindstone. As the steel touches the stone, sparks shoot across the room, lighting up the dark brick walls, flashing diabolically in Wood's glasses.

When he is finished, I help him carry several boxes of heads out of the workshop. As I hump them across the yard, Wood says to me: 'You, my friend, are holding the first axes made in Sheffield for thirty years.'

* * *

Why did Sheffield decline as a manufacturing power, after a thousand years of often incontestable supremacy? It certainly wasn't helped by a collapsing Empire, a surge of international competition and its own failures to adapt and invest. But it was also undermined by a more fundamental change: by the fact that we simply don't use our hands as much as our ancestors did.

Sheffield's cutlers specialised in creating high-quality tools for a nation of doers and makers. But as Britain shifted from a producer society to a consumer society, demand for their wares inevitably dwindled. How many of us nowadays spend our time scything crops and shearing sheep, tailoring clothes

and cobbling shoes? When was the last time you felled a tree, slaughtered an animal or shaved with a cut-throat razor? All of us admittedly own some tools: the utensils in the kitchen drawer, the contents of a rarely opened toolbox. But most of them are so cheap and shoddy that if they see anything like regular use they'll need to be replaced over and over again.

'You can learn everything about a society from its tools,' John Adams once told me, waving a blade in front of his soot-stained face. 'A single knife can tell you what someone did for a living and how they did it. But above all it'll tell you if they took pride in their work.'

A good, handmade tool – whether it's a forged knife or a pair of precision-assembled scissors – has the power to elevate everyday life. It can spark joy when you least expect it, turning mundane routines into rituals, tiresome chores into pleasures. Every time you feel its reassuring weight in your palms, its honed surfaces on your fingertips, you can't help but take more care in what you're doing. Before you know it, without even realising it, you are transformed into a craftsperson yourself, as if the object has quietly passed the spirit of creation from its maker on to you.

CHAPTER TWELVE

The Crucible

Urban Crafts
London

London is everything all at once. While many British places are known for a single industry, this city has excelled in all of them. Rising from the marshy banks of the Thames 2,000 years ago, this small Roman outpost slowly evolved into the commercial capital of the world – a giant, smoggy metropolis where vast quantities of goods were made, bought and sold. As the city grew larger and more complex, every neighbourhood developed its own expertise. Two hundred years ago you could have wandered through dozens of self-contained craft communities – from the goldsmiths of Hatton Garden to the watchmakers of Clerkenwell, the tanners of Bermondsey to the

brewers of Southwark, the printers of Fleet Street to the silkweavers of Spitalfields – without having to leave the city.

Most of London's traditional craft clusters have now been displaced by modern industries, but they too tend to gather in specific districts. The City is home to one of the largest financial and professional service sectors in the world, accounting for 10 per cent of the UK's entire economy. The streets around Silicon Roundabout in Shoreditch teem with coders, software developers and tech entrepreneurs. Soho and Fitzrovia are dominated by media companies, their smart Georgian interiors transformed into editing suites and recording studios. Head north to King's Cross and you'll see institutes and laboratories in every direction – part of the city's self-proclaimed 'Knowledge Quarter'.

London's supremacy is built not just on size but diversity. It functions like a giant magnet, attracting people from all over the world and forcing them to live side-by-side. Two-thirds of its nearly ten million inhabitants hail from other places; half weren't even born in the United Kingdom. The city is marked by constant churn and exchange, fertilised by jostling cultures and generations. This is why, even now, London remains a crucible of craft. Thousands of practitioners work here, sustaining hundreds of global traditions, collaborating and experimenting every day. More than anywhere else in Britain, London embodies the past, present and future of craft: a place where ancient artforms are being preserved, and new ones born.

* * *

The North London streets are quiet this morning, apart from the distant drone of a rubbish truck. I stroll past rows of neat suburban houses, dodging wheelie bins as I go. The driveways are empty, the net curtains closed. Most residents are presumably at work, no doubt clicking through emails somewhere in the city. Theirs is an unflashy neighbourhood – the kind so many of us live in. And yet these ordinary streets are home to a truly extraordinary craft, hiding everywhere in plain sight. At the front of almost every house, fastened to the frame of almost every door, hangs a small, finger-sized tube. It contains a scroll of parchment on which a scribe has written in exquisite calligraphy a sacred passage from the Hebrew Bible. The object,

called a *mezuzah*, is an emblem of the Jewish faith, and every observant Jew must have one on their home.1

Jews have been living in London for a thousand years, though for most of that time their economic prospects were limited. Forbidden from owning land, excluded from guilds and prohibited from respectable professions, they were long confined to the less regulated sectors of finance, commerce and small retail. By the beginning of the twentieth century the majority of British Jews – particularly the impoverished Ashkenazim fleeing pogroms in Eastern Europe – were tailors, cobblers and cabinetmakers. Most lived and worked in the East End of London, around Whitechapel and Spitalfields. Over time they left this crowded district, dispersing along commuter routes to the suburbs. Poorer Jews generally moved east to Hackney, West Ham and Ilford, while wealthier families migrated north to Finchley, Edgware and Golders Green.

I turn left into Golders Green Road, a bus-thronged thoroughfare full of shops and shoppers. Most of the stores here cater to the Jewish population, still one of the largest in Europe: there's a family bakery famed for its challah and bagels, a bookshop called 'Torah Treasures', a kosher supermarket whose aisles glisten with London Cure smoked salmon and locally pickled cucumbers. Half-way along the parade, between a dry cleaner called 'Posh Wash' and a smart children's clothier, stands a small signless shop. I double-check the address in my notes, then step inside, pausing as the door chime tinkles into silence. I browse the Judaica on display until a young staff

member surfaces from behind the counter. Before I have a chance to introduce myself, he directs me down the corridor.

At the back of the premises, behind the till, behind the stockroom, behind the place where they keep the mops and brooms, a white door bears a scratched sign. It reads: 'B. Benarroch: Certified Scribe'.

What lies beyond wouldn't look out of place in the Warsaw Ghetto: a small windowless room, one wall piled high with scrolls, the others with leather-bound books. The shelves are scattered with knives and scalpels, calf's tails and ram's horns, spools of dried intestines, and a bundle of feathers that tremble in the rattling breath of a table fan. The only tidy spot in the workshop is a green cutting mat on an old wooden desk. A small, round man with a white beard and a black skullcap bends over a scroll, his face mere inches from the parchment.

Bernard Benarroch has a duty of existential importance. As a sofer, he writes and preserves sacred Jewish texts: from marriage contracts (*ketubah*) and divorce documents (*get*) to *mezuzot* and scriptural scrolls (*sefer Torah*). His predecessors have been doing the same thing for more than 2,000 years: the earliest examples of their work can be found in the Dead Sea Scrolls. Benarroch learned the craft from his father – *ish mi pi'ish,* as the Jews say: 'from one man's mouth to another'. His father was a rabbi and practising scribe until fifteen years ago, when, half-way through an important scroll, a stroke left him permanently paralysed.

CRAFTLAND

Bernard already knew it was his calling. As a young boy he had practised his Hebrew handwriting until his hands cramped with exhaustion. He rarely went outdoors without sunglasses and refused to read in low light, determined to preserve his precious eyesight for the vocation that lay ahead. He wrote his first full scroll at the age of twelve. He is still going forty-six years later.

To call his work exacting would be an understatement. The sofer's art is governed by thousands of strict rules dating back to the time of Moses. They specify every aspect of every text: the required number of columns and lines, the proper spacing between words and letters. Entire treatises have been dedicated to the formation of each and every character. *Shin*, for instance, must consist of fourteen strokes that can only be applied in one particular sequence. These rules don't only govern the act of writing. They command a sofer to blow his nose before sitting down, to make a blessing before starting his first letter, and to take a ritual bath before spelling out any of the seven authorised words for 'God'.2 His tools haven't changed in millennia. He writes with a quill, uses ink made with foraged gall nuts, and inscribes his words on the skins of kosher animals, scoring lines with thorns picked from nearby rose bushes.

The job is without shortcuts. A *mezuzah* takes four or five hours to write and is usually sold for about £75. A *sefer Torah* – a hand-written scroll comprising the first five books of the Hebrew Bible – contains 304,805 characters and takes more than a year to complete. The stakes are dauntingly high. A sofer

is transcribing sacred words – God's own words, according to believers – and mistakes are technically blasphemous. 'Perhaps you will omit one letter or add one letter,' warns the Talmud; 'you would therefore destroy the entire world.'3 As metaphors go, it's an intimidating one.

If a sofer misspells a word, misjudges a space, misshapes a character, smudges the parchment, or dares correct an earlier error, the text is no longer kosher and, strictly speaking, must be abandoned without delay. A momentary lapse in concentration can cost a scribe many months. If an incorrect text happens to contain one of God's names, it must be buried, like a person, in a Jewish cemetery.

In reality, and as ever with Judaism, there is room for interpretation. Many Jews honour their injunctions without necessarily obeying them to the letter. But while Judaism is always evolving, the sofer's work will never change. It is governed

by doctrines that are absolute and therefore unalterable. His methods can't be sped up, let alone mechanised. These sacred texts can only be written by morally upstanding Jews who believe in the words they are writing and consider their transcription a spiritual exercise in and of itself.

'People often ask me whether a machine could do this job,' Benarroch says. 'But machines don't have souls. They don't believe in God. And, as far as I'm aware', he chuckles, 'they aren't Jewish.' He continues: 'Only a human being – his commitment, his patience – can imbue these documents with sanctity. This is why we kiss the Torah scroll. Why we store it in a special ark. And why, if, God forbid, we drop it, everyone who witnessed the accident has to fast for three days.' Benarroch is in no doubt: in hundreds of years' time, when every other job has been delegated to machines, the sofer will still be scribbling away with a quill.

Benarroch switches on an old jeweller's lamp and straps a magnifying visor around his head. He pulls a scrap of parchment off the shelf, dips his quill into a jar of ink made by his father forty years ago, and conducts another arcane soferic ritual. He writes the word 'AMALEK' on the parchment, then immediately crosses it out with three diagonal lines. The purpose of the exercise is partly practical – a valuable opportunity for a scribe to test his ink, quill and skill before he turns to more serious tasks. But it also carries deep, ancient meaning. The Amalekites, according to the Old Testament, were sworn enemies of the Israelites. 'Remember what Amalek did unto

thee,' runs one vengeful passage in *Deuteronomy*. 'Thou shalt blot out the remembrance of Amalek from under heaven: thou shalt not forget it.'⁴

Benarroch spends most of his time restoring old sefer Torahs sent from synagogues and libraries around the world. Today he begins work on a particularly precious scroll, made in Prague over four hundred years ago. He carefully removes the embroidered mantle and unties the strap. He can barely disguise his excitement as he grasps the wooden rollers and unfurls the crackling parchment. 'This is the best part of my job,' he whispers. 'I didn't sleep last night, I was too excited.' He pores over the scroll, his breath heavy, his eyes skitting hungrily across the text. As he advances through the document, he repeatedly erupts into voice. 'Careless man!' he cries, 'Why did you do that?' Then, 'Wow, that's good, well done my friend!'

I ask him who he's talking to.

'The sofer, of course!' he exclaims. 'He's right there in the scroll. I know everything about him: his talents, his shortcomings, when he got tired, when he got lazy. And you know,' he adds, with a gleam of pride in his eye, 'long after I'm dead, the soferim of the future will likewise be talking to me.'

Benarroch's line of work isn't for everyone. The job is lonely, repetitive and scandalously underpaid (one rule explicitly requires scribes to be 'haters of profit'). But soferim aren't motivated by earthly rewards. They are impelled by a desire to serve a faith, and a community, that they believe couldn't function

without them. They are custodians of Jewish law itself, as transcribed in the Torah, and have toiled for thousands of years – surviving diasporas, wars and genocides – to ensure its traditions are never forgotten.

* * *

Ten miles east of Golders Green there is a grand old cinema. Its art deco façade has loomed over Leyton High Road since the 1930s, when picture palaces just like it were going up all over the city. The building hasn't actually screened a film in half a century: the elegant foyer is now a betting shop, the screens partitioned into offices leased by travel agents and cab firms. I cross the urine-scented threshold and pass through a fire exit to a car park at the back of the building. There, next to the ruins of an abandoned vending machine, a man in combat shorts is stretching a goat skin in the drizzle.

Moussa Dembele is a griot (pronounced *gree-oh*), a hereditary West African occupation that originated within the Mali empire as early as the thirteenth century.5 The role has no real western equivalent. Griots have been compared to genealogists, historians, storytellers, town criers, minstrels and celebrants, though none of those terms is anything like sufficient. They played an essential role in every Western Sahel community – tasked with remembering the lineage of local families, the facts of historical events, the words of epic poems, the procedures of every ritual. Like sofers, they were custodians of collective heritage;

it's often said that whenever a griot dies, a library burns down. But while Jewish scribes preserved their stories in writing, griots kept them alive with music.

A handful of West African griots now live in London, most hailing from once British-run Gambia, but Dembele is the only one who makes as well as plays his ancestral instruments. He crafts koras, ngonis, balafons and djembe drums by hand, using methods unchanged in centuries. Each one takes three or four weeks to construct, if not longer.

He has just started work on a kora – a stringed instrument often compared to a harp. He has come to the car park as a courtesy to the other tenants: the hides are far too pungent to be unleashed indoors. He sits on a blue tarpaulin, using a log

as a workbench. After washing and trimming a large orange calabash – a gourd smuggled into the country from Ghana – he stretches the moist skin over its surface, fastening it with hundreds of metal pins. 'You've got to be careful with these,' he tells me. 'Last week I stepped on one. My foot didn't stop bleeding for hours.'

As Moussa heaves and prods, I ask him how he ended up here in London. 'You really don't want to know,' he mutters. When I insist I do, he pauses, sizing me up, then tells me a story so gripping, so tragic, that I almost forget the smell of the goat skin. Moussa was born in 1982 – the same year as me – in the scrubland of Burkina Faso. His father was a local griot, and his mother – who was just fourteen when she bore him – came from neighbouring Mali. When he was only a few weeks old, for reasons he still doesn't fully understand, Moussa's mother's family separated him from his parents. He grew up as his great-uncle's slave, farming in the heat, walking miles every day to collect water from the nearest well. He was tied up, beaten, often going days without food. He wasn't allowed to attend school, play in the streets, even make eye contact with other children. 'As a child I didn't know what a smile was because I'd never seen one,' he says. 'I've had to teach myself how to do it.'

He was eleven when he learned that his great-uncle wasn't his father and the melancholy woman he sometimes saw watching him from afar was his mother.

Moussa resolved to run away, hiding under the seats of a bus bound for Burkina Faso, but was captured and returned to

the village. A few years later, after further failed escapes, his uncle decided to sell him to his biological father, calculating a fee based on room and board. His father refused, deeming the price too high.

Moussa was fifteen when he finally got out of Mali, sneaking back across the border to his country of birth. He lived on the streets of Ouagadougou for several years: sleeping under bridges, pilfering rotten fruit from the market, joining gangs, even serving a short sentence in prison. On his release he joined the army, offering his entire salary to his father in return for his acceptance. His father agreed.

Moussa spent most of his twenties in Ghana, where his innate musicality, a talent inherited from his griot forefathers, at last came to his rescue. He started making and playing instruments on the streets of Accra, and before long established something of a local reputation. Within a year he was the lead balafon player of the Pan-African Orchestra, performing to cheering crowds all over the world. He first came to the United Kingdom in 2013 to participate in the Luton International Carnival. Though unable to read or write, he managed to complete the necessary forms to gain British citizenship. He settled in London in 2015. He was homeless for his first three months in the city, sleeping in night buses, curled up under trees in the park. Moussa now spends the days making traditional instruments in his workshop and the nights in clubs and concert halls, performing his people's music.

CRAFTLAND

When the goat skin is fully dried – a process that takes several days in the Sahel but several weeks in the United Kingdom – Moussa builds the rest of the instrument. I return to Leyton the following month to observe the process. His workshop is a small windowless room crowned by a neon light. The walls are hung with instruments, the floor scattered with tools. I spot a sleeping bag in the corner of the room, bundled furtively under a desk.

Moussa sits spreadeagled on the carpet tiles, humming as he works. He has already cut a sound hole into the calabash and carved the softwood handles. He's now wrestling the four-foot neck into position, wriggling it until straight. Moussa measures, marks and drills twenty-one holes into the sides, fits the tuning keys, affixes the fishing wire and draws it through a bridge made from a piece of plywood he found in the car park.

When the instrument is assembled and tuned, Moussa places the calabash on his lap. He grasps the handles in front of him, adjusts his grip and begins to play. As his thumbs and fingers skip across the strings, a restless melody lilts around the room. Head down, eyes closed, Moussa recites his culture's foremost epic. Voice crackling like an old record, he sings of a disabled boy and his exile, his wanderings through the African deserts, his growing strength and confidence, his return to his homeland, his sorcerous struggles with diabolical enemies, and his ultimate triumph as Sundiata, Lion King of Mali, founder of a mighty empire. When he is finished – though he will never

be finished (it is said to take a lifetime to recount the complete tale) – he puts down the kora and picks up a can of Coke.6

I would have applauded had he not looked so sad. 'I heard this story many times when I was a boy,' he explains. 'It brings back bad memories. The past is my enemy now.' I ask him if he's at least proud to be keeping an old African tradition alive. He takes another swig from the can. 'I wish I could be doing something else, anything else,' he says. 'But if your parents are griot, you are griot. There's no way out of it. It's my fate.' Moussa knows he can't stay in London indefinitely. When his father dies he will need to return to the village of his ancestors, the place he was smuggled out of as an infant, and become the voice of its people.

Moussa's story is in part a testament to London: its remarkable ability to attract the most unlikely people and nurture the most esoteric livelihoods. Travel through the city's suburbs, so often inhabited by immigrants, and you'll find hundreds of expat craftsmen and women sustaining their heritage far away from home. In my own wanderings I've discovered Islamic calligraphers, Japanese seal-engravers, Uyghur textile artists and Polynesian feather-workers, all carving a niche for themselves in the mongrel metropolis. Many have found that with its size, wealth and tolerance, London is more conducive to their work than the countries they come from.

And yet London isn't just a refuge for old traditions. It is, and has always been, a crucible – a place where people and ideas are thrown together and fired up to make something

new. A younger generation of makers is now emerging across the city, setting up studios, founding collectives, establishing companies, building partnerships and reaching out to their communities. They are advancing a different model of craft, rooted in the needs and wants of the twenty-first century. Most reside in the city's grittier neighbourhoods, where impecunious artists tend to live and work. One such hub is located not far from Moussa Dembele's workshop, just across the Olympic Park.

* * *

Hackney Wick used to be one of London's most important industrial districts. In the second half of the nineteenth century this smoke-thick corner of the city was packed with oil refineries, rubber mills, dyeworks, printing complexes and peanut-processing plants, not to mention the largest chocolate and sweet factory in Britain. It also happened to be the birthplace of the world's first synthetic plastic, Parkesine, which was briefly manufactured here in the 1860s. However, as Britain de-industrialised in the 1960s and '70s, the machines were switched off and the factories closed. Towards the end of the century the first young artists, searching for low-cost space in the city, began to arrive. They commandeered the old industrial buildings, repurposing them for a different kind of making. The area now boasts one of the densest concentrations of artists' studios in Europe.

THE CRUCIBLE

As I move through the graffiti-smeared streets I catch glimpses of current residents at work: a fashion shoot taking place beneath a long-dormant chimney; a band rehearsing behind a heavy-duty door; an artist lugging what I hope is a mannequin down an alleyway. I find myself in a place called Fish Island, which isn't an island at all unless you consider the A12 Flyover to be a body of water. There are new buildings everywhere. One, called 'Makers Corner', is offering mixed use studios and commercial units for creative practitioners. At the northern edge of the district a red-brick building fronts the canal, looking out over the area's past and future: a forest of half-built apartment blocks rising from ruined Victorian warehouses. Inside, four young women are immersed in their craft, their aprons smeared with clay.

Cone8 was founded in January 2024. It is the newest of many new ceramic studios in East London, all of which are catering to the area's growing population of potters. Its members come and go seven days a week, sharing wheels and kilns, teaching classes to craft-hungry locals. The studio is home to nine teachers and twelve residents – all of them women – who've come here from the United States, India, Vietnam, Hong Kong, Australia and New Zealand. They aren't escaping poverty or persecution but seeking opportunity in one of the world's cultural capitals, drawn to London's famed institutions and international outlook. 'If you want to succeed as a creative', one told me, 'London is still the best place in Europe – possibly anywhere.'

Ka Ching Ip ('KC'), one of the studio's founders, arrived in London a decade ago to attend university. She's currently preoccupied with a quintessentially Chinese project, making a series of traditional porcelain plum vases (*meiping*) that stand on the shelf above her head. 'Centuries ago,' she says, picking one up, 'a whole town in China was dedicated to producing this type of vase. Hundreds of potters lived there, working day and night to make them for the Emperor. But the form was so challenging, and their standards so high, that sometimes they needed to make a thousand for just one to be good enough.' She runs her hand over a dark blue inscription on the shoulder. 'If a vase was approved, they would write "To the Palace" on the rim, just like I've done here. All the others were destroyed.'

I ask her why she's reviving this old tradition now – and in East London rather than East Asia. She pauses, weighing her words. 'I grew up in Hong Kong in the '80s and '90s when it was run by the British. But it has changed so much in the last few

years that I don't even know who I am any more.' She glances down at her vase, cradling it like a newborn. 'I guess this is my way of getting back to China. When I'm making these objects I feel connected to the Chinese potters before me, almost as though our hands are touching.'

KC places a slab of white porcelain at the centre of the wheel and powers up the machine with a foot pedal. She leans forward, locking her elbows into place, cupping the material beneath her wet hands. 'Porcelain is really difficult to work with – much harder than clay,' she tells me. 'It's stretchy and bouncy, almost like raw meat. It resists you every step of the way, sensing weakness and hesitation. If you're not strong it will take its own shape or sometimes just fall to pieces.'

She works the material with subtle but assertive movements: the flick of a wrist, the twist of a palm, the press of a fingertip. When she has fashioned a symmetrical cone she adjusts her hands again, using her left thumb and right index finger to make a hole in the middle. As she pushes and pulls, the cavity widens, the mass becoming a volume.

A vessel is beginning to take shape.

KC leans back, inspecting her progress. The porcelain is still spinning on the wheel, the wet surfaces reflecting the neon strip-lights above. 'OK,' she says, 'now for the difficult bit.'

Leaning in, hands pointing downwards, she gently pinches the rim. The form shapeshifts again, rising to meet her fingers, its striated surfaces glitching like a stop motion animation. She slides her middle finger into the volume and hooks it back

on itself, pushing the vessel inside-out, creating the tapered shoulder for which plum vases are famous. Then, making a circle with her hands, she squeezes the shoulder into a narrow neck. She trims and pinches the top, rolling it over itself into an elegant rim. 'This is the way they do it in China, even today. They won't tell you what they're doing but I've observed them very carefully!'

KC won't leave the wheel until she's thrown at least ten plum vases. She usually ends up making a hundred a week, but only a couple of them are good enough to fire. She breaks the others down, preserving the valuable porcelain for future attempts. The chosen few are then glazed with the traditional royal inscription. 'All of them say "To the Palace", but they're obviously not going to a real palace!' she laughs. 'I guess the palace is *me*. It's the perfection I'm searching for – my goal of becoming a master of the craft.'

But when I ask if she considers herself a craftsperson, she cringes. 'I don't think so. I don't really know what I am.'

I ask others present what they think of the term.

'I'm a product designer,' says one, carefully glazing her latest cocktail cups.

'I usually say I'm a maker,' says another, boxing up some tableware she's created for a smart café in the West End.

I approach a woman who's finishing up a noodle bowl in the corner of the studio. 'What about you?' I ask, struggling to get her attention. 'Are you a craftsperson?'

'No,' she eventually responds, removing a wireless earbud from beneath her hair. 'I'm a multidisciplinary artist and researcher.'

These women may not like the 'c' word, but they are busy shaping its future. They belong to a broader cultural movement that extends far beyond traditional practices like pottery. Spend a few hours wandering around Hackney and you'll find people applying artisanal principles to all kinds of modern businesses, whether they're tattooists, florists, animators, stylists, bike-builders, graphic designers or filmmakers. This ethos even pervades the area's flourishing food scene. Hackney is famously overrun with 'artisan' bakeries, 'craft beer' breweries and 'small-batch' coffee roasteries, their staff clad in the workers' coats and tradesmen's aprons worn by traditional craftsmen before them.

Some might ridicule this new trend as hipster posturing. But in my view the people behind it are breathing new life into ailing practices and making them commercially viable. Many of their businesses are earning real money and creating real jobs, while supporting a range of other similar enterprises. I know at least one café in the area that serves locally roasted coffee in cups thrown by local potters on tables built by local cabinetmakers: it is rammed every day of the week. This isn't a betrayal of craft or even an ersatz imitation of it, but a genuine continuation of its principles. We shouldn't forget that historical crafts were businesses before they were anything else, their

principal purpose being to satisfy consumer demand. Whether it's grinding blades or grinding beans, the rationale remains the same.

This isn't just happening in Hackney, and it isn't just happening in London. The movement is unfolding all over the country – in repurposed factories, disused shops, abandoned barns, spare bedrooms and even garden sheds. Its members are together advancing a new kind of craft – one that overlaps and intersects with art, design, entrepreneurship and community outreach; that engages with brands and institutions; that's capable of reaching vast global audiences through social media; and that above all allows a generation of digital nomads to reject the alienations of office employment, to work for themselves rather than others, and to ground their lives in creativity.

CONCLUSION

They meet in the village of Bethlehem. On the second Monday of every month, six women leave their cottages, travel through the Carmarthenshire countryside and park outside the church hall. Their muddy cars are piled with possessions: bags of textiles, boxes of spooled threads, sewing machines they've owned and loved for years. They gather in the magnolia meeting room and unpack their equipment beneath an arched window. They chat, laugh, boil the kettle, cut the cake, then take their seats – always the same ones – around the communal table. When their fabrics are laid out and their tools are lined up, they stop talking and

start working: heads down, fingers moving, faces obscured by steaming tea.

Each woman is engrossed in her own project. Mrs Elvy, who has been quilting since the 1960s, is making yet another floral cover for her matrimonial bed. Mrs Bennett, who started at the age of fourteen, is stitching a star-spangled quilt for her eleventh grandson which she's not convinced he'll like. Mrs Llewellyn is finishing up a padded dog coat for her new puppy; Mrs Hill is creating a quilt in 'courthouse steps' pattern for her daughter-in-law, who recently qualified as a barrister; Mrs Tomlinson – who runs the group – is finally completing an appliqué quilt she started four years earlier; and Mrs Cottage is rummaging through a box of hexagons, searching for the next piece to sew on an eiderdown.

Jeanie Cottage has been quilting since 1950 – her mother taught her when she was just three. She has sewn every day for the last seventy-four years, devising exuberant patterns with her husband – himself an artist – and making textiles for her extended family. His recent death, after a long battle with kidney cancer, has weakened her body and broken her heart. His colourful shirts are neatly folded and boxed in the spare room. When she is finally able to look at them without breaking down, she plans to turn them into a set of quilts through which the family can remember him. Quilting is her only remaining consolation, the monthly meetings in Bethlehem more precious than ever. 'I'm disabled now and very, very lonely,' she says, the tears chasing themselves down her cheeks.

CONCLUSION

'Quilting is my therapy. It quietens my mind. As soon as I start using my hands, I can feel myself settling.'

Quilting is a craft of love. Quilts are often fashioned from materials freighted with personal significance, some having been cherished for decades: a piece of fabric collected on a honeymoon; a jumper outgrown by a child; the shirt of a deceased relative that still smells of its wearer. Large quilts are the products of hundreds of hours of work, spread across months if not years, typically for little or no remuneration. They are usually made for people their makers care about: friends, relatives – anyone who might benefit from such generosity. The women of Bethlehem have stitched them for terminally ill patients, children who've just left care, and serially abused women in refuges. 'A quilt is a *cwtch*,' says Mrs Llewellyn, using the wonderful Welsh word for hug. 'Something you can wrap yourself up in when you need comfort and makes you feel at home wherever you are.'

The 'Starry Stitchers' is one of roughly a thousand quilting groups now active in the United Kingdom. The practice has undergone a remarkable resurgence in recent decades, as ever more people – many of them young – have taken up the craft and joined its associated communities. Quilting isn't the only beneficiary of such demand. Craft groups of all kinds are thriving right now, particularly since the pandemic. Hundreds of thousands of amateur knitters, florists, potters, basket-weavers and green woodworkers are meeting regularly all over the British Isles, coming together

to share ideas and exchange skills, to offer mutual encouragement and support.

We shouldn't confuse them with the professional practitioners featured in this book. The former are crafting for pleasure, the latter running businesses. If you ever really want to annoy a full-time craftsperson, just ask them if they find their work relaxing. 'Of course it isn't!' Felicity Irons once barked at me, as she wrestled a rush doormat on a cold November morning. 'It's bloody hard work, just like any other job.' Both groups, however, are fired by the same conviction: that in an increasingly digital world, when physical reality seems ever more incidental, making things by hand still matters.

* * *

Britain may no longer be the world's workshop but it hasn't yet lost its craftspeople. They are still out there, all over the country, as resourceful and creative as ever. Most are making a living from their skills and some are genuinely prospering, but all are united by an unwavering commitment to their work. The siblings who toil through winter storms, hauling rocks across the Pennines so farmers won't lose their sheep; the fisherwoman who battled breast cancer to weave more sustainable equipment; the lettercutter who carved her husband's gravestone through tears; the watchmaker who devoted five years of his life to a single timepiece simply to prove he could do it; the cutlers who stand at the very machines that mutilated their

hands; the African griot who escaped poverty and persecution to bring his music to London.

If this book is nostalgic, it is nostalgic for the *present* – for the skills and traditions we think have gone but are actually all around us. This doesn't mean their future is secure. Even the most successful craft businesses are small and often precarious, their fate tethered to a single person. A few weeks after my final visit to Colyton, Greg Rowland – the strapping Devonshire wheelwright whose family's connection to the trade went back to the fourteenth century – suffered a life-changing motorcycle accident on a lane near his home. His company would surely have folded had it not been for his young apprentice – who was also his daughter's fiancé – who agreed to take over the workshop before his training was complete. Sam then took his new wife's surname so as to keep the Rowland legacy alive.

Britain leads the world in its preservation of physical heritage. We have been diligently caring for our museums, castles and stately homes for longer than any other country (though funding is increasingly thin on the ground). But when it comes to the practices and traditions that make up our collective inheritance, we lag far behind our peers. The government offers no legal protections, no grants or subsidies, and little support for the apprenticeships that transmit and sustain skills. While some countries – notably Japan and South Korea – call their foremost artisans 'living national treasures' and treat them almost like royalty, ours remain overlooked and

undervalued, aided only by a handful of steadfast charities. That any survive at all is a miracle.

Traditional crafts matter. They are part of who we are and where we come from. They connect us to our ancestors and our local communities, weaving past with present, forging collective identities, shaping our immediate surroundings. Long after their deaths, Britain's craftspeople continue to leave a mark on our world. Head out to your local high street and you will see their work everywhere. It lives on in the flagstones beneath our feet and the signs above our heads; in the tolling bells of the church tower and the tick of the town hall clock. These forgotten people even crafted our countryside, creating the field walls and hedgerows we all now know and love. The United Kingdom has written its autobiography in craft, and so it is through craft by which we might best understand it.

Make no mistake: craft isn't some dusty relic whose only purpose is to remind us of our past. It has always been a living tradition, constantly adapting to changing times, perpetually modern and necessary. Britain's craftspeople have always driven us forwards, not backwards: building industries, advancing technologies, changing lives. That remains true today, even in a world governed by automation and algorithms. Our traditional crafts may be marginalised, but they are still answering our needs, still solving our problems. As we lurch through an era of political volatility, economic inequality and climate catastrophe, they suddenly feel rather relevant.

CONCLUSION

Taken as a whole, their economic potential is considerable. The crafts belong to Britain's booming creative industries sector, which is growing three or four times faster than the national average, and is now larger than the automotive, aerospace, life science and fossil fuel industries combined. Moreover, unlike those infrastructure-dependent fields, craft businesses can flourish anywhere, including in remote, rural areas otherwise starved of economic opportunities. The recent resurgence of Harris tweed has transformed the social fabric of the Outer Hebrides, employing hundreds of people directly while supporting many other jobs in tourism and hospitality.

As Britain transitions to a green economy, craft can become an industry of the future. Traditional crafts are far more sustainable than most manufacturing processes. Their practitioners work with renewable organic materials and low-carbon local supply chains, creating products that tend to be kept and cherished rather than thrown away after a few disappointing uses. Some might even offer pathways to environmental amelioration: potters and basket-weavers are already supplying viable alternatives to polluting plastics, while hedge-layers and coppice-workers are restoring small pockets of biodiversity to rural areas. In the right circumstances craft can change our collective behaviour and redefine our relationship with the world, providing an alternative to the cycle of consumption and waste on which our current economic model is built.

CRAFTLAND

We are said to be living through a new industrial revolution, which may prove even more transformative than its predecessors. Modern technology isn't only supplanting our hands but aping our thoughts, blurring distinctions between human life and artificial intelligence, physical reality and its virtual simulacra. This remarkable moment is creating opportunities but also anxieties. Despite living in a highly interconnected world, people feel increasingly estranged from their jobs, bodies and surroundings. Craft, as many have already discovered, can be a powerful antidote. After all, what could be more grounding, more reassuringly real, than feeling a material between your fingers and turning it into something useful?

Humans are natural born craftspeople. From the moment our ancestors knapped their first axes from flint, we have been using our hands to make things. We have done so throughout our history, in every part of the world. The practice is so universal that it might even be a defining trait of our species. Technology may have advanced and society may have changed, but our instincts remain the same. Just watch a child shaping plasticine or stacking blocks, completely absorbed, mesmerised by their own powers of transformation. They express something that far too many of us have grown out of or forgotten: that *making* satisfies a deep and essential need, and so helps us feel truly human.

I'm not suggesting that we should all devote our lives to whittling wood and weaving willow. But I do think we could

CONCLUSION

spend more time appreciating the craftsmanship around us. It is everywhere, hiding in plain sight: the old watch you inherited from your grandfather; the dowdy quilt you put in the loft years ago; the peeling sign above your local pub. Britain is still a craft land, if only we have eyes to see it.

A Selection of (Mostly) Extinct Occupations

Action man: gunsmith who specialised in the making of actions for rifles, guns & pistols.

Air ball-maker: manufacturer of inflatable rubber balls (also known as 'balloons').

Arrow featherer: fitter of feathers to the nock ends of arrows.

Back end girl: refilled shuttles & mended broken threads at the backs of Swiss embroidery machines under the direction of a *front girl*.

Badger (also *sand blaster* & *brilliant cutter*): etcher of glass.

Bag woman: mender of sacks & bags, either by darning or patching.

A SELECTION OF (MOSTLY) EXTINCT OCCUPATIONS

Baller: occupation in various sectors, including (in pottery) one who measured balls of clay for throwers, or (in textiles) prepared balls of wool in advance of spinning.

Beetle cutter: maker of wooden mallets (beetles) for finishing textiles.

Belly man (also ***bellyer, bellymaker* & *belly builder*)**:** made & assembled sound boards inside pianos.

Bender: occupation in various sectors; usually involved bending a material (esp. glass, metal & wood) as part of a larger manufacturing process.

Biscuit oddman: responsible for odd jobs around a pottery kiln.

Blubberman (also ***blabber*)**:** responsible for the removal of blubber from whale or seal skin.

Body builder: made bodies of coaches, carriages, motorcars, tramcars & perambulators.

Bogeyman: transporter of ingots, plates or sheets of metal from furnaces to rolling mills and shearing machines on a two-wheeled truck called a 'bogey'.

Boner: inserter of whale bones into corsets.

Bottom action-maker: manufactured the main bellows of player pianos; fixed the pedals & controls.

Bottom stainer: applied paint or stain to the bottom of a boot or shoe.

Breeze riddler: riddled or sifted breeze or cinders from furnace ashes for use in a smithy.

Buddleboy (also ***buddleman* & *buddler*)**:** operator of buddle vats, where crushed ore was cleaned and refined with water.

CRAFTLAND

Bumboat man: seller of goods from a flat-bottomed 'bumboat' to the crews of ships anchored nearby.

Butt woman: seller of flatfish on quaysides.

Calender girl: presser of embroidered articles with a calendering machine.

Catgut maker (also *gut maker* & *tharme maker*): splitter & cleaner of animal gut for strings of musical instruments.

Cave man: responsible for removal of clinkers & ashes from the cave or a tunnel beneath a furnace.

Cheeker (also *plinther*): fitter of ends (cheeks), plinth, toes & feet to upright pianos.

Chip chopper: fed wood used by medicinal or dye industries into chipping machines.

Cock-maker: maker of bridges for balances or pallets of watches or clocks.

Cullet picker: sorted out cullet (waste glass) for remelting.

Cure man: responsible for vulcanising rubber products.

Dagger sheath mounter: riveter of steel or brass components to leather dagger cases.

Dandy roll-maker: maker of dandy roll (part of a papermaking machine).

Decomposing man: maker of chlorine gas.

Devil: odd-job man (more often, boy) in a printing office.

Doler: preparer of tanned glove leather.

Dollop weigher: weigher & sorter of jute bundles.

Drowner: managed watercourses, sluices & irrigation of water meadows.

A SELECTION OF (MOSTLY) EXTINCT OCCUPATIONS

Ear trumpet-maker: maker of ear trumpets & other acoustic instruments for the partially deaf.

Eye puncher: operator of a fly press, piercing eye holes into needle blanks.

Fat boy: greaser of axles of haulage systems used in mines & quarries.

Fellmonger: merchant who washed, cured, processed & sold animal hides & skins (esp. those of sheep).

Fiddler: maker of 'fiddles' or 'waists' of boots or shoes.

First half doer: turner of points or pivots for the centre, third or fourth wheels of a watch.

Flasher: maker of glass discs by rotating bulbs of glass on pontil rods at the mouths of furnaces.

Flirter: remover of loose bristles from brushes.

Gadger: sewer of cloth hat or cap parts before they went to the machinist for finishing.

Gaff hook-maker: forger of frost nails.

Gimp-maker: manufacturer of ornamental trims (gimps) in the textiles industry.

Helmet underer: fixer of material under the brims of helmets.

Higgler: itinerant manufacturer and salesman of various transportable wares, including textiles.

Hot-presser: operator of a hot-pressing machine, used to flatten & improve surface of cloth or paper.

Hugger: quarryman responsible for carrying blocks of stone to the surface using hugging ladders & saddles.

CRAFTLAND

Hypo boy: submerger of photographic negatives into solutions of hyposulphite of soda to fix images.

Jumbler: maker of chronometer fittings.

Lad: responsible for maintaining incandescent gas lamps at stations.

Lurer: hat polisher.

Maiden-maker: manufactured the blocks, feet, shanks, handles & pegs of washing machines, then fitted them together.

Mangler: operator of mangling machines, which rolled and pressed fabric.

Mellor: stone breaker.

Mitre-maker: chimneypot maker who specialised in mitred forms.

Muffleman: annealer of nails, screws & tacks in muffles (furnaces).

Pom-pom man: operator of coal-cutting machines.

Pugger: operator of a pug mill, which kneaded leaves of clay into homogeneous, bubble-free masses for use in pottery manufacture.

Quarrel picker: cutter & fitter of small panes of glass used in lattice windows.

Random-maker: cutter of rough-shaped 'crazy-paving' stone setts.

Ransacker: examined fishing nets for holes & passed them to *beatsters* for repair.

Riddler: sorter of various materials by shaking through a sieve or riddle.

A SELECTION OF (MOSTLY) EXTINCT OCCUPATIONS

Scratch brusher: maker of wire brushes.

Slagger: furnace keeper responsible for removing slag during & after the smelting process.

Snob: journeyman boot- & shoemaker.

Snuffer-maker: producer of candle snuffers.

Spittle-maker: maker of small spades, hoes & scrapers.

Sprigger: embroiderer who decorated fabrics with sprigs, flowers & leaves.

Stripper: name for many occupations in various sectors; usually involving the stripping or cleaning of natural materials.

Thrower-up: passed steel sheets up to a platform for galvanising.

Tingle-maker: maker of tiny tack-like nails.

Tinker: travelling tinsmith engaged in the repair of household utensils.

Verge-maker: maker of traditional escapement movements of verge watches.

Well-sinker: digger or borer of wells.

Whatnot-maker: maker of small ornamental stands or cabinets for the display of trinkets.

Whiff-maker: maker of small cheroots (whiffs).

Whim driver: operator of a horse or steam-powered winding engine for extracting water or ore from a mine.

Whip thong-maker: maker of whips from whalebone & braided leather.

Willy man: operator of a willying machine, which thinned, separated & cleaned matted wool before carding.

Wood faggotter: coppice-worker who made up bundles of waste sticks for firewood.

Yowler: a thatcher's assistant, responsible for throwing bundles (yowls) of reed up to his master on the $roof.^1$

The Thirty-Four Trades of Watchmaking

1. **The frame-maker,** who makes the frame; that is to say, the two plates, the bar, and the potance.
2. **The pillar-maker,** who turns the pillars, and makes the stud for the stop-work.
3. **The cock-maker,** who makes the cock and stop-work.
4. **The barrel and fusee-maker,** who makes the barrel, great wheel, fusee, and their component parts.
5. **The going fusee-maker,** who makes the going fusee (the means by which the watch is kept going while winding up), when made use of.

CRAFTLAND

6. **The centre wheel and pinion-maker,** who makes the same.
7. **The small pinion-maker,** who makes it of wire, previously drawn by another workman, called pinion-wire; the third and fourth wheels, and escapement-wheel pinion; and in the case of repeaters, the pinions of the repeating train of wheels: these are all finished in the engine.
8. **The small wheel-maker,** who makes the third and fourth wheels, and the wheels of the repeating train for repeating movements, and rivets them into their pinions.
9. **The wheel-cutter,** who cuts the wheels.
10. **The verge-maker,** who makes the verge of vertical watches.
11. **The movement-finisher,** who turns the wheels of a proper size previously to their being cut, forwards them to and receives them from the wheel-cutter, examines all the parts as they are made, to see that they are as they should be; and finally completes the movement, and puts it together.
12. **The balance-maker,** who makes the balance of steel or brass.
13. **The pinion wire-drawer,** who prepares the pinion-wire; this, however, may be considered as only a branch of the trade of wire-drawing.
14. **The slide-maker,** who makes the slide.
15. **The jeweller,** who jewels the cock and potance, and, in a more forward state of the water, any other holes that are required to be jewelled.

THE THIRTY-FOUR TRADES OF WATCHMAKING

16. **The motion-maker,** who makes the brass edge; and, after the case is made, joints and locks the watch into the case, and makes the motion-wheels and pinions.
17. **The wheel-cutter,** who cuts the motion-wheels for the motion-maker.
18. **The cap-maker,** who makes the cap.
19. **The dial-plate-maker,** who makes the dial.
20. **The painter,** who paints the dial.
21. **The case-maker,** who makes the case.
22. **The joint-finisher,** who finishes the joint of the case.
23. **The pendant-maker,** who makes the pendant.
24. **The engraver,** who engraves the name of the watch-maker on the upper plate; and also engraves the cock and slide, or index, as the case may be.
25. **The piercer,** who pierces the cock and slide for the engraver, and afterwards engraves them.
26. **The escapement-maker,** who makes the horizontal, duplex, or detached escapements; but the escapement of a vertical watch is made by a finisher.
27. **The spring-maker,** who makes the main-spring.
28. **The chain-maker,** who makes the chain.
29. **The finisher,** who completes the watch, and makes the pendulum-spring, and adjusts it.
30. **The gilder,** who gilds the watch.
31. **The fusee-cutter,** who cuts the fusee to receive the chain, and also the balance-wheel of the vertical escapement.
32. **The hand-maker,** who makes the hands.

CRAFTLAND

33. **The glass-maker,** who makes the glass.
34. **The pendulum-spring wire-drawer,** who draws the wire for the pendulum-springs, which is almost a distinct trade.

Source: A. Rees, *The Cyclopaedia; or Universal Dictionary of Arts, Sciences and Literature,* vol. 37 (Longman, Hurst, Rees, Orme & Brown: 1819)

Acknowledgements

Writing is manual labour. Far too many times in this project I've felt like a dry stone waller, trying vainly to shape a disobedient material into something that stands up. I know for certain that I couldn't have built it on my own. My agent Sophie Lambert was there from the beginning, gathering the loose rubble of my ideas into a meaningful proposal; my editor Will Hammond hacked and honed my craggy construction into respectable shape; and my long-suffering wife Kirty (herself an editor) kept me company on the mountain, reminding me of every stone I'd put in wrong.

CRAFTLAND

Unlike my previous books, which came out of lonely hours in libraries and archives, this one emerged from journeys, encounters and conversations. I relied on countless acts of generosity with nothing ever requested in return. I have so many people to thank that I name them in the order their contribution appears in the text. First, to Michelle de Bruin for telling me about the abandoned smiddy in the Scottish Borders, and to Michael Tweedie for granting me access to it; to the Dry Stone Walling Association for putting me in touch with the great William Noble; to Bert and Lydia for gamely walling through a winter storm in my company; and to Johnny Lloyd, who introduced me to the trade on a windswept fell in Northumberland.

I am grateful to Brian Wilson and Troy Holt for allowing me to trail them across the Highlands; to Stuart King and John Morris for sharing their knowledge of the Chilterns, and to Steve Roberts and Andy Jarvis for letting me observe them at work; to Andy Alder, Sue Reeve and Leo Bjorkegren at the Association of Pole-lathe Turners and Green Woodworkers for granting me access to the Bodger's Ball; to Felicity Irons and her husband Ivor for giving me so much of their time (and an unforgettable pheasant stew); to the wheelwrights Greg Rowland and Sam Phillips; to Andrew and Lizzie Parr at J. & F. J. Baker; and to many other Colytonians, including Claire Bujniewicz and Jasper Highet, for talking me through their respective trades.

I would like to thank Sarah and Darren Ready for offering me a bed in Brixham and taking me out to sea in what ended up being a Biblical rainstorm, and David French for putting

ACKNOWLEDGEMENTS

his hands through hell to make a withy pot out of season for my benefit. I am indebted to David Potter for driving across England to show me around the John Taylor bell foundry while suffering crippling back pain; to other members of the team – particularly Antony Stone, Girdar Vadhukar and Kit Bardsley – for speaking so openly about their work; and to everyone at the Cardozo Kindersley workshop (especially Lida and Roxanne) for letting me disrupt their otherwise clockwork routines.

I am grateful to Roger Smith and his exemplary team of watchmakers for tolerating my clunking presence in their usually silent workshop and spending so much time fielding my foolish questions; to Ellen Turbett and her colleagues for allowing me behind the scenes at the Old Distillery in Bushmills, and to Alastair and Chris Kane for divulging the secrets of coopering. I am indebted to a great number of people in Sheffield, including John Adams, Paul Jacobs, Neil Wilson and Robin Wood, all of whom were so generous with their time. I would also like to thank Bernard Benarroch, Moussa Dembele, K. C. and Sarah Feder at Cone8 in London, and of course the wonderful quilters of Bethlehem described in my conclusion.

Dozens of others took my calls, answered my questions, shared their knowledge and gave me their time, a number of whom appeared in earlier drafts of the text and whose contribution – though invisible – has been invaluable. Among them are Daniel Carpenter, Sandie Lush, Jen Jones, Ceri Poulson, Daniel Harris, Clare Revera, Caitlin Jenkins,

Mordechai Pinchas, Aviel Barclay, Emma Williams, Becky Little, Karolina Merska and Benji Lerigo. I am also grateful to the small army of people working behind the scenes at and with my publishers who did so much to refine my words and get them out into the world: Juliet Brooke, Sam Stocker, Henry Howard, Saava Benjamin, Mary Chamberlain, John Garrett, Joe Pickering, Ellie Auton, Annie Rose, Nathaniel Breakwell, Nick Cordingly, Malissa Mistry and Madhulika Sikka.

A book is itself a work of craft – a collective endeavour, the sum of many people's skills and talents. From the very beginning of this process the whole team at Vintage, led by Hannah Telfer, were committed to making *Craftland* an embodiment of the principles it described. The UK edition was designed by the great Suzanne Dean, a masterful craftsperson in her own right. If you have admired the bold beauty of the cover and the elegance of the internal layout, it is Suzanne you have to thank. Suzanne oversaw every visual feature of the book, including the marbled endpapers created by Jemma Lewis, one of Britain's last professional marbling artists.

From the outset we chose to illustrate the text with handmade images rather than photographs. I must therefore pay tribute to the five exceptional artists whose craftsmanship graces its pages. The remarkable artworks that appear at the start of every chapter were made by three of the finest printmakers working today, each evoking a different aspect of craft. Neil Bousfield's intensely dynamic images (Chapters 1, 2, 7 and 11) capture the physicality of so much

ACKNOWLEDGEMENTS

artisanal work; Kit Boyd's lyrical romanticism (Chapters 3, 4, 6 and 10) expresses the deep connection between craft and the landscape; while Lucie Spartacus (Chapters 5, 8, 9 and 12) portrays with characteristic grace and economy the human beings at the heart of this story. I am also grateful to Nathaniel Russell, who made the mesmerising hand that runs through these pages like a leitmotif.

I must conclude by thanking Helen Cann, who spent the best part of four months drawing the many maps, diagrams and illustrations that animate and beautify the text, and for filling them with so much grace, charm and humour. I have always thought of *Craftland* as a *place* – a rarefied realm that hides in the shadows of our world, visible only to those who know where to look. Helen's work has brought this fragile but inspiring world vividly to life.

List of Illustrations

1. *Craftland: some crafts & products of the British Isles*, Helen Cann, 2025, pen and ink drawing © Helen Cann
2. *Bert and Lydia Noble gapping a wall in a rainstorm, Yorkshire*, Neil Bousfield, 2025, wood engraving © Neil Bousfield
3. *Wall country*, Helen Cann, 2025, pen and ink drawing © Helen Cann
4. *Every region has its own walling style*, Helen Cann, 2025, pen and ink drawing © Helen Cann

LIST OF ILLUSTRATIONS

5. *The anatomy of a dry stone wall*, Helen Cann, 2025, pen and ink drawing © Helen Cann
6. *Dunachan returning home, Lonbain*, Neil Bousfield, 2025, wood engraving © Neil Bousfield
7. *A map of the Highlands & Islands*, Helen Cann, 2025, pen and ink drawing © Helen Cann
8. *A few of Scotland's thatching materials*, Helen Cann, 2025, pen and ink drawing © Helen Cann
9. *Andrew Jarvis coppicing hazel on a January morning*, Kit Boyd, 2025, linocut print © Kit Boyd
10. *A map of the Chilterns*, Helen Cann, 2025, pen and ink drawing © Helen Cann
11. *The coppice cycle*, Helen Cann, 2025, pen and ink drawing © Helen Cann
12. *A Windsor chair*, Helen Cann, 2025, pen and ink drawing © Helen Cann
13. *Felicity Irons harvesting rush on the Great Ouse*, Kit Boyd, 2025, linocut print © Kit Boyd
14. *The River Great Ouse*, Helen Cann, 2025, pen and ink drawing © Helen Cann
15. *A stand of bulrush in summer*, Helen Cann, 2025, pen and ink drawing © Helen Cann
16. *Felicity Irons' favourite weaves*, Helen Cann, 2025, pen and ink drawing © Helen Cann
17. *Greg and Sam Rowland bonding a wheel*, Lucie Spartacus, 2025, linocut print © Lucie Spartacus

CRAFTLAND

18. *A map of Colyton, Devon*, Helen Cann, 2025, pen and ink drawing © Helen Cann
19. *The parts of a hide*, Helen Cann, 2025, pen and ink drawing © Helen Cann
20. *Anatomy of a wheel*, Helen Cann, 2025, pen and ink drawing © Helen Cann
21. *Greg Rowland's traveller*, Helen Cann, 2025, pen and ink drawing © Helen Cann
22. *Sarah Ready fishing, Brixham*, Kit Boyd, 2025, linocut print © Kit Boyd
23. *The south-west of England*, Helen Cann, 2025, pen and ink drawing © Helen Cann
24. *Herring swill and cran*, Helen Cann, 2025, pen and ink drawing © Helen Cann
25. *Withy pot*, Helen Cann, 2025, pen and ink drawing © Helen Cann
26. *Pouring bell metal at John Taylor's, Loughborough*, Neil Bousfield, 2025, wood engraving © Neil Bousfield
27. *The casting of a bell*, Helen Cann, 2025, pen and ink drawing © Helen Cann
28. *The sound of a bell*, Helen Cann, 2025, pen and ink drawing © Helen Cann
29. *Lida Kindersley cutting an inscription*, Lucie Spartacus, 2025, linocut print © Lucie Spartacus
30. *Kindersley Street*, Helen Cann, 2025, pen and ink drawing © Helen Cann

LIST OF ILLUSTRATIONS

31. *Anatomy of lettering*, Helen Cann, 2025, pen and ink drawing © Helen Cann
32. *Ligature, nesting, flourish*, Helen Cann, 2025, pen and ink drawing © Helen Cann
33. *Lida Kindersley's workbench*, Helen Cann, 2025, pen and ink drawing © Helen Cann
34. *A young Roger Smith making his first pocket watch*, Lucie Spartacus, 2025, linocut print © Lucie Spartacus
35. *Roger Smith's second pocket watch*, Helen Cann, 2025, pen and ink drawing © Helen Cann
36. *A mechanical watch movement*, Helen Cann, 2025, pen and ink drawing © Helen Cann
37. *Roger Smith's single wheel co-axial escapement*, Helen Cann, 2025, pen and ink drawing © Helen Cann
38. *The cooperage, Bushmills*, Kit Boyd, 2025, linocut print © Kit Boyd
39. *The anatomy of a cask*, Helen Cann, 2025, pen and ink drawing © Helen Cann
40. *A barrel is just one kind of cask*, Helen Cann, 2025, pen and ink drawing © Helen Cann
41. *How to build a cask*, Helen Cann, 2025, pen and ink drawing © Helen Cann
42. *Robin Wood grinding axe heads, Sheffield*, Neil Bousfield, 2025, wood engraving © Neil Bousfield
43. *Anatomy of a pair of scissors*, Helen Cann, 2025, pen and ink drawing © Helen Cann

CRAFTLAND

44. *Putter-togethering*, Helen Cann, 2025, pen and ink drawing © Helen Cann
45. *Bernard Benarroch at work, London*, Lucie Spartacus, 2025, linocut print © Lucie Spartacus
46. *A mezuzah*, Helen Cann, 2025, pen and ink drawing © Helen Cann
47. *Mr Benarroch's workbench*, Helen Cann, 2025, pen and ink drawing © Helen Cann
48. *Traditional instruments of West Africa*, Helen Cann, 2025, pen and ink drawing © Helen Cann
49. *K. C.'s plum vase*, Helen Cann, 2025, pen and ink drawing © Helen Cann

Notes

INTRODUCTION

1 *The Engineer* (30 April 1869), p. 315.
2 More of these extinct trades, with definitions, can be found in the Selection of (Mostly) Extinct Occupations on p. 323.
3 For two important but contrasting perspectives, see R. Sennett, *The Craftsman* (Penguin, 2009) and G. Adamson, *The Invention of Craft* (Bloomsbury, 2018). For a wider review, see P. Greenhalgh, 'Words in the World of the Lesser: Recent Publications on the Crafts', *Journal of Design History*, vol. 22, no. 4 (2009), pp. 401–11.
4 https://www.britannica.com/dictionary/craft (accessed: 10 March 2025).

CHAPTER I

1. See V. Cummings, *The Neolithic of Britain and Ireland* (Routledge, 2017).
2. The classic account of Dartmoor's reaves is Andrew Fleming's *The Dartmoor Reaves: Investigating Prehistoric Land Divisions* (Batsford, 1988).
3. See T. Lord, 'Field Guide to the Medieval Dry Stone Walled Landscape at Winskill in the Yorkshire Dales National Park' (12th International Dry Stone Walling Conference, University of Cumbria, 2010): http://www.lowerwinskill.co.uk/pdf/XII%20 International%20Dry%20Stone%20Walling%20Conference%20 Winskill%20Field%20Guide.pdf (accessed: 26 March 2024).
4. For an excellent summary of dry stone walls during the Enclosures, see M. Paterson, 'Set in Stone? Building a New Geography of the Dry-Stone Wall' (PhD thesis, University of Glasgow, 2015): https://core.ac.uk/download/211236291.pdf (accessed: 1 March 2024).
5. One of the only contemporary accounts of such a waller, dating back to 1820, runs: 'He is in general a blunt, manly, taciturn fellow, his employment is less purely mechanical than many others, he is not like a man ceaselessly engaged in pointing needles, or fashioning pin-heads. On the contrary every stone he lays or hews demands the exercise of a certain amount of judgement for itself; and so he cannot wholly suffer his mind to fall asleep over his work . . . The mason is always a silent man; the strain of his respiration is too great, when he is actively employed, to leave the necessary freedom to the organ of speech.' Cited in A. Raistrick, *Pennine Walls* (Dalesman, 1946), p. 26.
6. For more on dry stone walling, see F. Rainsford-Hannay, *Dry Stone Walling* (Faber, 1957). See also A. Winchester, *Dry Stone Walls:*

History and Heritage (Amberley, 2016) and N. Aitken, *Dry Stone Walling: Materials and Techniques* (Crowood, 2023).

7 There are said to be approximately 125,000 miles of dry stone walls in Britain. 'Defining Stone Walls of Historic and Landscape Importance', final report produced for Defra and partners by Land Use Consultants with AC Archaeology (April 2007): https://assets.publishing.service.gov.uk/media/5a7e47b3e5274a2e8ab46fec/Defining_stone_walls_of_historic_and_landscape_importance.pdf (accessed: 1 March 2024).

8 Wales has its own version of the hedge, called a *clawdd*.

9 For more on some of these variations, see https://conservationhandbooks.com/dry-stone-walling/walls-in-the-landscape/characteristic-regional-walls/ (accessed; 1 March 2024).

10 Priestley's comments are so evocative that I can't resist quoting further: 'The North of England is the region of stone walls. They run from the edges of the towns to the highest and wildest places on the moors, firmly binding the landscape. You never see anybody building them or even repairing them, but there they are, unbroken and continuous from every tram terminus to the last wilderness of bog and cloud. No slope is too steep for them. No place is too remote. They will accurately define pieces of ground that do not even know a rabbit and only hear the cry of the curlews.' J. B. Priestley, *English Journey* (Heinemann, 1934), p. 154.

11 A few years ago, for instance, the Nobles were commissioned to build a wall, in Cotswold stone, for a complex in Gifu, Japan.

12 For a good discussion of the walling process, see N. S. Farrar, 'Tacit knowledge, learning and expertise in dry stone walling' (PhD thesis, University of Huddersfield, 2006): https://core.ac.uk/download/40070454.pdf (accessed: 1 March 2024).

13 The pre-eminent American waller Dan Snow phrased this contradiction well. 'When now and again a stone falls into a place that is utterly inevitable I feel I am standing under a shower of grace. If I'm lucky, it happens a lot. Then again, some days it doesn't happen at all.' D. Snow, *In the Company of Stone: The Art of the Stone Wall* (Artisan Books, 2001), p. 6.

14 A survey conducted in the mid 1990s found that only 13 per cent of the nation's dry stone walls were in good condition. The figure would be significantly lower today. See https://conservationhandbooks.com/dry-stone-walling/dry-stone-walls-and-conservation/ (accessed: 1 March 2024).

CHAPTER 2

1 This account is based on the memories of about a dozen people in Applecross. For written descriptions of Dunachan and his home, see A. Wright, 'A History of the Thatched House at Lonbain, Applecross, Wester Ross', *Vernacular Buildings*, vol. 34 (2010–11), pp. 67–82; J. Campbell, *Invisible Country: A Journey through Scotland* (Weidenfeld & Nicolson, 1984), p. 138; and P. Kemp, *Of Big Hills and Wee Men* (Luath, 2013), n.p.

2 *The Rough Guide to Scottish Highlands & Islands* (Rough Guides, 2012), p. 6.

3 Before the road arrived, the only connection to the outside world was the mailboat that sometimes stopped on its way to Kyle of Lochalsh or Stornoway.

4 'Eviction at Applecross', *Northern Ensign* (25 August 1859). The circumstances surrounding the eviction aren't clear.

5 S. Johnson, *A Journey to the Western Isles of Scotland* (Strahan & Cadell, 1775), n.p.; E. Burt, *Burt's Letters: From the North of*

Scotland (W. Paterson, 1754), vol. 2, p. 64; T. Kirke (1679), quoted in P. Brown, *Early Travellers in Scotland* (Edinburgh, 1891), p. 28.

6 Quoted in C. Dingwall, 'Written Accounts of the Perthshire Highlands: The Traveller's Contribution to Landscape History', pp. 25–6: https://www.mountblairarchive.org/wp-content/ uploads/2016/02/Landscape-History.pdf (accessed: 10 May 2024).

7 Historic Scotland, *Thatch and Thatching Techniques: A Guide to Conserving Scottish Thatching Traditions* (Technical Advice Note 4, 1996), pp. 25–8.

8 '*Ruisgeadh e a thaigh fhéin a thuathadh thaigh a choimhearsnaich*.' Quoted in T. D. Macdonald, *Gaelic Proverbs and Proverbial Sayings* (Eneas Mackay, 1926), p. 58.

9 *A Survey of Thatched Buildings in Scotland* (SPAB Scotland, 2015). Between 1800 and 1960, England lost 96.4 per cent of its thatched buildings. Matters have since stabilised, thanks to stricter planning laws and listed building status. There are now 24,000 buildings in England whose thatched roofs are protected by law, which together sustain the careers of 800 professional thatchers: a fraction of the 6,300 who thronged the country's villages in 1851, but almost twice as many as there were sixty years ago. See *The Thatcher's Craft* (Rural Development Commission, 1960).

10 R. W. Summers, *Abernethy Forest: The History and Ecology of an Old Scottish Pinewood* (RSPB, 2018).

11 For more on this, see J. Souness, 'Heather Thatching in Scotland – Further Observations', *Vernacular Building* 15 (Scottish Vernacular Buildings Working Group, 1991), pp. 3–26.

12 For Wilson's own account of the expedition, see B. Wilson, *Blazing Paddles: A Scottish Coastal Odyssey* (Oxford Illustrated Press, 1988).

13 Matheson was above all famous for building the set for the 1986 film *Highlander*, and for carving two walking sticks for Prince

Charles and Princes Diana as a gift from the people of Ross-shire to mark the occasion of their wedding. For more, see A. Munro, 'Duncan "Stalker" Matheson' (obituary), *The Scotsman* (22 November 2010), p. 44.

14 See A. Peach, 'Craft, Souvenirs and the Commodification of National Identity in 1970s Scotland', *Journal of Design History*, vol. 20, no. 3 (Autumn 2007), pp. 243–57.

15 M. Wade, 'Sporran Maker Given Marching Orders', *The Times* (5 June 2021), p. 12.

16 The Harris Tweed Act 1993 defines the product as a tweed which 'has been handwoven by the islanders at their homes in the Outer Hebrides, finished in the Outer Hebrides, and made from pure virgin wool dyed and spun in the Outer Hebrides': https://www. legislation.gov.uk/ukla/1993/11/enacted (accessed 22 May 2024).

17 For more on the Harris tweed revival, see B. Wilson, 'The Tweed Crisis that Became an Opportunity', *Stornoway Gazette* (18 November 2022).

18 Scottish development organisations recognised the economic value of the handicrafts long ago. For a superb discussion, see A. Peach, 'The Making of Modern Scottish Craft: Revival and Invention in 1970s Scotland' (PhD thesis, Robert Gordon University, 2017).

CHAPTER 3

1 Though today the surname Collier is widely associated with coal mining, it originally referred to someone who burnt and sold charcoal; Parkers were occupational names for park stewards and gamekeepers; and Hurst and Shaw were topographic names given to people who lived in or near groves, copses and other small woodlands, from the Old English *hyrst* and *sceaga* respectively.

NOTES

2 For more, see I. Rotherham, *Ancient Woodland: History, Industry and Crafts* (Shire, 2013). See also O. Rackham, *Trees and Woodland in the British Landscape: The Complete History of Britain's Trees, Woods and Hedgerows* (Weidenfeld & Nicolson, 1976).

3 The finest description of the Chilterns remains H. J. Massingham, *Chiltern Country* (Batsford, 1940). For more on its woodsmen, see P. Preece, 'Woodmen of the Oxfordshire Chilterns, 1300–1800', *Folk Life: Journal of Ethnological Studies*, vol. 26, no. 1 (1987), pp. 70–77.

4 For more on the tradition, see C. Cater & K. Cater, *Wassailing: Reawakening an Ancient Folk Custom* (Hedingham Fair, 2013).

5 For more, see K. Kirby, G. Buckley & J. Mills, 'Biodiversity Implications of Coppice Decline, Transformations to High Forest and Coppice Restoration in British Woodland', *Folia Geobotanica* (2017), pp. 5–13, and R. J. Fuller & M. S. Warren, *Coppiced Woodlands: Their Management for Wildlife* (Joint Nature Conservation Committee, 1993).

6 From the Iron Age onwards, many walls were in-filled with a combination of wattle (wooden stakes interwoven with branches and twigs) and daub (usually made with local mud and clay). The basic method continued into the twentieth century, using lath and plaster, with the introduction of plasterboard.

7 J. Hopkins & K. Kirby, 'Ecological Change in British Broadleaved Woodland since 1947', *Ibis*, vol. 149, no. 2 (November 2007), pp. 29–40.

8 The classic account of woodland crafts remains H. Edlin, *Woodland Crafts in Britain: An Account of the Traditional Uses of Trees and Timbers in the British Countryside* (David & Charles, 1973).

9 See J. Eyers, *Chilterns at Work* (Amberley, 2018).

10 L. J. Mayes, *The History of Chairmaking in High Wycombe* (Routledge & Kegan Paul, 1960).
11 Many of these observations draw on conversations with Buckinghamshire-based bodger authority Stuart King, and his book, *The Chair Bodgers* (Old Bucks Boy Publications, 2020).
12 *Furniture Gazette* (21 April 1877), cited in C. Edwards, 'Vernacular Craft to Machine-Assisted Industry: The Division of Labour and the Development of Machine Use in Vernacular Chair-Making in High Wycombe 1870–1920', *Proceedings of the 9th International Symposium on Wood and Furniture Conservation* (Stichting Ebenist, 2009), pp. 91–102.
13 C. Leighton, *Country Matters* (Victor Gollancz, 1937), pp. 65–6. Massingham has a similar account in *Chiltern Country*, 1940, pp. 58–65.
14 A fascinating account of the Deans, told by their descendants, can be found here: https://www.chilternsaonb.org/news/the-bodger-by-alice-dean (accessed 15 February 2024).
15 See, for example, *Chair Bodging and Chair Making in the Chiltern Hills* (c. 1935): https://eafa.ehost.uea.ac.uk/work/?id=1030176; and the BBC's short film *The Chair Bodgers of the Chilterns* (1950): https://www.bbc.co.uk/archive/the-chair-bodgers-of-the-chilterns/zhybpg8.
16 E. F. Schumacher, 'Small is Beautiful', *The Radical Humanist*, vol. 37 (August 1973), p. 22.

CHAPTER 4

1 According to one relatively recent survey, Bedfordshire is Britain's least popular county: https://yougov.co.uk/topics/travel/articles-reports/2018/08/20/dorset-and-devon-are-most-popular-english-counties (accessed 25 March 2025).

NOTES

2 L. Grof, *Children of Straw: The Story of a Vanished Craft and Industry in Bucks, Herts, Beds and Essex* (Buckingham: Barracuda, 1988).
3 https://historicengland.org.uk/images-books/publications/hat-industry-luton-buildings/hat-industry-luton-and-buildings/ (accessed 25 March 2025).
4 There are three other Ouse rivers in Britain: one in Yorkshire, one in Sussex, and another in East Anglia, named the Little Ouse, which is connected to the Great Ouse. Their name probably derives from the Celtic *$udso^-$*, meaning 'water'.
5 H.E. Bates, *Down the River* (London: Victor Gollancz, 1937), p. 74.
6 B. Flanagan & K. Grimwade, *The Watermills and Landscape of the River Great Ouse, Cambridgeshire* (Windgather Press, 2025).
7 E. Porter, 'Folk Life and Traditions of the Fens', *Folklore*, vol. 72, no. 4 (December 1961), pp. 584–98. See also J. Boyce, *Imperial Mud: The Fight for the Fens* (Icon Books, 2021).
8 This strange void was even noted by Daniel Defoe in the eighteenth century, who couldn't believe the area had no market towns outside of Bedford.
9 See Bates, *Down the River*, p. 87.
10 L. Fletcher, 'Strewings', *Folk Life*, vol. 36, no. 1 (1997), pp. 66–7.
11 Letter from Erasmus to Francis, quoted in N. Lloyd, *A History of the English House* (London: The Architectural Press, 1931), p. 80.
12 'Rushbearing' ceremonies can still be found in parts of Yorkshire and Cumbria, some of them claiming long histories.
13 Rushwork was briefly revived in Norfolk in the 1930s, Pavenham in the 1940s and Suffolk in the 1950s, but usually without success. The only initiative to survive was established by Waveney Apple Growers, which in 1947 took over an abandoned rush workshop in Aldeby, Norfolk, in order to offer year-round employment to its seasonal apple-pickers.

14 N. Luxford, *A Working Life on the Great Ouse* (SB Publications), 2000.

15 W. Page (ed.), *The Victoria History of the County of Bedford*, vol. 2 (London: Constable, 1908), p. 125.

CHAPTER 5

1 These data are derived from official census records where occupational categories are often incomplete and inconsistent. The chart is therefore best read as indicative of broader trends.

2 At its peak in the nineteenth century, when its population was about 2,500, Colyton had 23 stonemasons, 18 carpenters, 18 tanners, 14 shoemakers, 11 cordwainers, 10 blacksmiths, 7 butchers, 7 tailors, 5 wheelwrights, 4 bakers, 4 coopers, 3 papermakers, 3 maltsters, 2 printers, 2 watchmakers, 2 fishmongers, 2 saddlers, 2 millers, 2 tallow chandlers, 2 sawyers, 1 currier, 1 glover, 1 ropemaker, 1 cabinetmaker and 1 basket-maker. Roughly half of all women were lacemakers. For sources, and a longer discussion, see A. E. Wrigley, 'The Changing Occupational Structure of Colyton over Two Centuries', *Local Population Studies*, vol. 18 (1977), pp. 9–21.

3 Martin Bodman, *Devon Leather: An Outline of a Lost Industry: Nineteenth Century Tanners and Tanneries* (Leat Press, 2008).

4 G. Sturt, *The Wheelwright's Shop* (Angelico Press, 2021), p. 18.

5 For more on these regional variations, see D. Viner, *Waggons and Carts* (Shire, 2008); J. Arnold, *Farm Waggons of England and Wales* (John Baker, 1969); and G. Jenkins, *The English Farm Wagon* (David & Charles), 1972.

6 Census returns. See https://www.visionofbritain.org.uk/census/ EW1891GEN/7?show=ALL (accessed: 29 October 2024).

7 For more, see J. Bailey, *Country Wheelwright* (Batsford, 1979); J. Bailey, *The Village Wheelwright* (Shire, 1994); J. Thompson, *The*

Wheelwright's Trade (Fleet, 1983); and the relevant chapter in G. Jenkins, *Traditional Country Craftsmen* (Amberley, 2009).

8 Sturt, *The Wheelwright's Shop* (2021), p. 74.

CHAPTER 6

1 For excellent summaries, see G. O'Hara, *Britain and the Sea: Since 1600* (Bloomsbury, 2010), B. Lavery, *The Island Nation: A History of Britain and the Sea* (Conway and Maritime, 2005), and I. Friel, *Maritime History of Britain and Ireland, c. 400–2001* (British Museum Press, 2003).

2 The building of the *Titanic* in Belfast between 1909 and 1912 employed 15,000 people – more than all the active commercial fishermen in the United Kingdom today.

3 For more, see M. Wright, *Cornish Guernseys & Knit-Frocks* (Polperro Heritage Press, 2008) and G. Thompson, *Patterns for Guernseys, Jerseys and Arans* (Dover, 1971).

4 C. Lancaster, 'University of Reading finds Ancient Traps and Footprints in the Severn Estuary', BBC News (6 January 2004): https://www.bbc.co.uk/news/uk-england-berkshire-67901154 (accessed: 21 March 2024).

5 The short newsreel film 'Pot Girls' (1931) shows several women making pots: https://www.youtube.com/watch?v=blMD1beex3c (accessed: 21 March 2024).

6 'A Crabber's Haven on the South Coast of Cornwall', *Pictorial World* (7 February 1884), p. 24.

7 A. Bennett, *The History Boys* (Faber, 2004), p. 102.

8 For more on this process, see Robb Robinson, *Trawling: The Rise and Fall of the British Trawl Fishery* (University of Exeter Press, 1998).

CRAFTLAND

9 At the end of 2020, Chris Giles of the *Financial Times* calculated that fishing was worth £436m to the UK economy and Harrods was worth £437m. For the full calculation, see https://twitter .com/ChrisGiles_/status/1339634774332370950 (accessed: 21 March 2024).

10 R. Thurstan et al., 'The effects of 118 years of industrial fishing on UK bottom trawl fisheries', *Nature Communications*, vol. 1, no. 15 (May 2010): https://www.nature.com/articles/ncomms1013 (accessed: 21 March 2024).

11 The figures were first published in the Marine Accident Investigation Branch and Health and Safety Executive's 2018 annual report.

12 K. Richardson et al., 'Global Estimates of Fishing Gear Lost to the Ocean Each Year', *Science Advances*, vol. 8, no. 41 (12 October 2022): https://www.science.org/doi/10.1126/sciadv.abq0135 (accessed: 21 March 2024).

CHAPTER 7

1 Willow is a natural source of salicylic acid, which de-gasses molten metal and brings its impurities to the surface. How bell-founders first discovered the material's properties remains a mystery. 'It's foundry witchcraft,' says Antony Stone; 'I have no idea how it works, it just does.'

2 There is a great deal of marvellous writing about the social function of bells. The most extensive is Alain Corbin's *Village Bells: Sound and Meaning in the Nineteenth-Century French Countryside* (Columbia University Press, 1998). For more concise accounts, see D. Garrioch, 'Sounds of the City: The Soundscape of Early Modern European towns', *Urban History*, vol. 30, no. 1 (2003), pp. 5–25; and W. Tullett, 'Political Engines: The Emotional Politics of Bells

in Eighteenth-Century England', *Journal of British Studies*, vol. 59 (July 2020), pp. 555–81.

3 Like many of history's famous quotations, Handel's immortal comment is probably apocryphal.

4 See L. F. Salzmann, *English Industries of the Middle Ages* (Constable & Co., 1913).

5 For more on the hosiery trade, which was particularly dominant in the East Midlands, see D. Smith, 'The British Hosiery Industry at the Middle of the Nineteenth Century: An Historical Study in Economic Geography', *Transactions and Papers (Institute of British Geographers)*, vol. 32 (June 1963), pp. 125–42.

6 A few years ago I made an embarrassing visit to Loughborough's last traditional hosier. Too scared to knock on the door, I climbed onto a bin around the corner to catch a glimpse inside. I was peering through one of the workshop's windows when a man emerged from the building, informed me that I'd been captured on CCTV, then asked me to leave the premises. When I told him I was researching a book on crafts, his demeanour changed. 'About bloody time someone showed some interest!' he piped, then led me through a forest of yarn trees, vibrating threads and gyrating Jumbercas. His firm, H. O. Bowley, has had to adapt to survive – most of its revenue now comes from fender socks, hair bubbles and kebab cases – but its future is uncertain. 'My family has had this building since 1863,' he told me. 'But we can't afford to stay here any longer.' I asked him what was going to happen to the workshop. 'They'll turn it into flats,' he replied. 'They always do.'

7 For more on the history of the firm, see M. Milsom, *Bells and Bellfounding: A History, Church Bells, Carillons, John Taylor & Co., Bellfounders, Loughborough, England* (CreateSpace Independent Publishing Platform, 2017).

CRAFTLAND

8 For a vivid contemporary account of the bell's journey, see 'Great Paul on his Progress', *The Builder* (27 May 1882), pp. 637–8.

9 http://news.bbc.co.uk/local/threecounties/hi/front_page/ newsid_9084000/9084367.stm (accessed: 13 June 2024).

10 For more on the process of bell-founding, see T. Jennings, *Bellfounding* (Shire, 1988).

11 For a mine of information on the sounds of bells, see Bill Hibbert's website: https://www.hibberts.co.uk/ (accessed: 13 June 2024).

12 The only exception appears to have been the Hemony brothers in the Low Countries, who produced a series of tuned bells as early as the eighteenth century. As far as we know, their secret died with them. For a famous discussion, see A. Simpson, *Why Bells Sound Out of Tune and How to Cure Them* (Skeffington & Son, 1897).

13 The other eleven foundries were Thomas Blackbourn in Salisbury (dissolved 1905), Bond & Sons in Burford (dissolved 1905), James Shaw in Bradford (dissolved 1908), Harrington, Latham & Co. in Coventry (dissolved 1916), James Barwell in Birmingham (dissolved 1920), Samuel Goslin in Bishopsgate, London (dissolved 1920), Warner & Sons in Cripplegate, London (dissolved 1921), Francis Birkett & Sons in Cleckheaton (dissolved 1922), Charles Carr in Smethwick (dissolved 1926), Alfred Bowell in Ipswich (dissolved 1939) and Lewellins & James in Bristol (dissolved 1940): https://dove.cccbr.org.uk/founders?bell_min_year=1900&bell _max_year=2000&order=dates&order_dir=desc (accessed: 10 June 2024).

CHAPTER 8

1 Only a handful of pub sign painters remain, the foremost being Andrew Grundon: https://signaturesignsuk.com/. David Smith is the only person in the country, and one of the last in the world, to

have mastered the highly complex glass and gold techniques listed: https://davidadriansmith.com (both accessed 1 August 2024).

2 See L. Lopes Cardozo Kindersley, *Cutting Across Cambridge: Kindersley Inscriptions in the City and University* (Cardozo Kindersley Workshop, 2011).

3 For more on Kindersley's recollections of his master, see D. Kindersley, *Mr Eric Gill* (Typophiles, 1967).

4 L. Lopes Cardozo Kindersley & D. Cohen-Sherbok, *The Alphabetician and the Rabbi* (Cardozo Kindersley Workshop, 2020), p. 38.

5 *Ibid*., p. 116.

6 L. Lopes Cardozo Kindersley, *Cutting into the Workshop: Celebrating the Work and Life of David Kindersley* (Cambridge University Press, 2013), p. 9.

7 R. W. Emerson, 'New England Reformers', in *Essays: Second Series* (James Munroe, 1844), n.p.

8 In conversation with the author.

9 M. Gayford, D. Kindersley & L. Lopes Cardozo Kindersley, *Apprenticeship: The Necessity of Learning by Doing* (Cardozo Kindersley Workshop, 2003), p. 30.

10 L. Lopes Cardozo Kindersley, *The Annotated Capital: On the Thinking Behind the Capital Letter of the Cardozo Kindersley Workshop* (Cardozo Kindersley Workshop, 2009), p. 16.

11 Though we tend to use the terms 'font' and 'typeface' interchangeably, they actually have rather different meanings. 'Typeface' refers to the design of the characters (i.e. Times New Roman), while 'font' refers to the variations (i.e. size, weight) applied to that typeface.

12 For more on the famous Trajan letterforms, see P. Shaw (ed.), *The Eternal Letter: Two Millennia of the Classical Roman Capital* (MIT Press, 2015).

CRAFTLAND

13 See Cardozo Kindersley, *The Annotated Capital* (2009).

14 E. Lloyd-Jones & L. Lopes Cardozo Kindersley, *Letters for the Millennium: Why We Cut Letters in Stone* (Cardozo Kindersley Workshop, 1999).

15 S. Garbett & L. Lopes Cardozo Kindersley, *A Suitable Stone: How Geology has Shaped the British Stones used for Letter Cutting and Fine Carving* (Cardozo Kindersley Workshop, 2004), pp. 36–7.

16 Lida has likened her masonry processes to the seven stages of life. *Blasting* (separating a piece of stone from the earth) is birth; *sawing* (cutting the stone into usable blocks) equates to early schooling; *pitching* (refining the block in the workshop) corresponds with further education; *pointing* (arriving at a finished shape) is the start of one's working life; *clawing* (scraping down the surface) is taking responsibility; *chiselling* is 'the moment of fulfilment, life's work, love's work, our destiny reached'; and *rubbing* (smoothing the surface) is a kind of ending. See Kindersley & Cohen-Sherbok, *The Alphabetician and the Rabbi* (2020), p. 12.

17 *Letters for the Millennium*, p. 55.

18 Ibid., p. 11.

19 'Quatrain LI', in E. FitzGerald, *Rubáiyát of Omar Khayyám: A Critical Edition*, ed. C. Decker (University of Virginia Press, 1997), p. 194.

CHAPTER 9

1 G. Daniels, *Watchmaking* (Philip Wilson, 1981).

2 For Smith's own account of this famous episode, see G. Daniels, *All in Good Time: Reflections of a Watchmaker* (Philip Wilson, 2013), pp. 207–16.

3 Quoted in D. Landes, 'Watchmaking: A Case Study of Enterprise and Change', *Business History Review*, vol. 53, no. 1 (Spring 1979), p. 4.

4 For a superb overview, see D. Landes, *Revolution in Time: Clocks and the Making of the Modern World* (Harvard University Press, 1983).

5 See N. Cummins and C. Ó Gráda, 'Artisanal Skills, Watchmaking, and the Industrial Revolution: Prescot and Beyond', *Northern History*, vol. 52, no. 2 (2022), pp. 216–38.

6 A. Davies, 'British Watchmaking and the American System', *Business History*, vol. 35, no. 1 (1993), pp. 40–54.

7 D. Landes, 'Watchmaking' (1979), p. 20.

8 G. Daniels, *All in Good Time: Reflections of a Watchmaker* (Philip Wilson, 2000).

9 A. Rees, *The Cyclopaedia; or Universal Dictionary of Arts, Sciences and Literature*, vol. 37 (Longman, Hurst, Rees, Orme & Brown: 1819).

10 Daniels, *Watchmaking* (1981), p. xiv.

11 Smith learned thirty-two of the thirty-four trades listed in 1819, fusees having become obsolete in the nineteenth century.

12 The finish is called *speculaire* in French, and *zaratsu* in Japan. For more on finishing, or *finissage*, see C. Besler, 'Watchmakers know that polish counts', *New York Times* (19 October 2023): https://www.nytimes.com/2023/10/19/fashion/watches-polish-kari-voutilainen.html (accessed: 1 December 2024).

CHAPTER 10

1 Edited footage of the ceremony can be viewed at https://www.youtube.com/watch?v=E4dkiJUlsVo (accessed: 15 August 2024).

2 The origin of whiskey in Ireland is clouded in myth. Many believe it was developed by Irish monks following their journeys around the Mediterranean and the Middle East, where they observed the distillation of grapes. It was certainly being made on the island a thousand years ago – long before it arrived in Scotland. The spirit

might first have served medicinal purposes. The word 'whiskey' derives from the Gaelic *usquebaugh*, meaning 'water of life'. For more on the history of Bushmills whiskey, see A. McCreary, *Spirit of the Age: The Story of Old Bushmills* (Longwood, 1984).

3 W. Bryant Logan, *Oak: The Frame of Civilisation* (W. W. Norton, 2006), p. 170.

4 See D. Twede, 'The Cask Age: The Technology and History of Wooden Barrels', *Packaging Technology and Science*, vol. 18 (2005), pp. 253–65.

5 D. Dean, 'London Lobbies and Parliament: The Case of the Brewers and Coopers in the Parliament of 1593', *Parliamentary History*, vol. 8, no. 2 (1989), pp. 341–65.

6 For more on coopers, see the various books by Kenneth Kilby, including *The Cooper and his Trade* (John Baker, 1972), *Coopers and Coopering* (Shire, 2004) and *The Village Cooper* (Shire, 2009). See also G. Jenkins, *The Cooper's Craft* (Museum of Welsh Life, 1972).

7 'A New Whiskey Story: From Father to Son', *Irish Times* (9 June 2017): https://www.irishtimes.com/sponsored/answer-the-call/a-new-whiskey-story-from-father-to-son-1.3112496 (accessed: 15 August 2024).

8 Many whiskey-makers partner with foreign producers to ensure a steady supply of casks. Bushmills works closely with a Spanish sherry cooperage called Antonio Páez Lobato.

9 For more on this, see I. Buxton & P. Hughes, *The Science and Commerce of Whisky* (Royal Society of Chemistry, 2015).

CHAPTER 11

1 Cited in D. Hey, *A History of Sheffield* (Carnegie, 1998), p. 79.

2 For more on Sheffield's steel and cutlery industries, see T. Cooper, *The Story of Sheffield* (History Press, 2021); M. Jones, *Sheffield at*

Work: People and Industries Through the Years (Amberley, 2018); M. Mollona, *Made in Sheffield: An Ethnography of Industrial Work and Politics* (Berghahn, 2009); and I. Rotherham, *Steel City: An Illustrated History of Sheffield's Steel Industry* (Amberley, 2018).

3 'A Day at the Sheffield Cutlery-Works', *The Penny Magazine of the Society for the Diffusion of Useful Knowledge*, vol. 13 (1844), p. 161. See also P. Machan, *The Little Mesters: The Rise, Decline and Survival of Sheffield's Traditional Trades* (ALD, 2023).

4 For a contemporary account, see G. Calvert Holland, *The Mortality, Sufferings and Diseases of Grinders* (Ridge & Jackson, 1842). See also D. Cullen, 'A Review of the History of Grinders' Asthma in Sheffield', *Topics in the History of Medicine*, vol. 2 (2022), pp. 102–113.

5 G. Orwell, *The Road to Wigan Pier* (Victor Gollancz, 1937), pp. 138–9.

6 G. Tweedale, *Steel City: Entrepreneurship, Strategy and Technology in Sheffield, 1743–1993* (Clarendon Press, 1995), p. 318.

7 For more on Brian Alcock, who was posthumously awarded a BEM, see https://www.yorkshirepost.co.uk/arts-and-culture/video-how-sheffields-last-grinder-forged-art-from-steel-1870381 (accessed: 21 November 2024).

8 The other is William Whiteley & Sons, established in 1760, which recently moved to a business park on the outskirts of the city.

9 The business was helped when in April 2020, as Covid-19 plunged people into virtual worlds, a video about its scissors was uploaded to social media. Six million people watched the video in its first week. The company did four Christmases' worth of business in one month. https://www.youtube.com/watch?v=bK4AWtTV3h4 (accessed: 29 November 2024).

10 E. Gill, 'Art and Reality', introduction to M. Raj Anand, *The Hindu View of Art* (Asia Publishing House, 1957), p. xiv.

CHAPTER 12

1 Every *mezuzah* contains two passages from the Torah (Deuteronomy 6: 4–9 and Deuteronomy 11: 13–21) written in one 22-line column; the parchment is rolled up and placed within a case called a *bayit*.

2 The seven major Hebrew names for God are *Shaddai, Adonai, Elohim, YHWH, El, Tzevaot* and *Ehyeh*.

3 Eruvin 13a, Talmud: https://www.sefaria.org/Eruvin.13a.10?lang=bi (accessed: 17 December 2024).

4 Deuteronomy 25: 17–19.

5 For more on griots, see T. A. Hale, *Griots and Griottes: Masters of Words and Music* (Indiana University Press, 1998), and B. Hoffman, *Griots at War: Conflict, Consolation and Caste in Mande* (Indiana University Press, 2001).

6 For more on the tale, see D. Conrad, *Sunjata: A West African Epic of the Mande Peoples* (Hackett Publishing, 2004).

A SELECTION OF (MOSTLY) EXTINCT OCCUPATIONS

1 Most of these occupations have been sourced from *A Dictionary of Occupational Terms Based on the Classification of Occupations used in the Census of Population 1921* (London: HMSO, 1927): http://doot. spub.co.uk/idx.php?letter=W (accessed: 13 November 2023). See also https://www.familyresearcher.co.uk/glossary/Dictionary-of-Old-Occupations-Index.html and https://www.visionofbritain.org.uk/ census/EW1881GEN/8 (both accessed 28 February 2024).